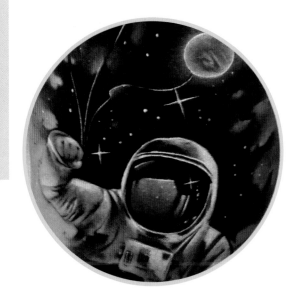
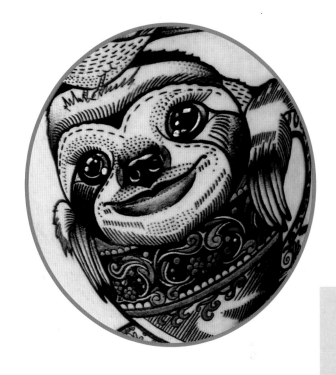

GEEK INK

THE WORLD'S SMARTEST TATTOOS FOR REBELS, NERDS, SCIENTISTS, AND INTELLECTUALS

FROM THE CREATORS OF

inkstinct

Race Point
PUBLISHING

Brimming with creative inspiration, how-to projects, and useful information to enrich your everyday life, Quarto Knows is a favorite destination for those pursuing their interests and passions. Visit our site and dig deeper with our books into your area of interest: Quarto Creates, Quarto Cooks, Quarto Homes, Quarto Lives, Quarto Drives, Quarto Explores, Quarto Gifts, or Quarto Kids.

10 9 8 7 6 5 4 3 2 1

ISBN: 978-1-63106-458-6

Editorial Director: Jeannine Dillon
Acquiring Editor: Melanie Madden
Project Editor: Jason Chappell
Managing Editor: Erin Canning
Cover and Interior Design: Jacqui Caulton

Printed in China

Opposite (clockwise from top right): Eva Krbdk, Emrah Ozhan, Jessica Svartvit, Balazs Bercsenyi, Bicem Sinik, María Fernández, Hugo Tattooer (center).

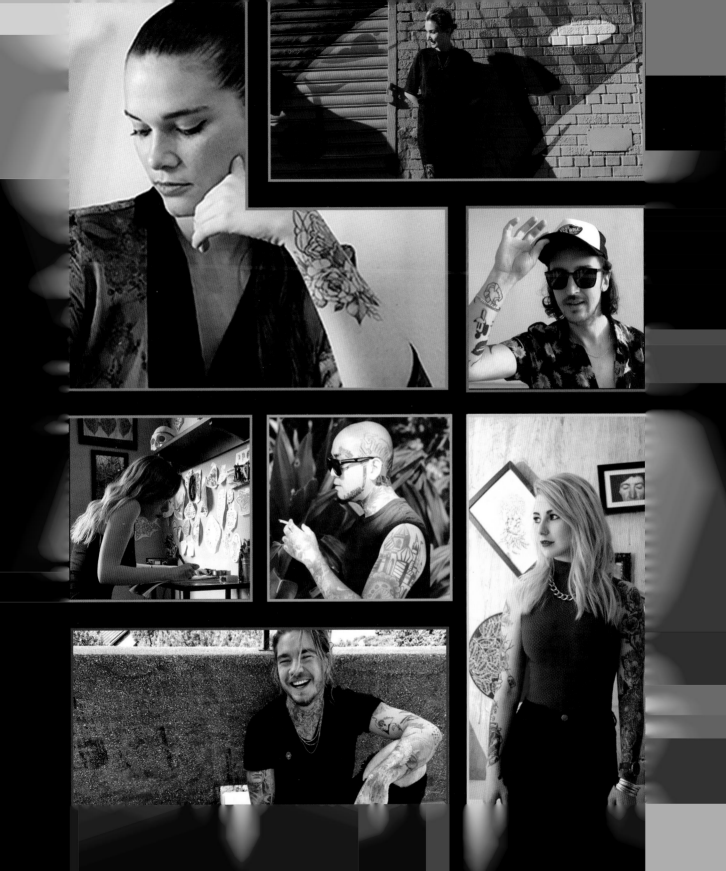

CONTENTS

INTRODUCTION

"Inkstinct was created," says founder Emanuele Pagani, "from the desire to bring tattoo artists, studios, and enthusiasts together, to expand the online tattoo community, and to elevate tattoo culture, showing that tattoos are not just a product of cultural trends or fads, but rather genuine art that reflects people."

Originally started in 2014 as the largest tattoo studio directory, Inkstinct is the first project that offers tattoo enthusiasts a 360-degree representation of the tattoo industry. In the short time it has existed, Inkstinct has gained respect and awareness from a new wave of elite tattoo artists across the globe, who are building their artistic profiles and brands through social media. Meanwhile, the budding platform has transformed itself into a community of more than 380,000 studios, each of which is synced directly with Facebook. Beyond simply displaying handpicked, high-quality tattoo designs from the best artists worldwide, the Inkstinct app allows tattoo enthusiasts to book appointments with their favorite studios and artists, and the continually updated gallery provides endless inspiration for fans and artists alike.

Currently, the Inkstinct platform is available at inkstinct.co or as a mobile app from the Apple App Store and Google Play. Artists can join and showcase their art for free, while fans can browse through countless designs on the app or via the official Instagram accounts, including:

"Inkstinct is dedicated to changing the word-of-mouth trend in the tattoo world, introducing people to talented artists who showcase their work via social media," says Pagani. "Connecting artists and studios with new and old tattoo enthusiasts is Inkstinct's ultimate mission."

HOW TO USE THIS BOOK

Geek Ink is organized into two sections. The first section features twenty-five of the world's best tattoo artists, organized alphabetically. These artists represent a diverse array of impressive tattoo styles and are spread across five continents. Many of them are in high demand, traveling frequently to develop customized tattoos with geeks of all nationalities.

The second section is a tattoo gallery, organized by theme. From animals and anime, to science fiction and technology, there's plenty of "ink-spiration" for every kind of geek! Just remember: As with any art form, direct duplication is frowned upon. These are original works of art by tattooists that have spent countless hours honing their craft. If you fall in love with a style or a design in this book and want to reproduce it, contact the artist first, or find a local artist with a similar style and add some personal touches that make your tattoo one-of-a-kind. Embrace your weird!

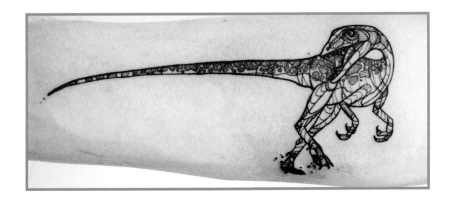

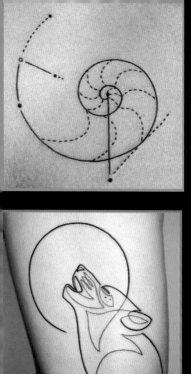

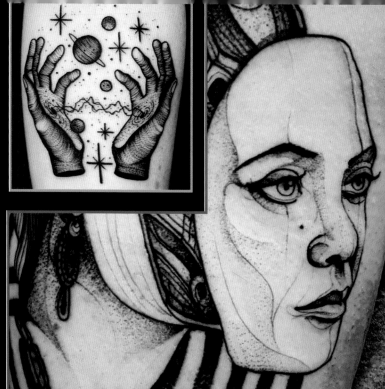

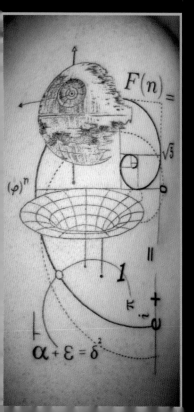

This page (clockwise from top right): Maeve Millay, inspired by *Westworld* by Felipe Kross; Made You Look by Balazs Bercsenyi; The Death Star, inspired by *Star Wars*; Euler's Identity; and the Golden Spiral by Emrah Ozhan; Wolf by Mo Ganji; Nautilus by Bicem Sinik; Cosmic Hands by Thomas Eckeard.

Opposite (clockwise from top right): Andrea Morales, Felipe Kross, Lustandconsume, Rita Nouvelle, PisSaro, Robson Carvalho, Mo Ganji (center).

FEATURED ARTISTS

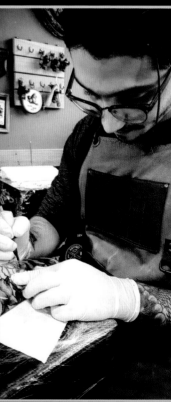

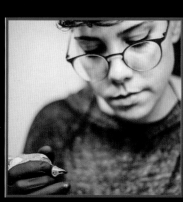

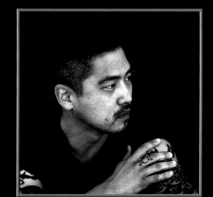

ADRIAN BASCUR

Navidad, Chile

Adrian Bascur is from a beautiful beach town located in Navidad, Chile, called La Boca de Rapel. The wind of his hometown runs through his veins, and the colors and movements of its nature live inside him. He takes his inspiration from the wind and all the motion it creates—the dance and the rhythm of nature. He studied at a couple of places, met a couple of masters, and learned a couple of techniques. Now, everyone asks for his signature "AB style" watercolor technique, often requesting tattoos of galaxies inside tiny cats or birds.

INSTAGRAM: adrianbascur
PORTFOLIO: www.inkstinct.co/artists/featured/adrianbascur

"I like to see how colors move and how they communicate with each other. I have been close to the sea my whole life. I like to be in touch with the waves, the tides, the sand crystals, and all the life that grows in between."

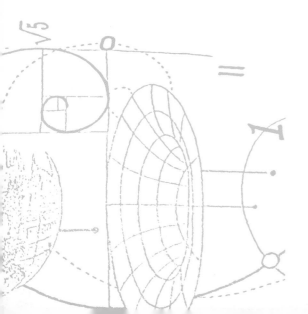

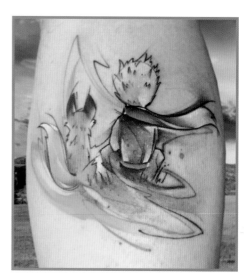

The Fox and the Prince, inspired by
The Little Prince

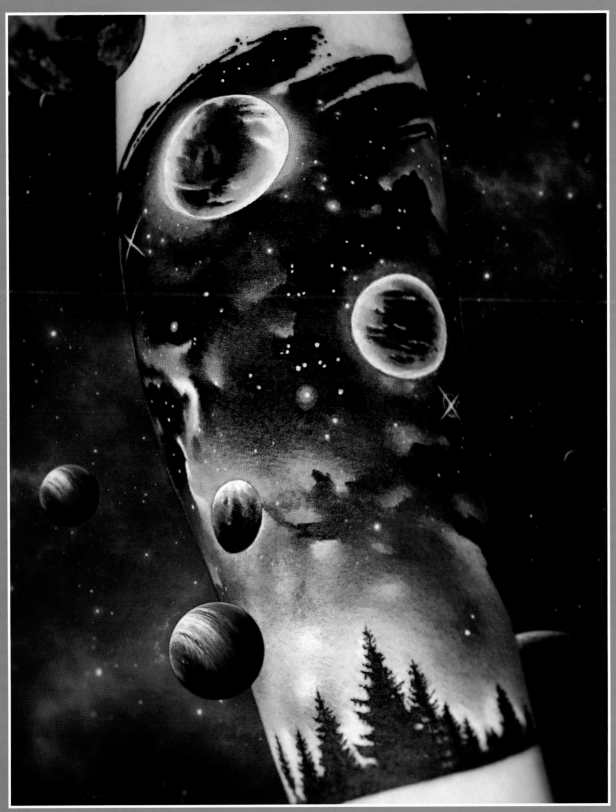

Galaxy Sleeve with Planets and Stars

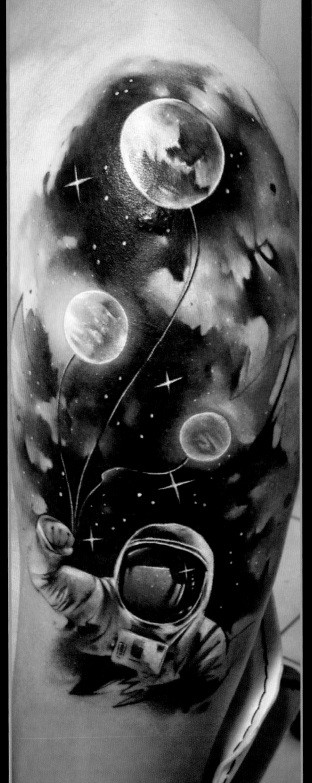

Astronaut in Space

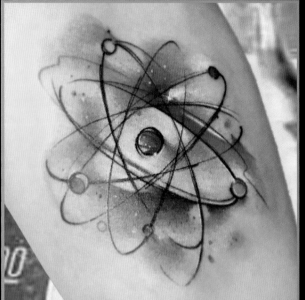

Atomic Particle

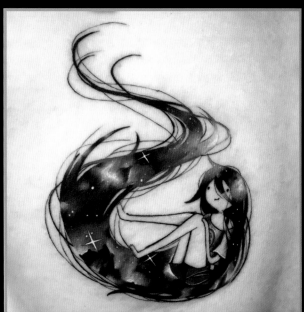

Marceline the Vampire Queen, inspired by
Adventure Time

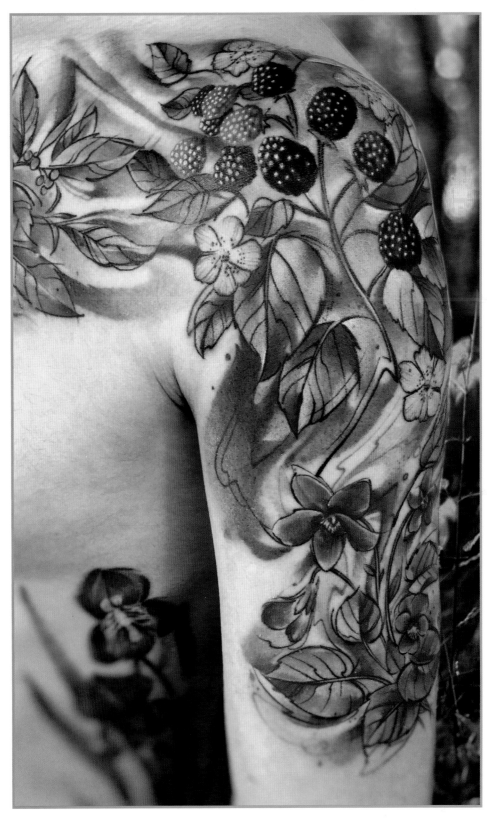

Berries on a Vine

BALAZS BERCSENYI

New York, New York

Balazs Bercsenyi started his career as a tattoo artist in London in 2009. The years since have been challenging, busy, and exciting. He is originally from Hungary and now lives and works in New York City. His aim is to continuously develop himself and his skills. Balazs enjoys meeting every client who comes to him, trusting him to recreate their visions and dreams.

INSTAGRAM: balazsbercsenyi
PORTFOLIO: www.inkstinct.co/artists/featured/balazs-bercsenyi

"I was mesmerized by the [tattoo] lifestyle, and the fact that I can give people something special every single day, and this memory is going to stay with them for the rest of their life. It's a very special bond between an artist and a client."

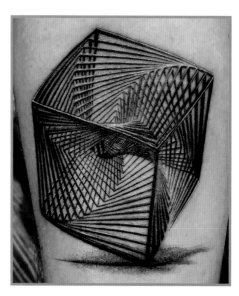

Cubic Illusion

14

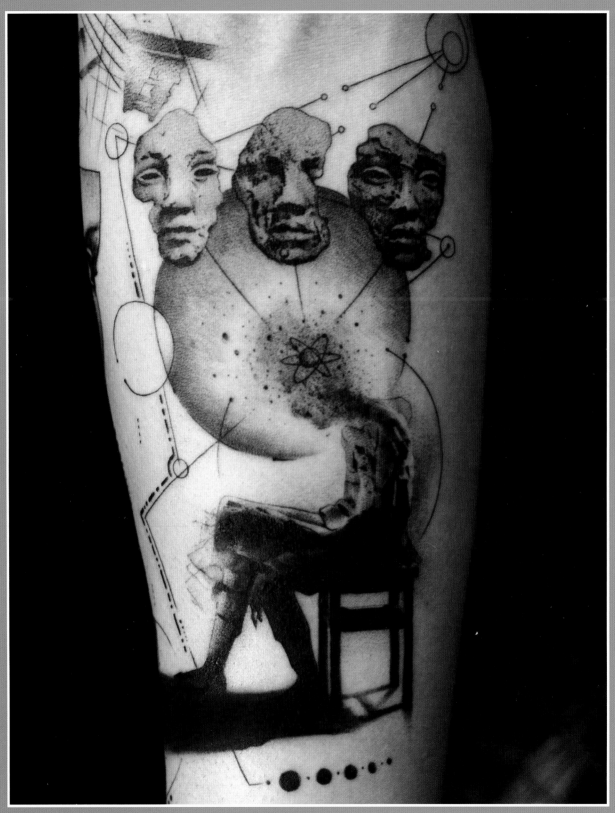

Got You on My Mind

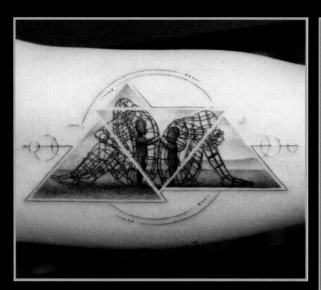

Inspired by *Love*, Alexander Milov's sculpture at
Burning Man 2015

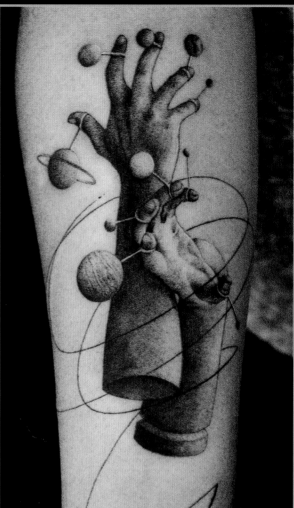

Planet Composer

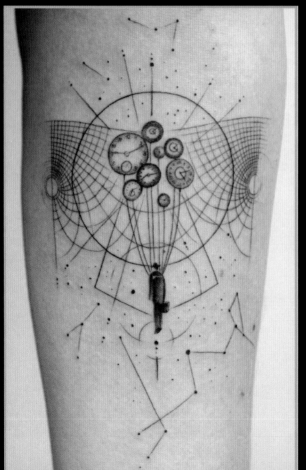

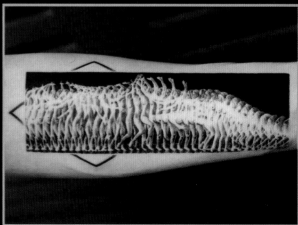

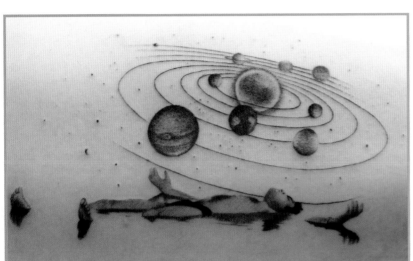

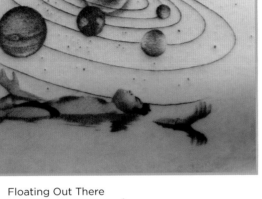

Floating Out There

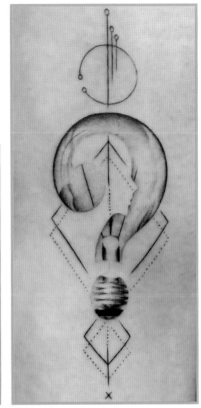

Inquiry

BALAZS BERGSENYI

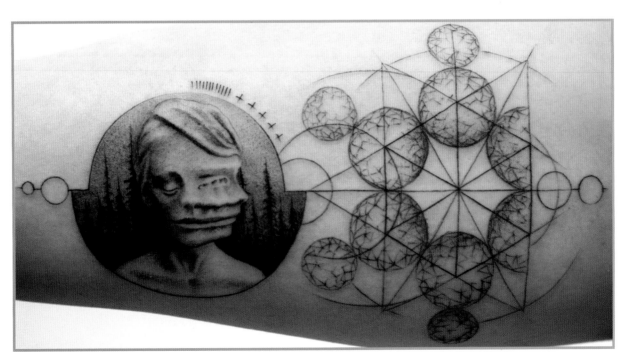

Made You Look

FRANK CARRILHO

Lisbon, Portugal

Frank Carrilho is a Brazilian-born artist living and working in Portugal. He names his art style "chaotic blackwork." It is influenced by comic-book storyboards and the work of great tattoo artists such as Kelly Violet, Róbert Borbás, Scott Move, Fredão Oliveira, and Felipe Rodrigues. The real starting point of this style happened when a client asked him to draw a shark in the hatching technique, using the fine lines in close proximity to give the effect of shading. The tattoo was scheduled for the next day, but Frank was too tired to finish the design and decided to post the unfinished work on Instagram. To his surprise, the client liked the tattoo as it was and decided to leave it unfinished. After that, Frank realized that people liked that style and realized that it gave him total freedom with his lines.

INSTAGRAM: frankcarrilho
PORTFOLIO: www.inkstinct.co/artists/featured/frank-carrilho

Fibonacci Vortex, inspired by the art
of Rafael Araujo

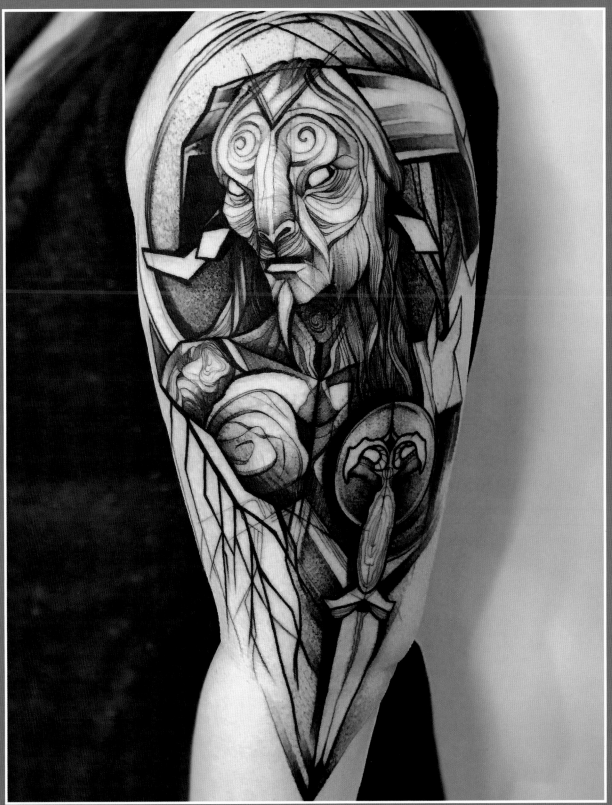

Faun, inspired by *Pan's Labyrinth*

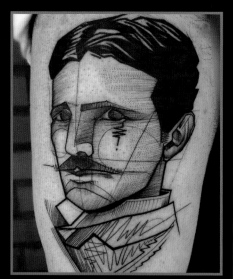

Nikola Tesla

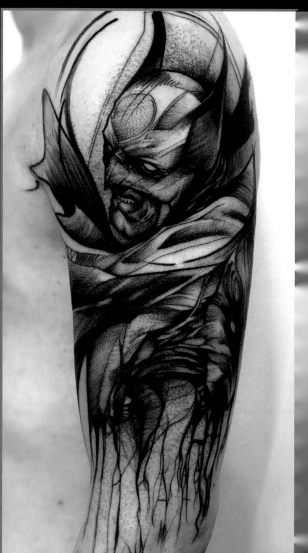

The Dark Knight, inspired by *Batman*

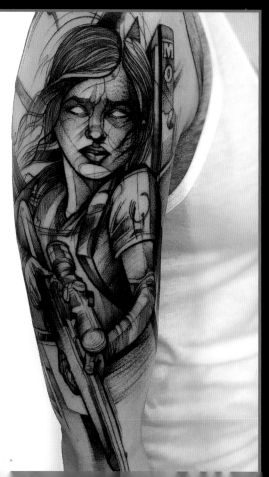

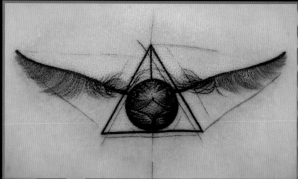

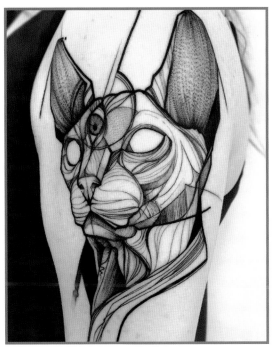

Cat with Third Eye

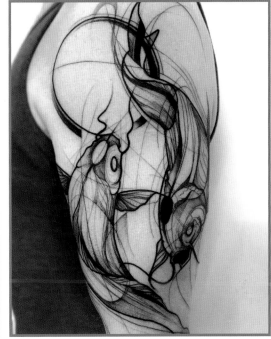

Koi Fish

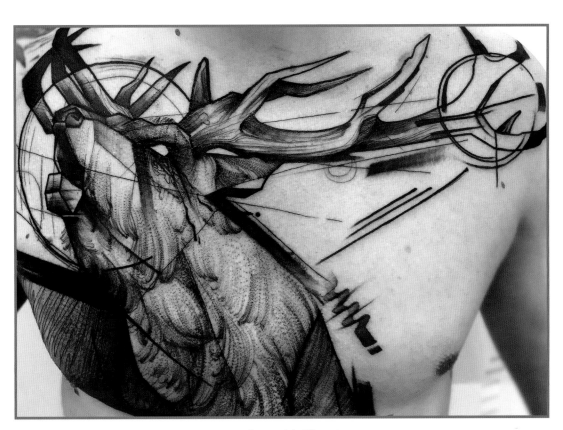

Geometric Elk

ROBSON CARVALHO

São Paulo, Brazil

Robson Carvalho, from São Paulo, Brazil, has been tattooing since 2015. His art is directly influenced by fantasy, comics, and graffiti. Rob is also a graphic designer and illustrator, and his love of sketching shows in his "loose pen" tattoos, which mix neo-traditional and watercolor techniques. His style conveys the imperfection—the ink sprays and faded lines and colors—of ink on vellum.

INSTAGRAM: robcarvalhoart
PORTFOLIO: www.inkstinct.co/artists/featured/rob-carvalho

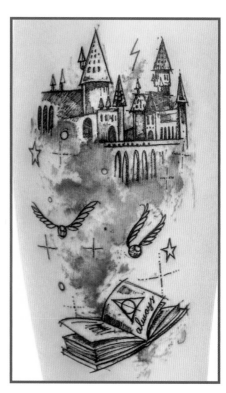

Hogwarts, inspired by *Harry Potter*

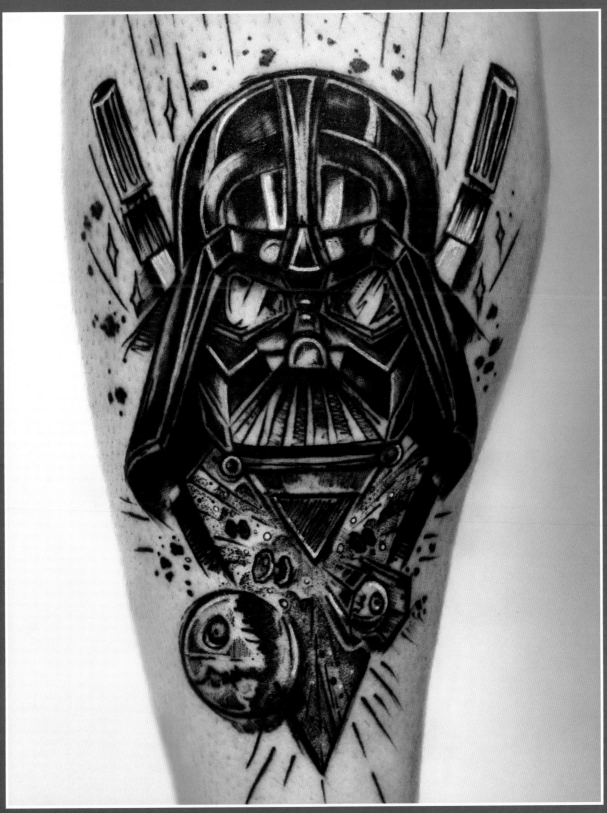

Darth Vader, inspired by *Star Wars*

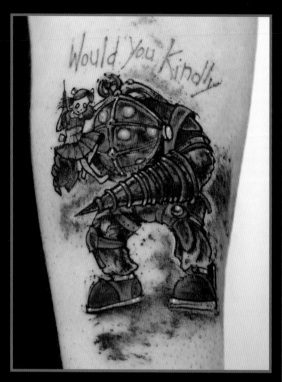

Big Daddy and Little Sister, inspired by *BioShock*

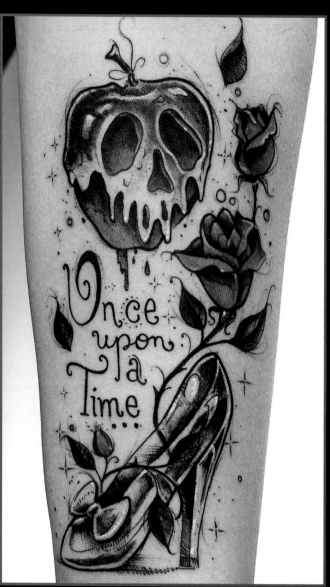

Once Upon a Time, a fairy-tale princess collage

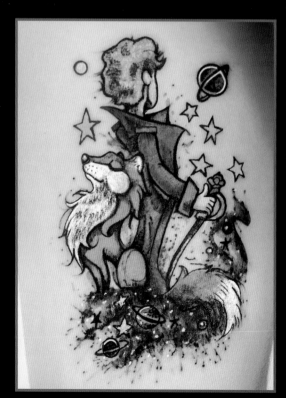

The Fox and the Prince, inspired by
The Little Prince

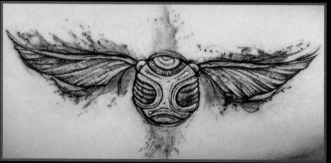

The Golden Snitch, inspired by *Harry Potter*

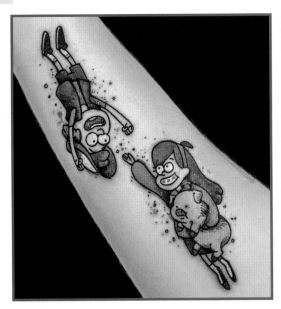

Dipper and Mabel, inspired by *Gravity Falls*

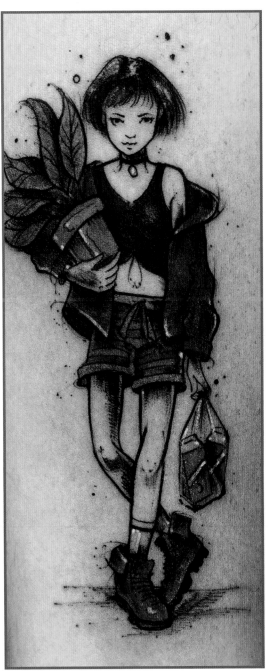

Mathilda, inspired by *Léon: The Professional*

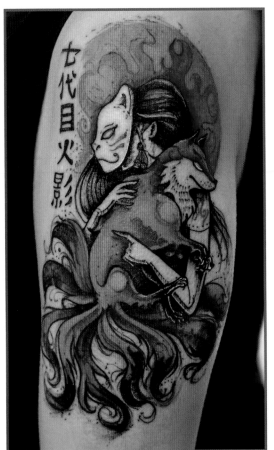

The Nine-Tailed Fox, inspired by *Naruto*

DAVID COTE
Montreal, Canada

David Cote was born in Montreal, Canada, in 1992. He studied graphic design to finally become a tattoo artist in 2011. He describes his style as a combination of neo-traditional and psychedelic tattooing. As a lucid dreamer, David gets many of his ideas while sleeping and always keeps a sketchbook next to his bed. He also gains inspiration from nature—everything from the silhouette of a tree to a shadow on the ground. He has many tattoos himself, but his favorite is the one on his head: a spiritual thing inked by his friend Jean-Philippe Burton.

INSTAGRAM: thedavidcote
PORTFOLIO: https://inkstinct.co/artists/featured/david-cote

"I like to learn about our cosmos and the universe we live in. I'm beyond fascinated by the atoms and cells that form everything we know today. It's a crazy dimension that we have access to and not many people are pleased to learn about what makes it so special."

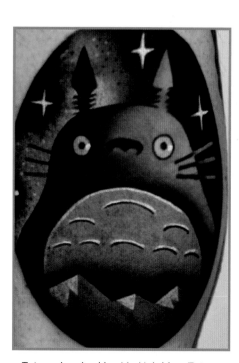

Totoro, inspired by *My Neighbor Totoro*

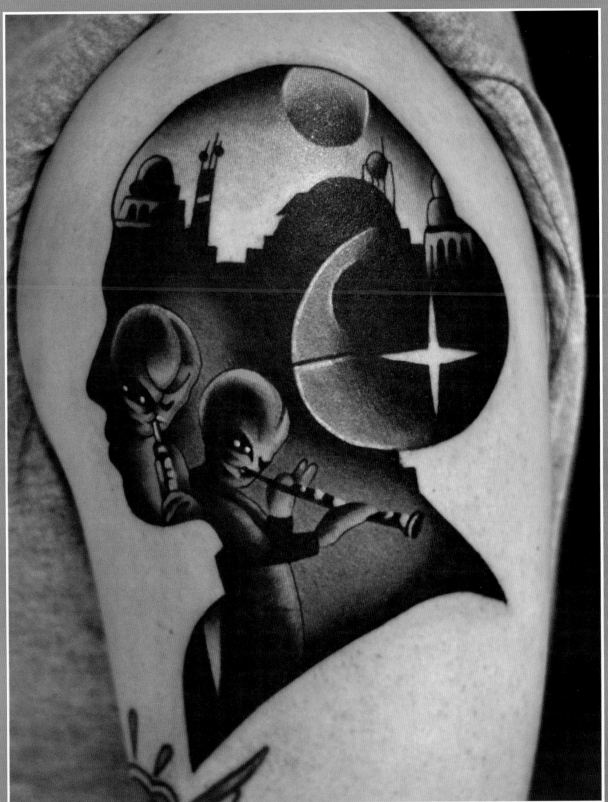

The Cantina Scene: A Tribute to Princess Leia, inspired by *Star Wars*

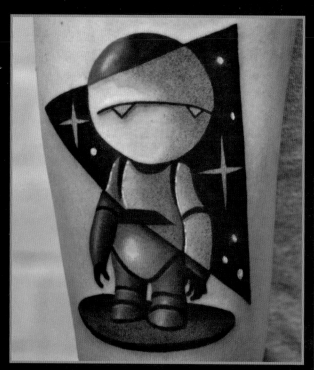

Marvin, inspired by *The Hitchhiker's Guide to the Galaxy*

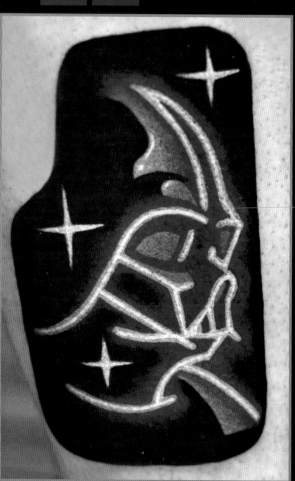

Neon Vader, inspired by *Star Wars*

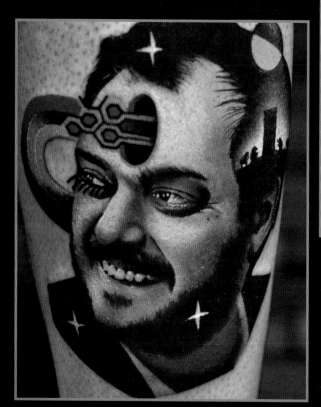

Stanley Kubrick

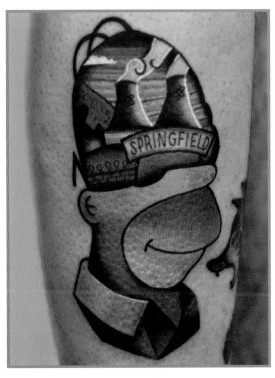

Trippin' Homer, inspired by *The Simpsons*

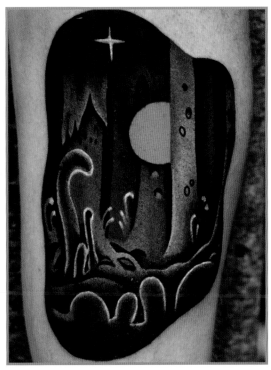

Nausicaä Forest, inspired by *Nausicaä of the Valley of the Wind*

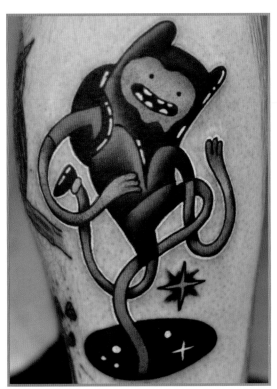

Finn, inspired by *Adventure Time*

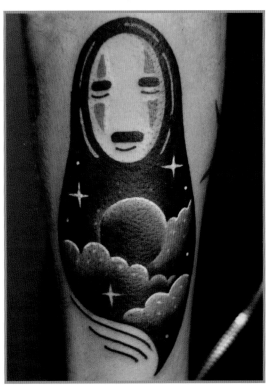

No-Face, inspired by *Spirited Away*

THOMAS ECKEARD
Arcadia, California

Thomas Eckeard has been an artist his whole life. He grew up influenced by graffiti art and skating and only began tattooing in 2014. When Thomas began tattooing, he quit his warehouse job to pursue a career in the arts and support his baby on the way. He soon discovered blackwork, which allowed him the artistic freedom to develop his signature dark, haunting style. He's inspired by space, magic, wizards, castles, and life, but his biggest inspiration is his son, Silas the King.

INSTAGRAM: thomasetattoos
PORTFOLIO: www.inkstinct.co/artists/featured/thomas-eckeard

"My favorite tattoo is my first tattoo ever: a square on my hand. For me it marks the beginning of it all. I did a square to remind me that technique and basics are . . . necessary to excel."

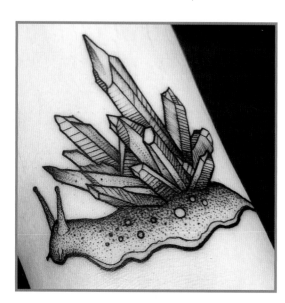

Crystal Slug

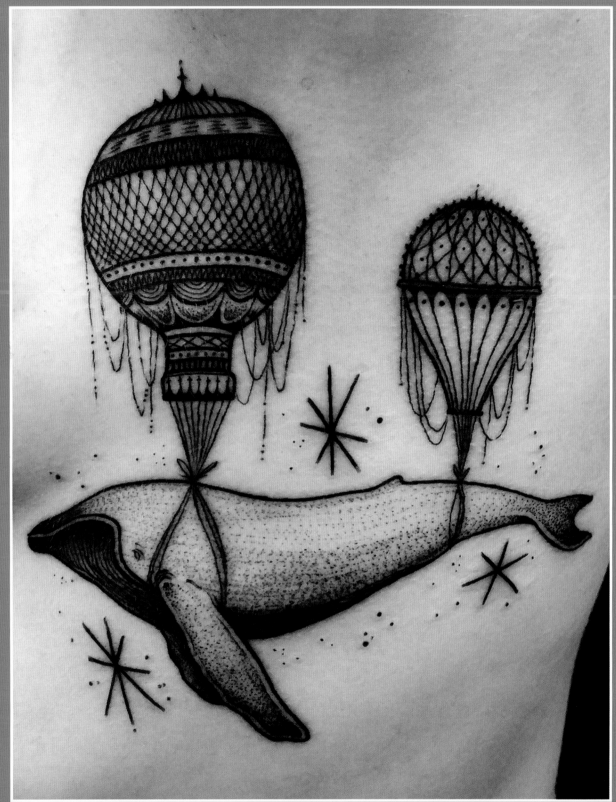

A Whale Held Aloft by Vintage Hot Air Balloons

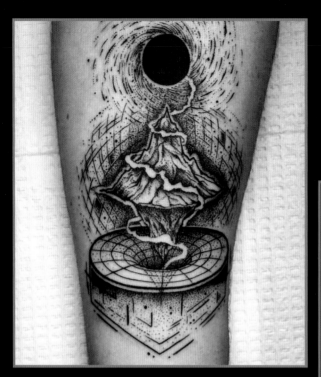

Dimensions

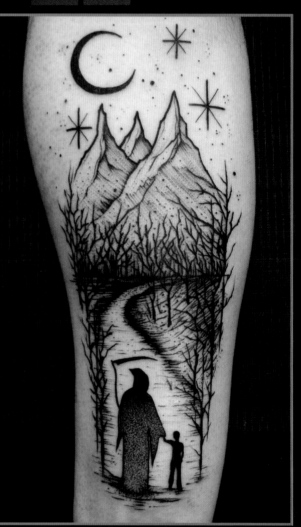

Embrace Death

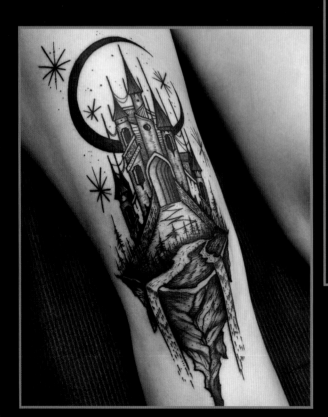

Dark Lunar Castle

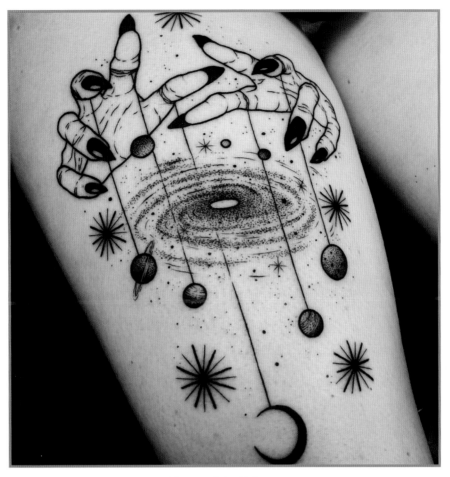

Master of the Universe

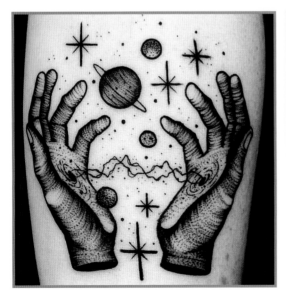

Cosmic Hands

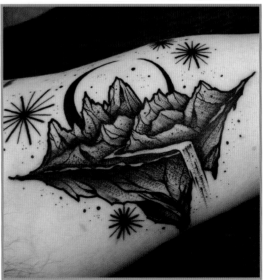

Monte Fitz Roy

33

MARÍA FERNÁNDEZ

Madrid, Spain

María Fernández González was born in Spain and spent the first part of her life in Madrid. When she was twenty years old, she moved to Germany. She studied painting and drawing in university and after receiving her master's degree, María began tattooing. Since the first tattoo she inked, her life has been devoted to the art and she loves her job. She draws her inspiration from books, of which she has a large collection. After working hard and making a name for herself in the tattoo scene, María returned to Madrid to open a studio of her own, Alchemist's Valley, together with her husband. Her life now is spent tattooing, traveling, and creating a positive and creative environment working with other great tattoo artists.

INSTAGRAM: mariafernandeztattoo
WEBSITE: www.alchemistsvalley.com
PORTFOLIO: www.inkstinct.co/artists/featured/maria-fernandez-gonzalez

"The same day I [first] got inked, I put all my drawings and sketches together and started looking for a studio that would want me as apprentice."

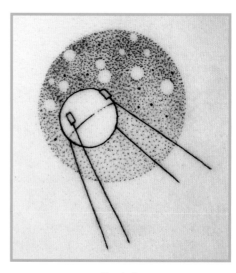

Sputnik

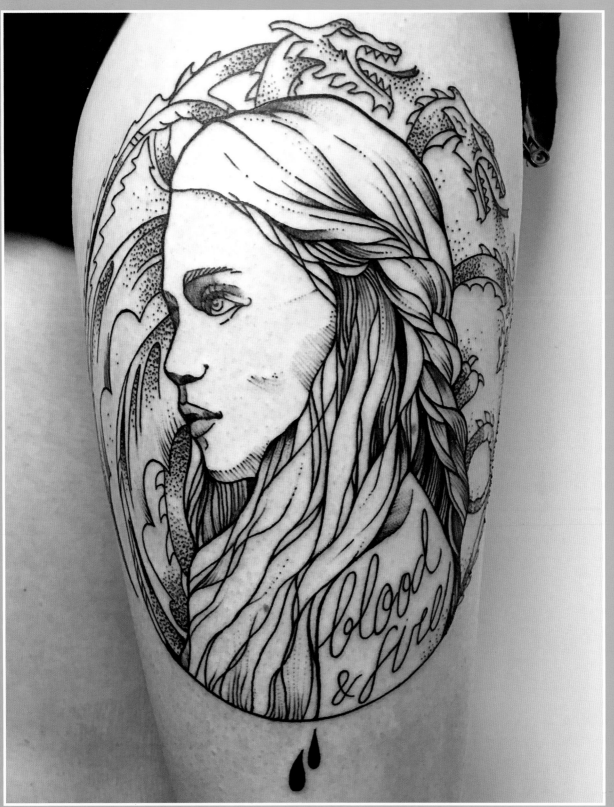

Daenerys Targaryen, inspired by *Game of Thrones*

Girl Watching the Universe

Zombies

Inspired by *Pan's Labyrinth*

Inspired by *Jurassic Park*

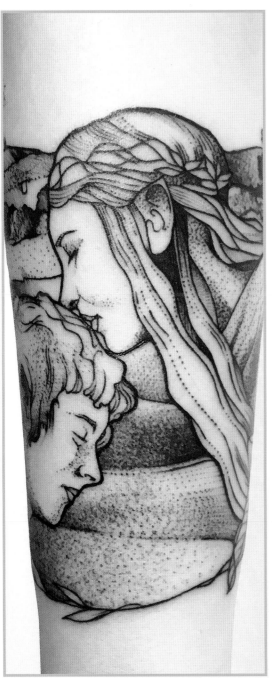

Frodo and Galadriel, inspired by
The Lord of the Rings

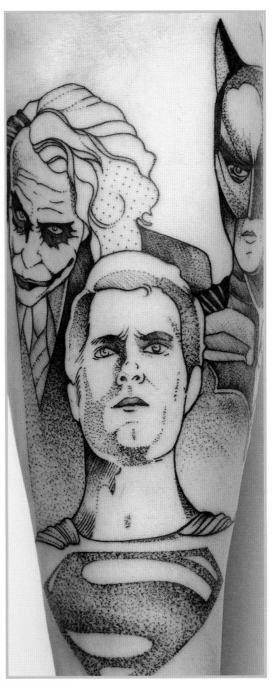

The Joker, Superman, and Batman, inspired
by DC Comics

MO GANJI
Berlin, Germany

Mo Ganji is a self-taught artist from Berlin, Germany. Originally born in Iran, his family fled the country in 1985, seeking a freer and more open-minded society. At age 30, after traveling the world, making a six-figure salary in retail management, he decided to pursue a more authentic life and learn how to tattoo.

Despite his popularity in the tattoo community, Mo does not have any tattoos on himself. He's fascinated by the power of simplicity, and his work is a reflection of the way he lives, pursuing minimalism in many aspects of his life. In Mo's mind, less is more, less is more satisfying, and less is more complex than most complex things. This carries through into many of his images.

Mo's style uses a single stroke to show that everything in this universe is somehow connected to each other: one energy that everything is made of. He is neither religious nor spiritual but he believes in that simple principle. Every work also includes three dots; these dots are his artist's signature and represent the body, the mind, and the soul.

INSTAGRAM: moganji
WEBSITE: www.moganji.com
PORTFOLIO: www.inkstinct.co/artists/featured/mo-ganji

"Once I heard from a client that we are all born with tattoos. They are underneath our skin and at one point of our life they push through on the outside. I guess that wasn't the case for me yet."

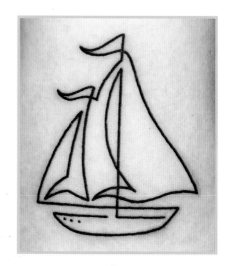

Sailboat

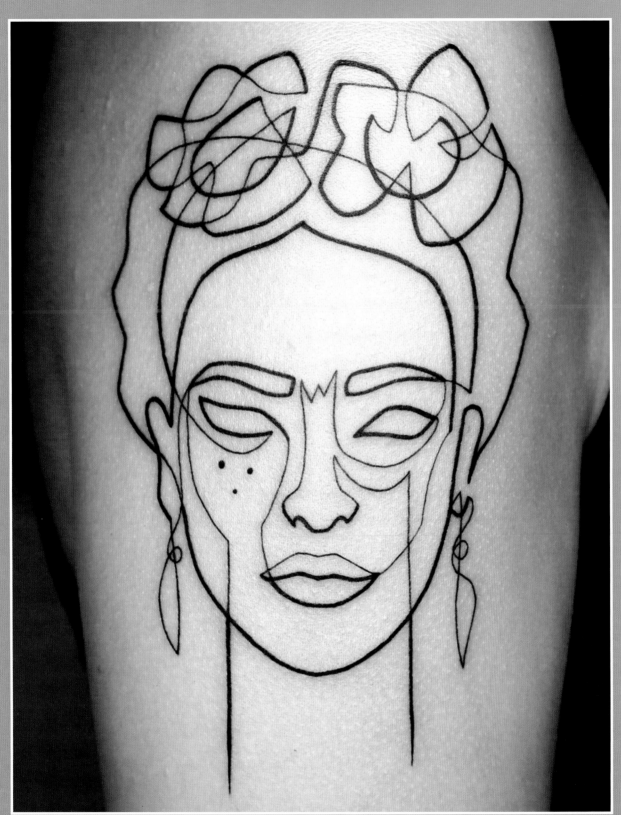

Frida Kahlo

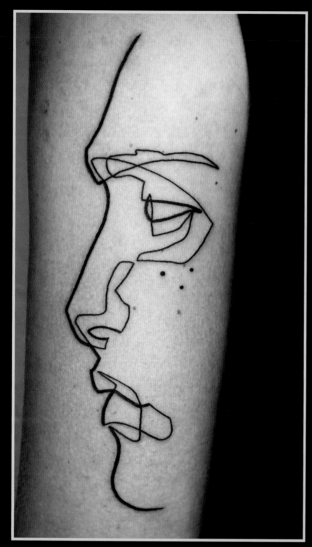

"Animal tattoos are an international language on and of the skin. . . . I think everyone loves animals. People who don't are suspicious."

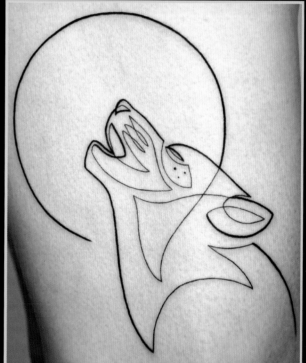

Profile

Wolf

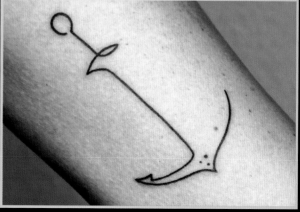

Bike

Anchor

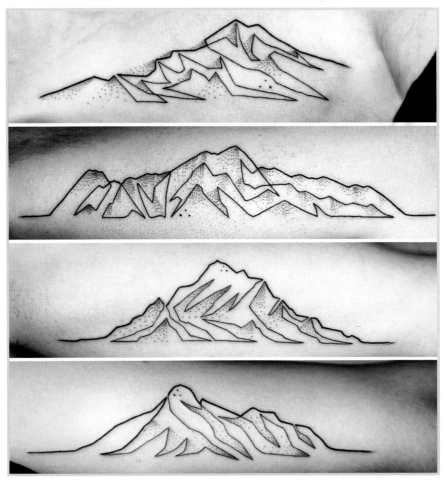

Mountains

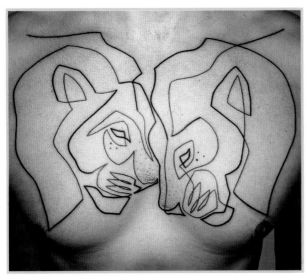

Lion Brothers

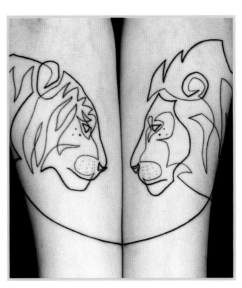

Sarabi and Mufasa, inspired by *The Lion King*

JAKE HAYNES
A.K.A. POKEEEEEEEOH
Malmö, Sweden

Jake Haynes, a.k.a. Pokeeeeeeeoh, is a self-taught Canadian hand-poked tattoo artist. This means he doesn't use a machine for his tattoos, instead simply poking the ink into the skin by hand. His tattoos generally include some humor or sarcasm, and sometimes include a political message, most often about feminism. He has had a variety of occupations in his life including café owner, licorice company owner, leather craftsperson, and waiter. He did his bachelor's degree in English literature and his master's degree in media studies. He currently works as a tattoo artist in Malmö, Sweden. Jake has about seventy tattoos on his body, but his favorite is the first one he ever inked: a collection of lines that looks like brickwork. He says that it's the worst tattoo ever.

INSTAGRAM: pokeeeeeeeoh
WEBSITE: pokeeeeeeeoh.wordpress.com
PORTFOLIO: www.inkstinct.co/artists/featured/jake-haynes

"I think one of my favorite [tattoos] is this scene I did on my friend's belly. It's a tomato and a bulb of garlic running towards a pizza shop because they're late for work … It's weird, but totally cute."

Something on the Other Side

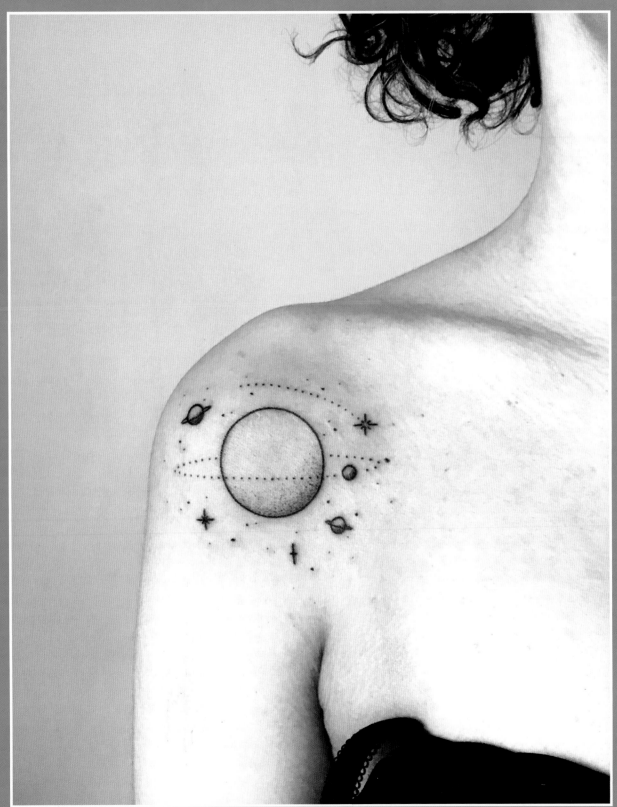

Twinkle Twinkle Little Star

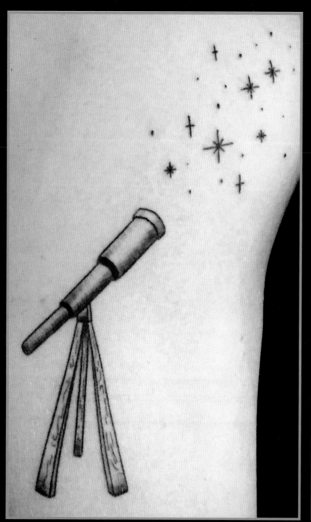

Don't Forget to Look Up at the Stars

Ye Olde Switcharoo

May the force be with you

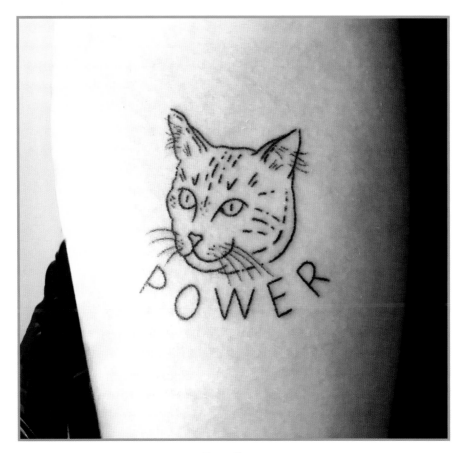

Pussy Power

RIP Carrie Fisher, inspired by *Star Wars*

Headless Beyond the Clouds

INEZ JANIAK
Łódź, Poland

Inez Janiak is a Polish tattoo artist based in Łódź who is best known for the chaotic drawing style that forms the base of her tattoo designs. She bought her first set of tattoo machines in 2011. A bit of a rebel, she went to school like her friends, but watched as all of their big dreams were slowly forgotten. Her friends realized that life is not as colorful as they thought it would be. Inez didn't want to live like that and held on to her dream of having a job she loved. That led to the decision to stop studying and buy the tattoo machines.

She began, working first on silicone skin, before some of her brave friends gave her their skin to work with. After six months, Inez was given a job in my first tattoo shop. At some point, somebody told her to use the tattoo needles in the same way as paint brushes. This led to experimentation with needles, helping her develop her unique style.

INSTAGRAM: ineepine
WEBSITE: www.facebook.com/ineepine/
PORTFOLIO: www.inkstinct.co/artists/featured/ineepine

The Deathly Hallows, inspired by
Harry Potter

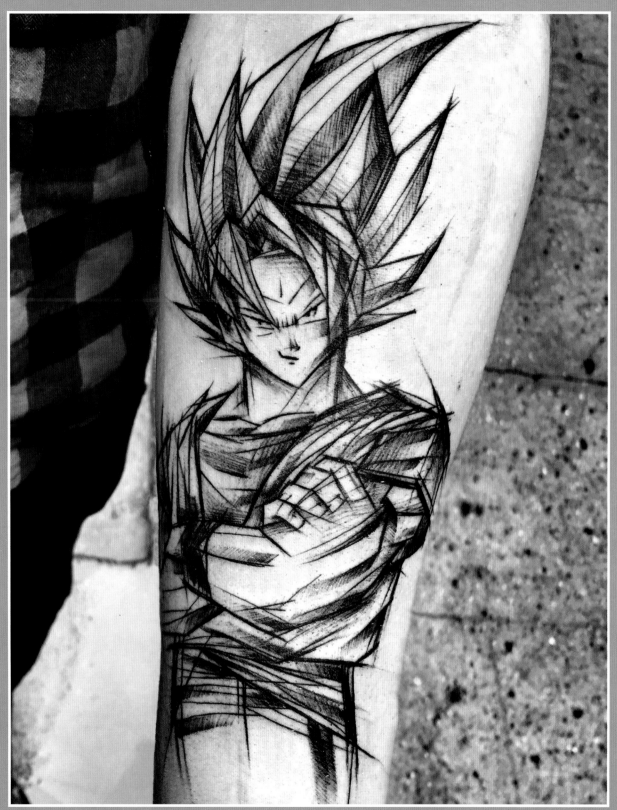

Super Saiyan Goku, inspired by *Dragon Ball Z*

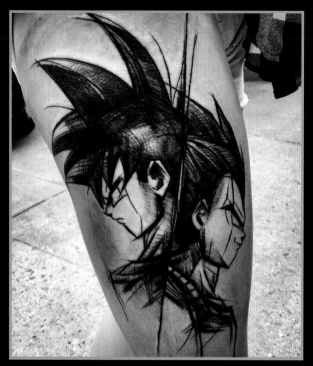

Goku and Vegeta, inspired by *Dragon Ball Z*

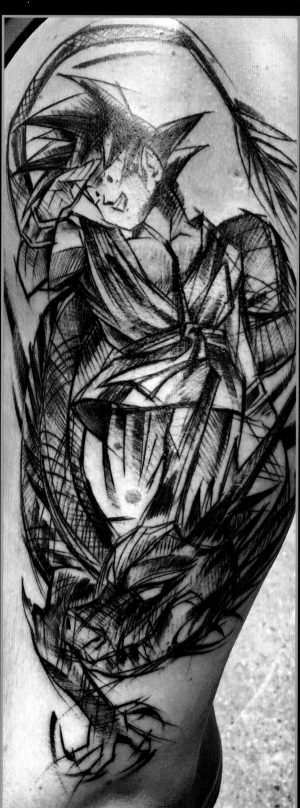

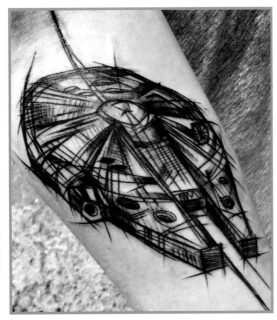

The *Millennium Falcon*, inspired by *Star Wars*

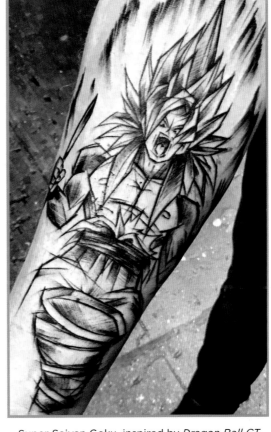

Super Saiyan Goku, inspired by *Dragon Ball GT*

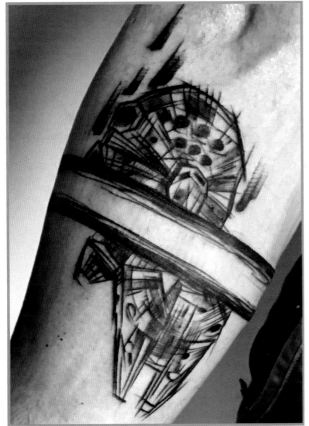

The *Millennium Falcon*, inspired by *Star Wars*

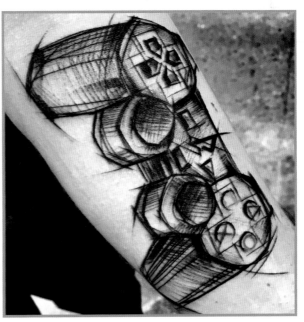

PlayStation 2 Controller

EVA KRBDK
New York, New York

Eva Krbdk is a Turkish tattoo artist based in New York. She attended Gazi University in Turkey to study art instruction, a competitive course of study that required a special talent examination to begin. She specialized at basic concepts of art and teaching while carrying out qualified research on subjects including painting, sculpture, ceramics, textiles, and industrial design.

Eva opened a tattoo studio in Ankara in 2011, but moved to Istanbul in 2015 to open a new studio. In 2016, she went to New York for a guest spot at Bang Bang Tattoos, an experience she enjoyed so much that she began the process of joining the team as a resident artist.

Her unique style allows her to follow her passion, fitting people's dreams and memories into miniature scenery tattoos. Her own childhood dreams are the biggest inspirations for her designs. She draws other inspiration from children's books and their illustrations.

INSTAGRAM: evakrbdk
PORTFOLIO: www.inkstinct.co/artists/featured/eva-krbdk

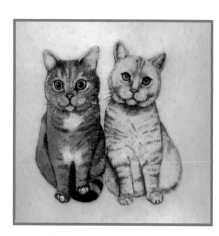

Two Cats

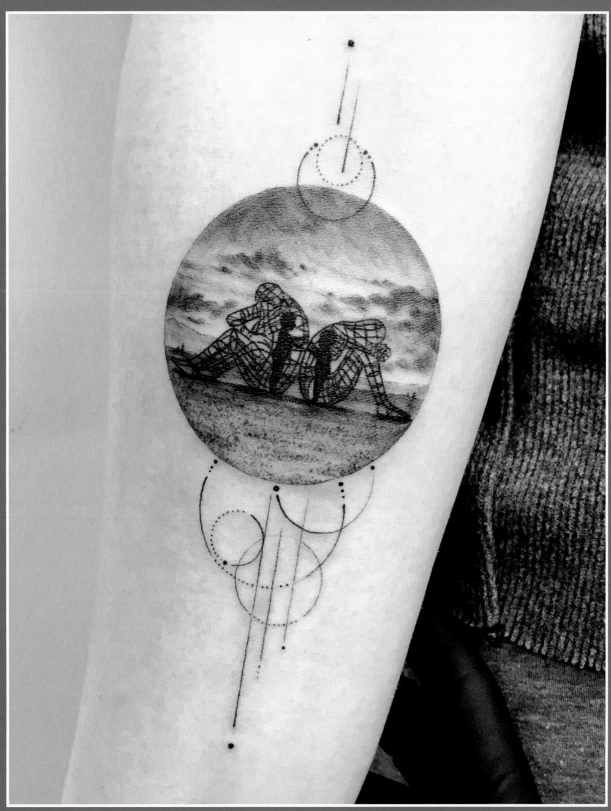

Inspired by *Love*, Alexander Milov's sculpture at Burning Man 2015

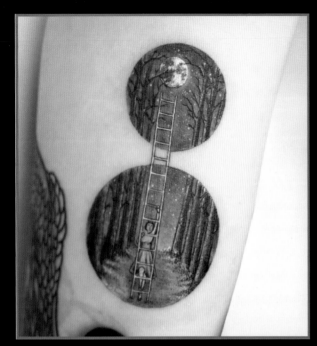

Climbing the Ladder

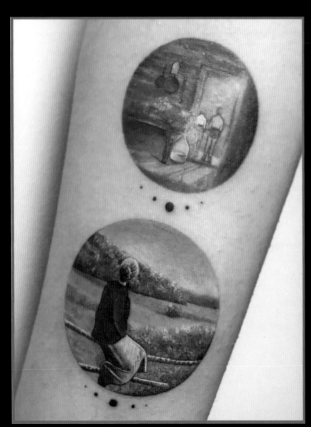

Inspired by Andrei Tarkovsky's 1975 film, *The Mirror*

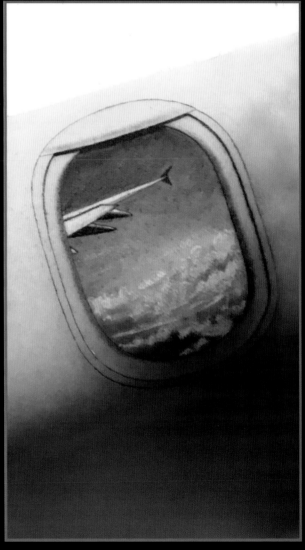

Airplane Window

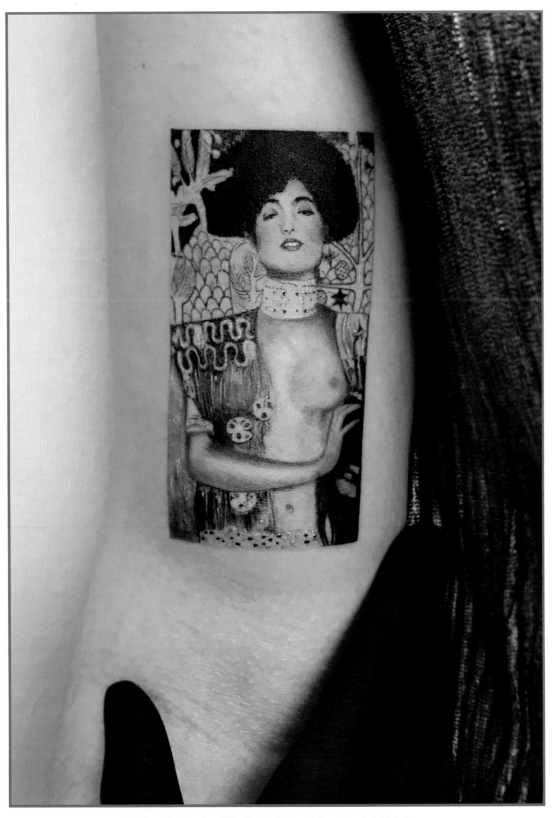

Inspired by Gustav Klimt's *Judith and the Head of Holofernes*

FELIPE KROSS
São Paulo, Brazil

Felipe Kross is a tattoo artist born in 1992, from São Paulo, Brazil. Coming from a family of artists, he was surrounded by the arts since childhood, and he grew up drawing his favorite fictional characters. In high school, Felipe began to have more contact with literature and history, and began to create ever more imaginative drawings. He worked for almost three years in technology, as a trainee and professional designer using AutoCAD, but at the end of 2011, he decided to change career directions.

Felipe began tattooing in his spare time. In 2013, after a long apprenticeship with master tattooist Paco Anes, Felipe decided to quit design school and dedicate himself full time to tattooing. He developed his personal tattoo style by harmonizing the ideas of his clients with his own particular art style and background. In 2016, together with another tattooist, Vinicius Lacerda, Felipe founded the New Black Studio, located in Vila Madalena, an artistic and bohemian neighborhood in São Paulo. The studio is dedicated entirely to black and gray tattoos, just as Felipe himself is dedicated to that line of work.

INSTAGRAM: fetattooer
PORTFOLIO: www.inkstinct.co/artists/featured/felipe-kross

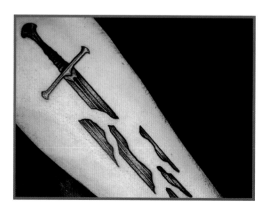

The Shards of Narsil, inspired by
The Lord of the Rings

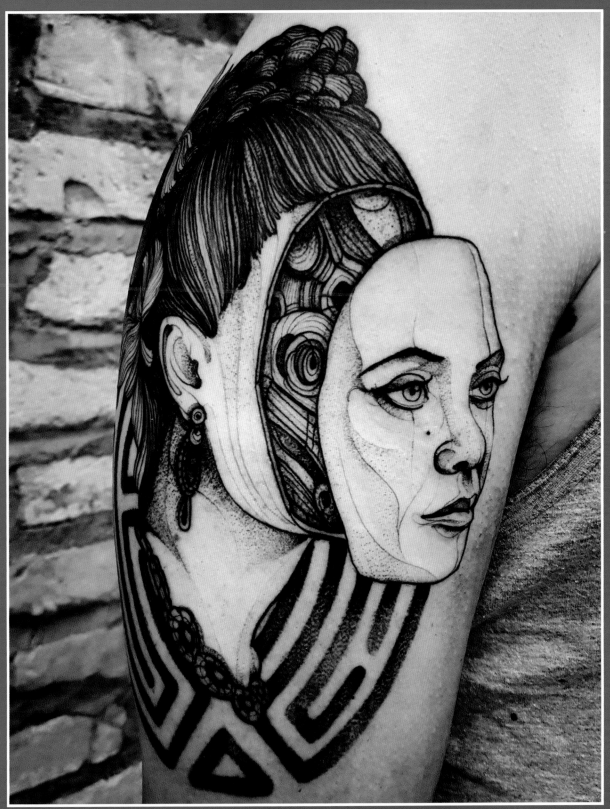

Maeve Millay, inspired by *Westworld*

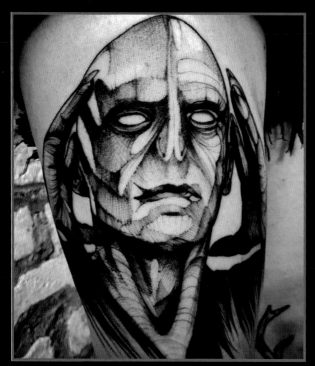

He Who Must Not Be Named, inspired by *Harry Potter*

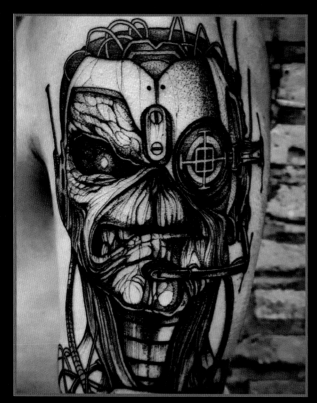

Eddie the Head, inspired by Iron Maiden

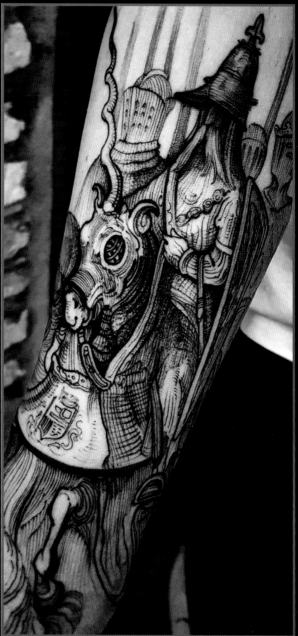

Inspired by Gustav Doré's *Medieval Knights*

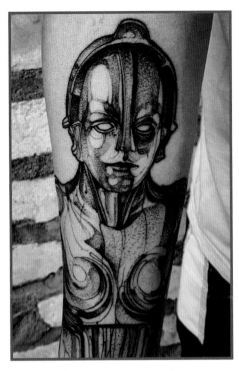

Inspired by *Metropolis*

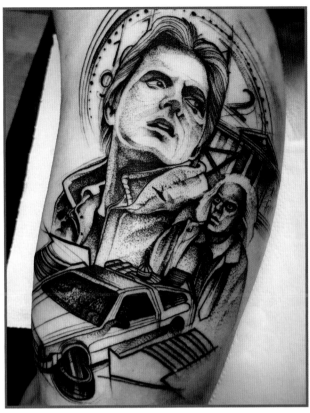

Marty McFly and Doc Brown, inspired by
Back to the Future

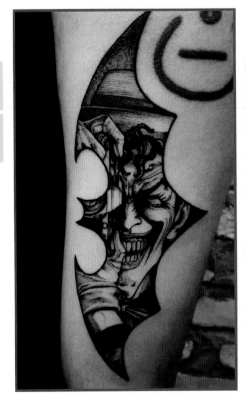

The Killing Joke, inspired by *Batman*

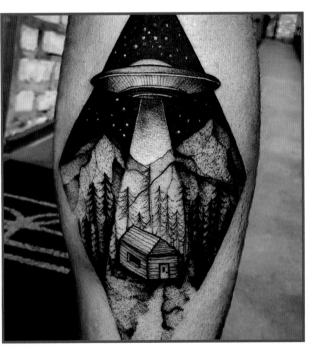

Alien Voice

LITTLE ANDY
Birmingham, United Kingdom

Little Andy (also known by his real name, Andrew Marsh) is a self-taught British tattoo artist at The Church Tattoo studio in Redditch, just outside Birmingham. Since beginning his practice in his bedroom in 2007, he has been all over the UK, Ireland, and Australia, developing his unique surrealist, psychedelic tattoo style. He enjoys tattooing portraits the most and just likes to have fun with his work, often beginning from a simple drawing and making everything else up as he tattoos the skin.

INSTAGRAM: Littleandytattoo
PORTFOLIO: www.inkstinct.co/artists/featured/little-andy

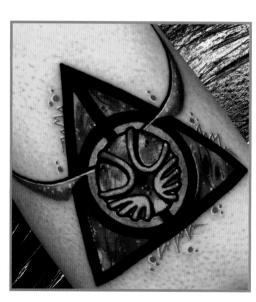

The Golden Snitch, inspired by *Harry Potter*

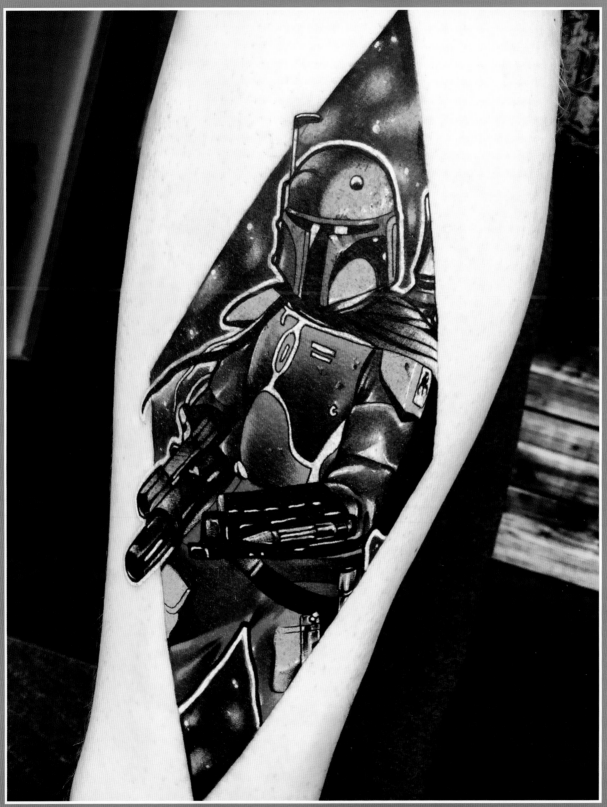

Boba Fett, inspired by *Star Wars*

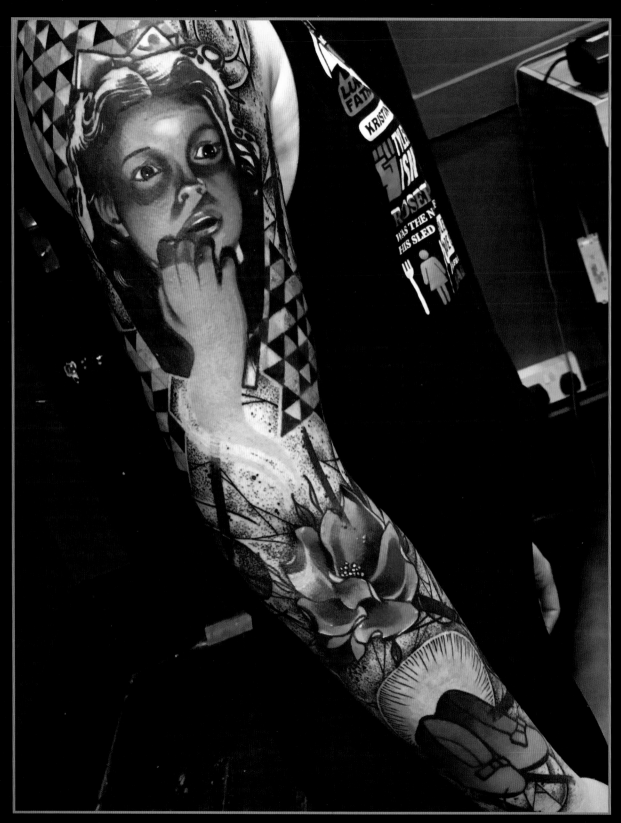

Dorothy, inspired by *The Wizard of Oz*

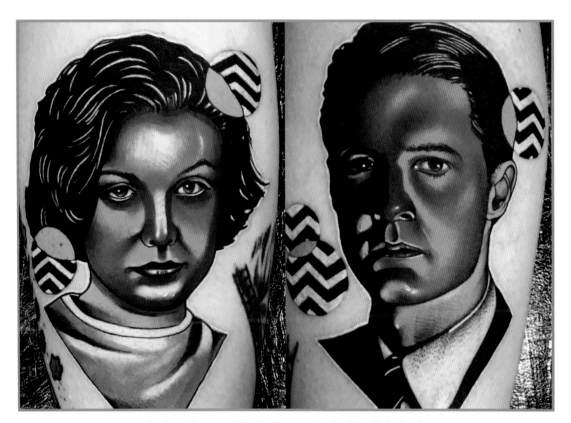

Audrey Horne and Dale Cooper, inspired by *Twin Peaks*

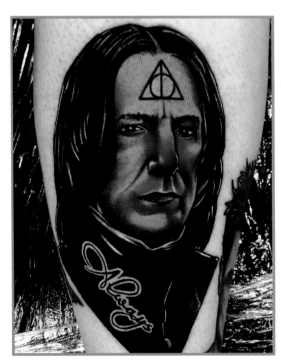

Severus Snape, inspired by *Harry Potter*

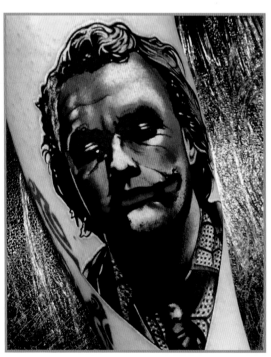

The Joker, inspired by *Batman*

LUSTANDCONSUME
A.K.A. PHIL TWORAVENS
Los Angeles, California

Lustandconsume prefers to let his ink do the talking. He is still digesting the evolution of his practice and career. Everything has been so fast, surreal, and amazing that he is trying to keep his head straight and his feet on the ground. Lustandconsume views tattooing as being similar to drawing and the essence of draftsmanship. He has always admired the engravings and woodcuts of Albert Durer, Francisco Goya, Gustave Doré, Franz von Bayros, and others. The line quality and craftsmanship of these artists are so remarkably exquisite.

Lustandconsume loves being a traveling artist because he can work alongside so many talented artists. He has been lucky enough that people have found him through social media and invited him into their shops as a guest artist. He loves the exchange of energy and ink that results from traveling and tattooing.

INSTAGRAM: lustandconsume
PORTFOLIO: www.inkstinct.co/artists/featured/lustandconsume

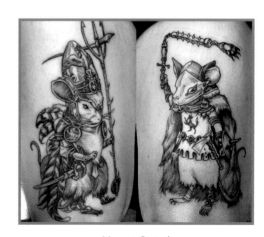

Mouse Guard

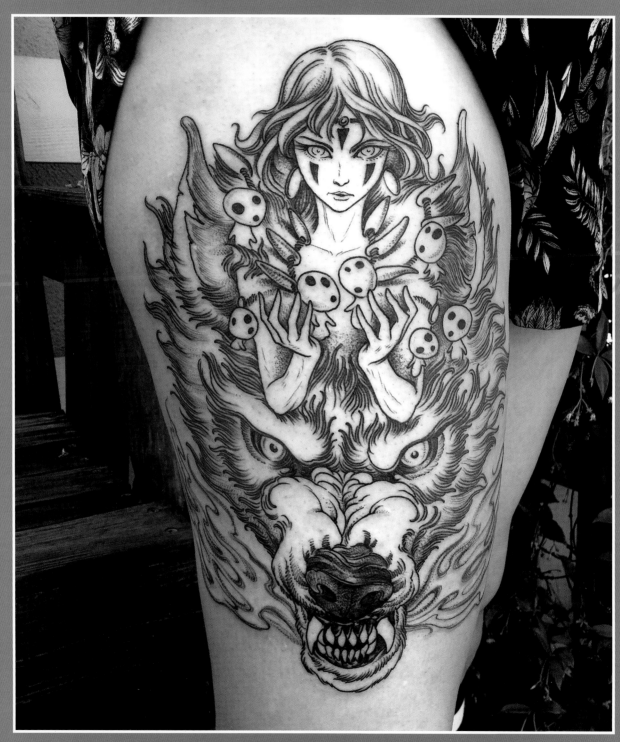

Forest Princess, inspired by *Princess Mononoke*

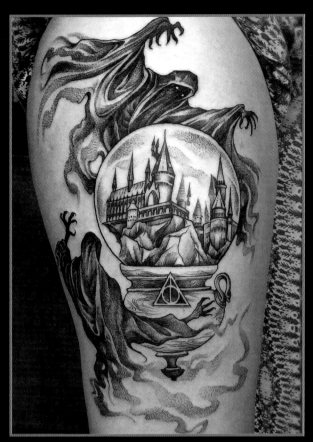

Dementors around Hogwarts, inspired by *Harry Potter*

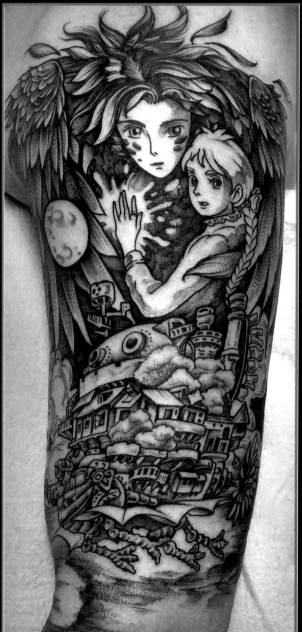

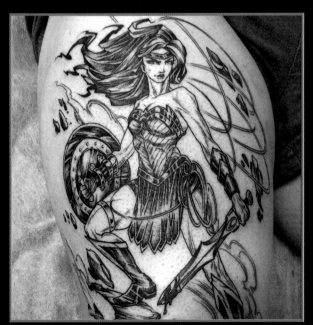

Wonder Woman, inspired by *Wonder Woman*

Inspired by *Howl's Moving Castle*

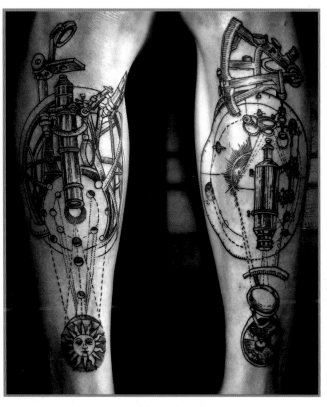

Telescopes

JUSTANDCONSUME

Ava, inspired by *Ex Machina*

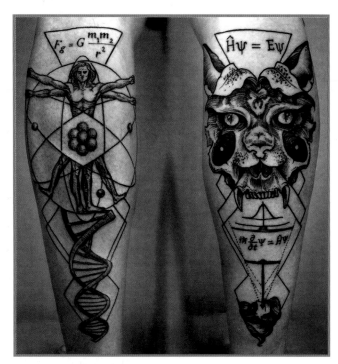

Newton's Law of Universal Gravity (left) and
Schrödinger's Equation (right)

ANDREA MORALES

Granada, Spain

Andrea Morales was born in Granada, Spain, in 1992. When she was twenty-three years old, she inked her first tattoo—a microphone—using a Cheyenne Thunder, which is still her tattoo machine. She has never taken a formal course or seminar in tattooing, but she is considered a tattoo artist reference in Spain, specializing in microrealism. She usually works in Granada, but she collaborates with other studios in Madrid and Barcelona, Spain, and in foreign countries at Equilattera (in Miami, Florida) and InkLabs (in Dresden, Germany). Andrea's own studio, 958 Tattoo Shop, opened in November 2017 in Granada. Some of the tattoos Andrea is proudest of are related to art, such as Gustav Klimt's *The Kiss* or Leonardo Da Vinci's *Mona Lisa*, among others. Andrea has also created a lot of geeky tattoos, related to famous films and sci-fi creations, but the strangest tattoo she ever inked was her own face eating a candy bar.

INSTAGRAM: Andrea.m0rales
PORTFOLIO: www.inkstinct.co/artists/featured/andrea-morales

"The weirdest experience was tattooing my face [on someone]. The boy came from Valencia with his wife. I thought it was a joke, but no—on the day of the appointment, I tattooed my face eating a Kinder."

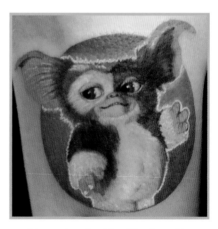

Gizmo, inspired by *The Gremlins*

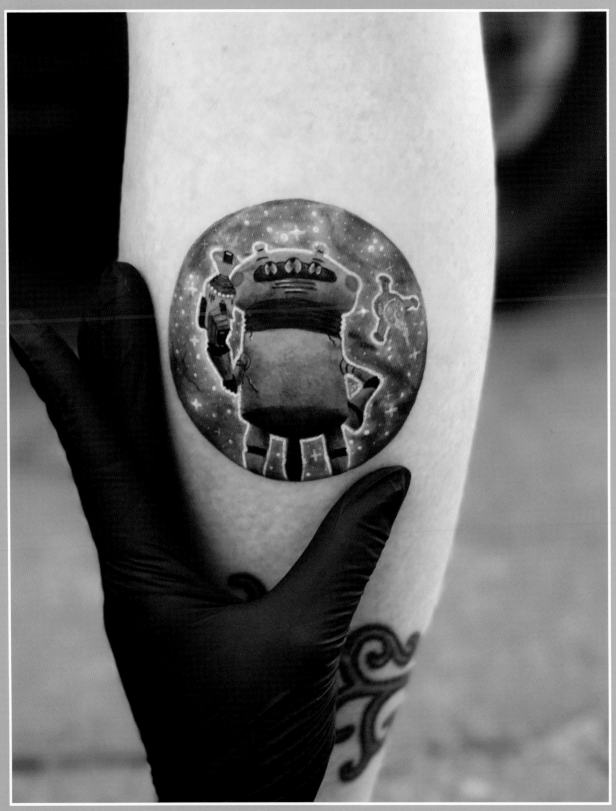

Killer Robot

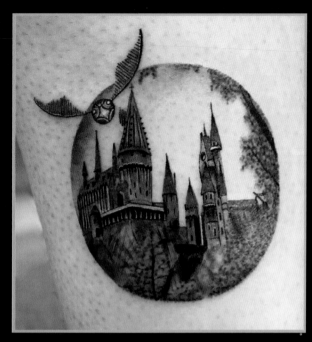

The Golden Snitch and Hogwarts, inspired by *Harry Potter*

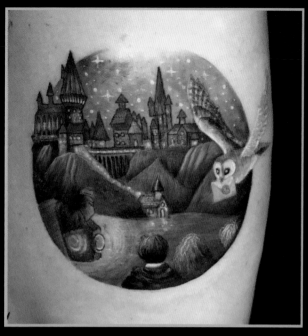

Hogwarts Castle, inspired by *Harry Potter*

Inspired by *Jurassic Park*

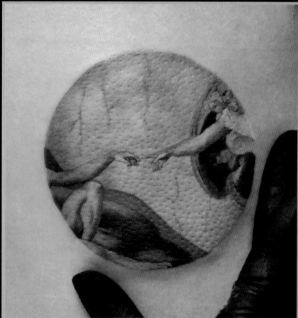

Inspired by *The Creation of Adam* by Michelangelo

ANDREA MORALES

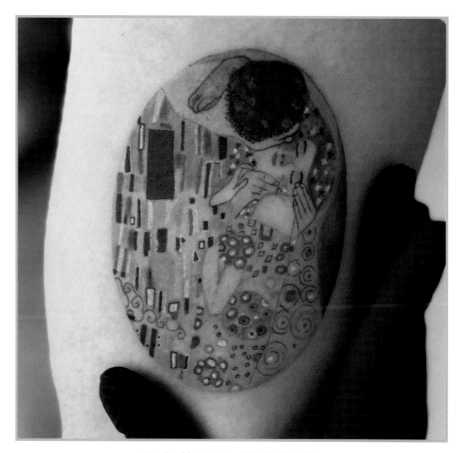

Inspired by Gustav Klimt's *The Kiss*

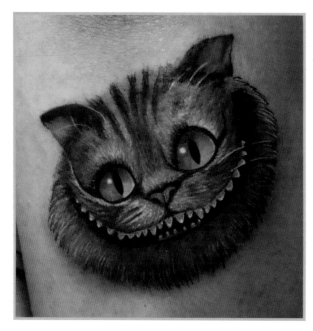

The Cheshire Cat, inspired by
Alice's Adventures in Wonderland

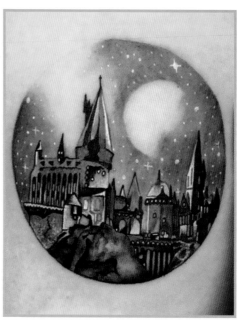

Hogwarts, inspired by *Harry Potter*

69

RITA NOUVELLE
Lisbon, Portugal

Rita Nouvelle lives in Lisbon, but was born in Setúbal, a seaside city thirty miles (50 km) south of Lisbon. She has been tattooing since October 2013, when she experimented once for fun and enjoyed it so much she never stopped. At that time, she was married to a tattoo artist, so she had known the world of tattooing for about five years. She was fresh out of the Fine Arts University of Lisbon where she had studied painting and animation and was trying to get a job or an internship in her area of expertise.

Rita took to tattooing right away, enjoying line work in particular because she wanted to perfect lines before she began shading. She ended up realizing that the lines she drew worked on their own and didn't need shading. Since then, she has lived the best and most challenging years of her life. She loves what she does, meeting amazing people and traveling often.

INSTAGRAM: nouvellerita
WEBSITE: www.nouvellerita.com
PORTFOLIO: www.inkstinct.co/artists/featured/nouvelle-rita

"I'm not a massive gamer, but I love the Legend of Zelda (my favorite one might be The Minish Cap or The Twilight Princess), and, like many of my generation, I grew up with Super Mario Bros and Mario Kart."

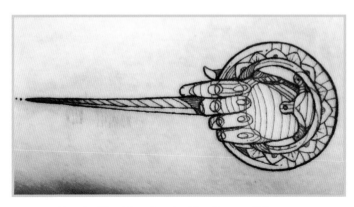

Hand of the King, inspired by *Game of Thrones*

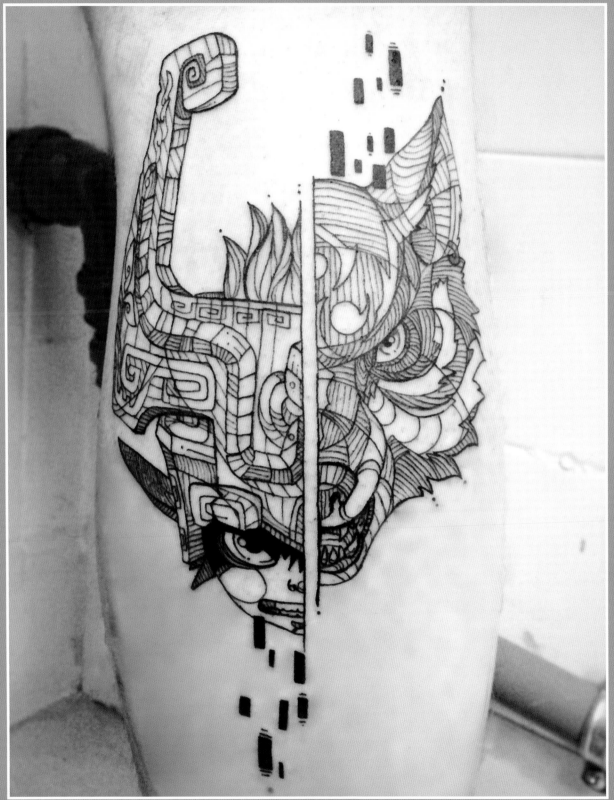

Midna and Link, inspired by *The Legend of Zelda: Twilight Princess*

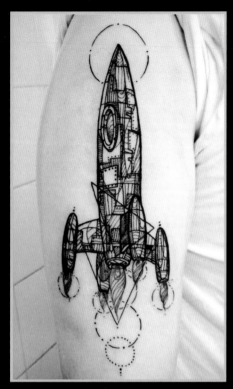

Rocket Ship

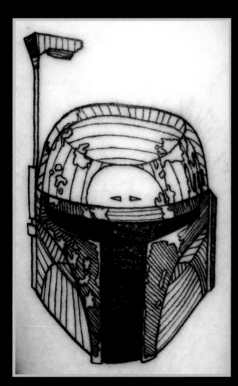

Boba Fett, inspired by *Star Wars*

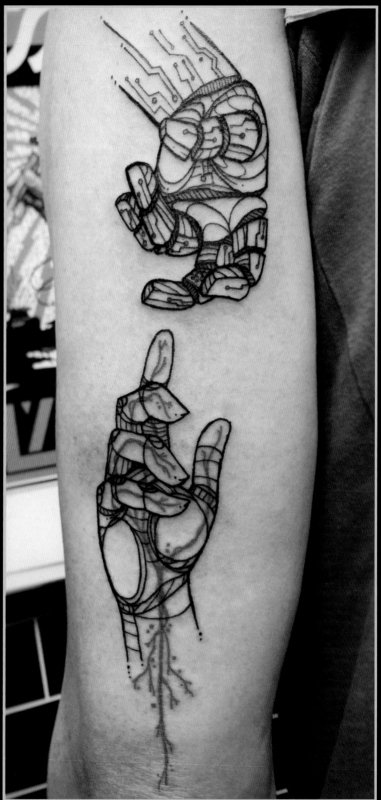

Bloodline

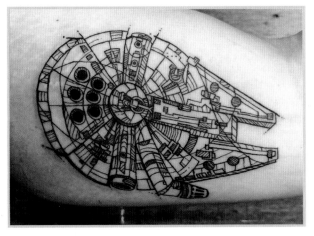

The *Millennium Falcon*, inspired by *Star Wars*

"My original source of inspiration for this style of tattoos was Luke Dixon, an illustrator who does amazing linework pieces. Since then it has evolved and I just try to do give volume and shade through lines, but I'm sure you can still see the influence."

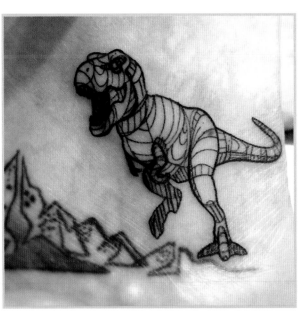

Tyrannosaurus Rex

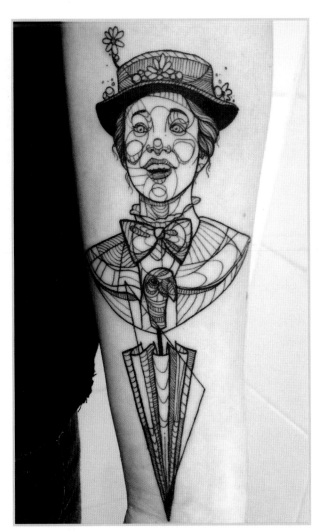

Mary Poppins, inspired by *Mary Poppins*

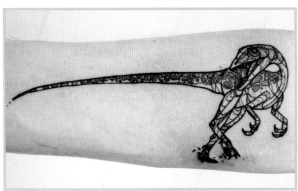

Velociraptor

EMRAH OZHAN

Brooklyn, New York

Emrah Ozhan is a multidisciplinary artist born in Turkey in 1981. His education started with Fine Arts High School in Eskişehir and continued with graphic design courses at Mimar Sinan Fine Art University in Istanbul. In 2000, during his first year in college, Emrah began tattooing. In the early 2000s, he started his professional career as a tattoo artist at Sacred Ink Tattoo in Istanbul. In 2010, he became partner and resident artist at Lucky Hands Tattoo Parlor. After three years there, he opened his first studio, Dramatik Tattoo. Emrah moved to Brooklyn, New York, in 2017 and became a resident artist at Gristle Tattoo. His tattoo style is geometric and abstract with a particular emphasis on his fine lines and dot work. Emrah's multidisciplinary art education gives him the ability to create unique and well-thought-out compositions.

INSTAGRAM: emrahozhan
WEBSITE: www.ozhanemrah.com
PORTFOLIO: www.inkstinct.co/artists/featured/emra-hozhani

"The sounds of nature and the ideas of customers are combined together to create my tattoo work. I also get inspired by science."

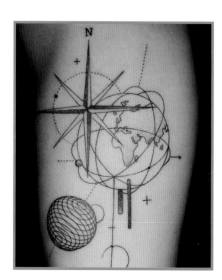

Traveling the Earth

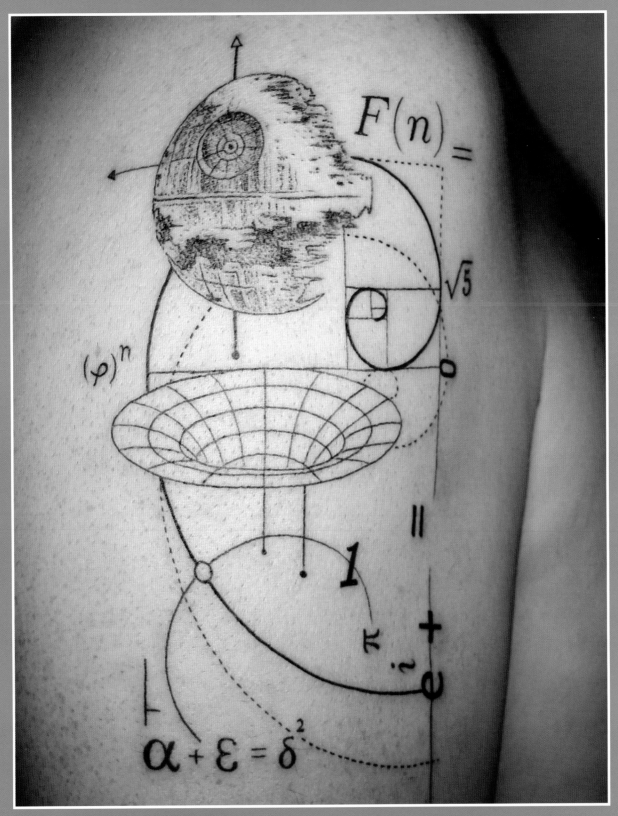

The Death Star, inspired by *Star Wars*; Euler's Identity; and the Golden Spiral

Black Hole

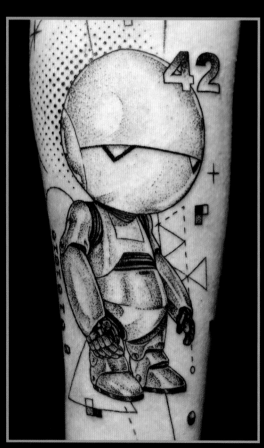

Marvin, inspired by *A Hitchhiker's Guide to the Galaxy*

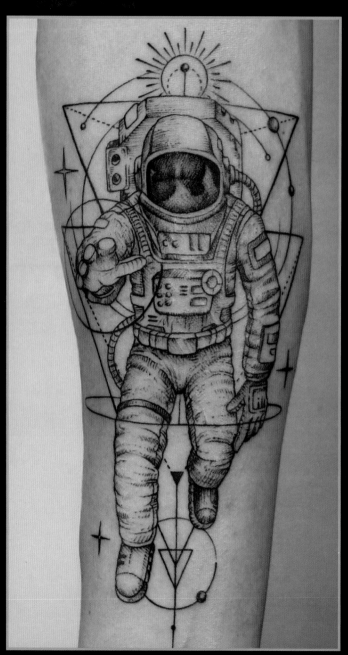

To the Unknown

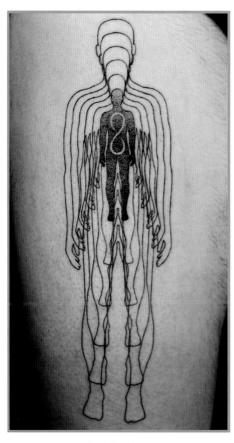

Infinite Man

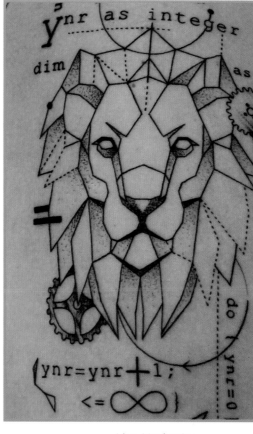

Lion Mechanics

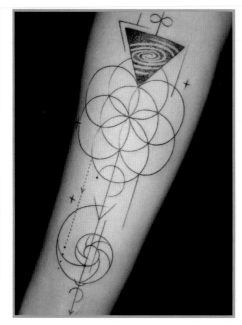

Galaxy

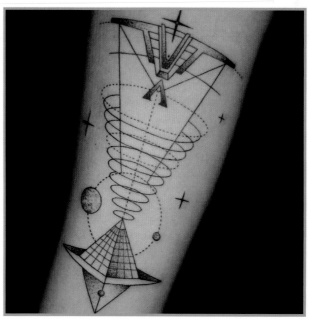

Stargate

PISSARO
Sebastopol, Crimea

PisSaro is a tattoo artist born and raised on the marvelous peninsula of Crimea in Eastern Europe. Her real name is Valeriya and she studied art in schools for nine years. After graduating, PisSaro did street art for a couple of years, becoming interested in all kinds of contemporary art. Her interest in contemporary art led her to tattoos and the switch from monumental art on walls to miniature art on bodies.

PisSaro has been tattooing since 2010. When she began, her tattoos were graphically styled with watercolor accents. In 2015, however, she fell in love with botanical tattooing. Traveling and watching flora and fauna in different corners of the world are things she enjoys and she imbues her works with her love of nature.

INSTAGRAM: pissaro_tattoo
WEBSITE: www.pissarotattoo.com
PORTFOLIO: www.inkstinct.co/artists/featured/pissaro

Delicate floral tattoos are the hallmark of PisSaro's style.

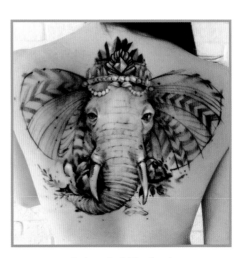

Bejeweled Elephant

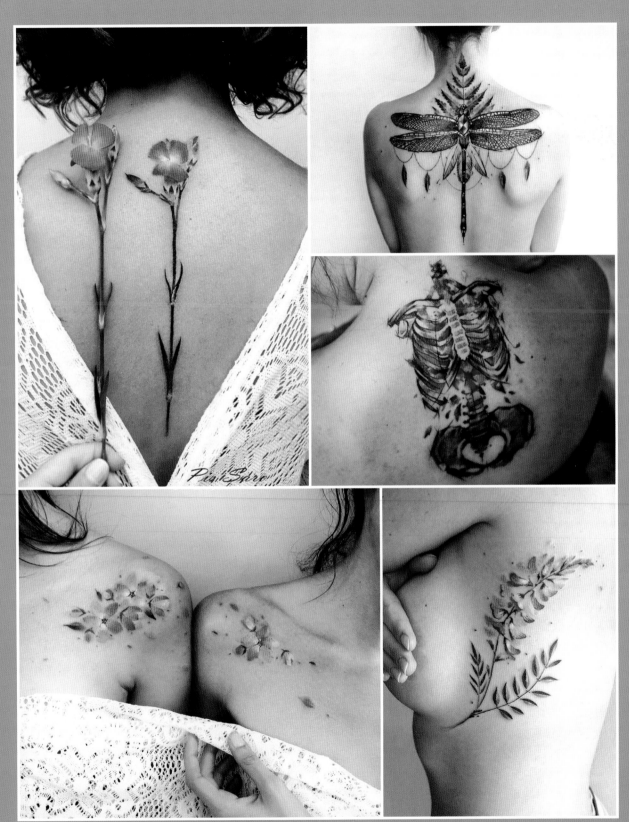

Clockwise from top right: Dragonfly and Fern; Floral Skeleton; Lupine;
Peach Tree Flowers tattoos for Sisters; Italian Carnation

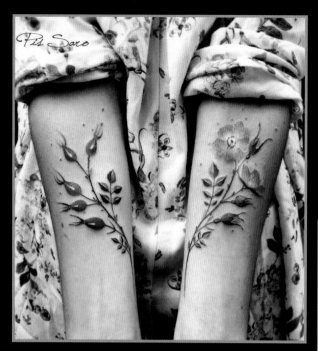

Briar Bud and Bloom

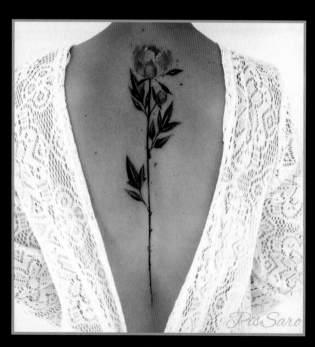

Peony

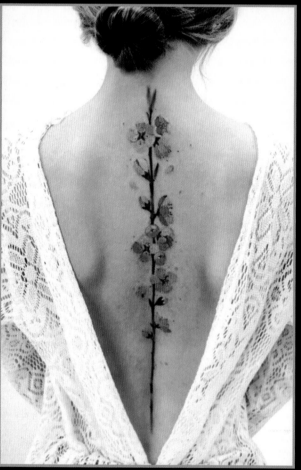

Sprig of Peach

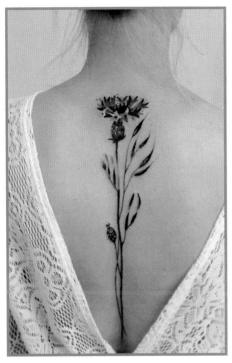

Cornflower in Duet with Spikelet

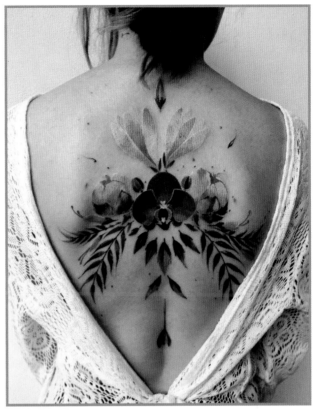

Floral Composition Featuring an Orchid and Magnolias

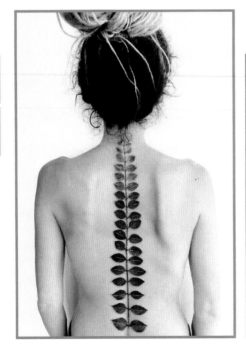

Branch tattoo

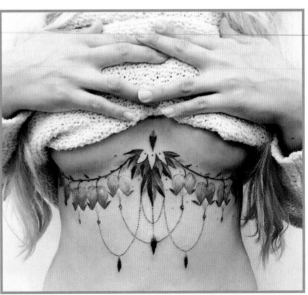

Dicentra

BICEM SINIK
Instanbul, Turkey

Bicem Sinik was born in Bursa, Turkey, in 1984. She graduated from the art teacher and graphic design program. All of her family members are art teachers and they expected her to follow in their footsteps, but she decided to leave her hometown and, in 2008, she moved to Istanbul. For seven years, she worked as an art director at various advertisement agencies. At first, she really liked her job, but after some fights over a silly brochure, she lost faith in it. Being locked in an office—like a cyberworld with computers—started to make her hate life.

In 2011, Bicem met Denizhan Ozkar, a great tattoo artist who taught her how to tattoo. The first tattoo she did was drawn on a banana. She was really excited and nervous when she tattooed a real body for the first time; she realized how hard the art was. In January 2013, Bicem quit her job to take up tattooing full time. She started to tattoo as a hobby, but it had become her job. Instead of the cyberworld office, she works at a home studio and lives with her two dogs. She draws only her own designs and never does the same tattoo twice. Because of her graphic design background, Bicem's drawings are more graphic, minimalist, and geometric. People from countries like Australia, Austria, Canada, Costa Rica, France, Germany, the Netherlands, Spain, and Switzerland come to her for tattoos.

INSTAGRAM: bicemsinik
PORTFOLIO: www.inkstinct.co/artists/featured/bicem-sinik

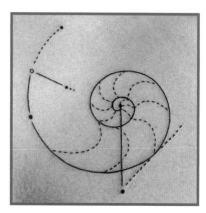

Nautilus

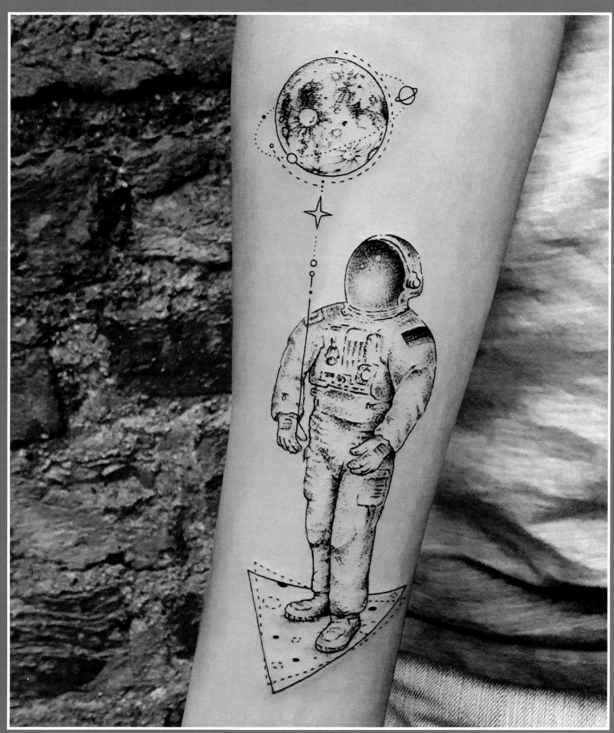

Astronaut

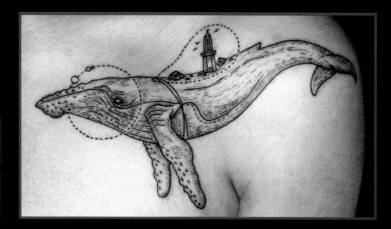

Humpback Lighthouse

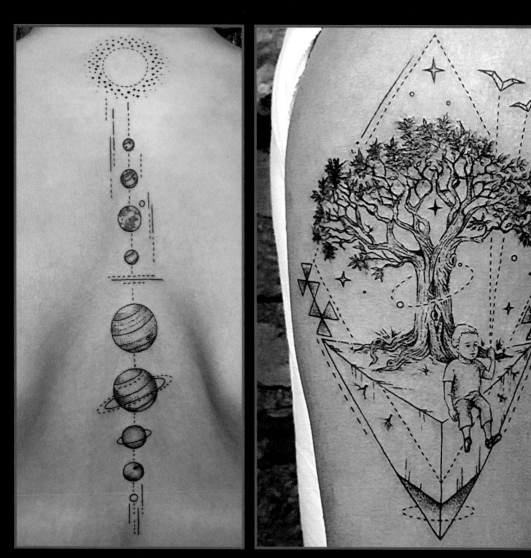

Solar System

The Physics of Life

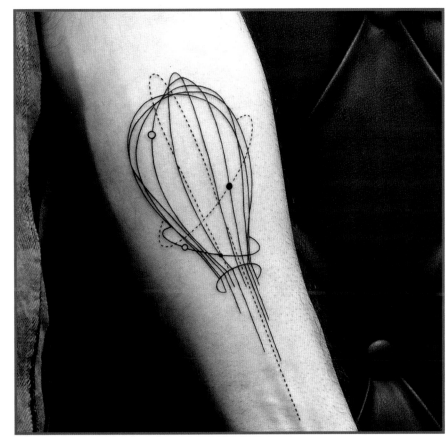

Whisk

Inspired by *My Neighbor Totoro*

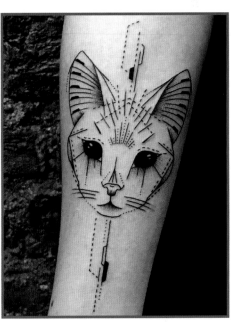

Black-Eyed Cat

JESSICA SVARTVIT
Stuttgart, Germany

Jessica Svartvit s a tattoo artist born in 1992. She is based in Stuttgart, Germany, and tattoos at Rabauke Tattoos and Arts in New Ulm. She decided to take up tattooing spontaneously in 2014, after designing merchandise for various clothing companies, bands, and music labels. Despite being a relative newbie, her New School tattoos are already attracting lots of attention for their playfulness and fusion of textures and techniques, including bold and fine blackwork, geometric patterns, stippling, and vibrant pops of color. In her free time, Jessica loves traveling, hanging around with nice people, good talks, good records, and discovering new things and perspectives in life. One day she would love to create a tattoo of an astronaut flamingo flying through the galaxy on a fixie bike.

INSTAGRAM: jessicasvartvit
PORTFOLIO: www.inkstinct.co/artists/featured/
jessica-svartvit

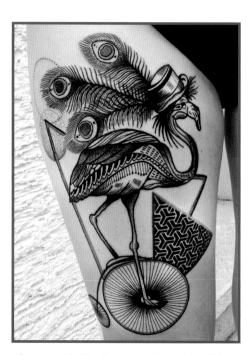

Steampunk Flamingo on a Penny-Farthing

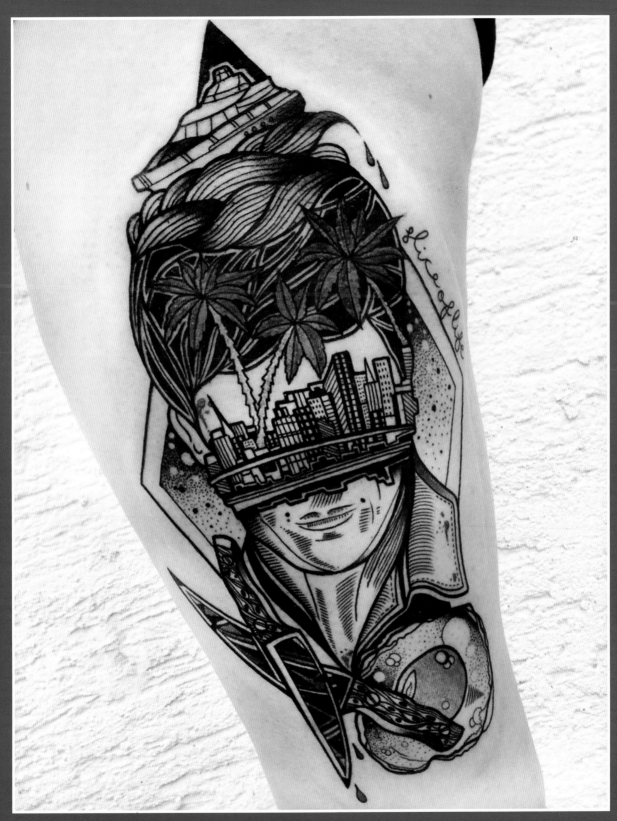

Tattoo inspired by *Dexter*

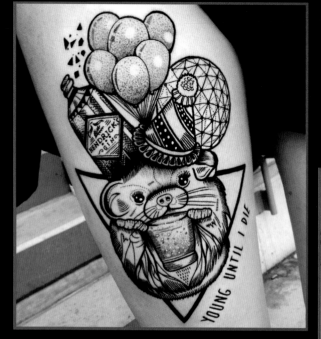

Young Until I Die

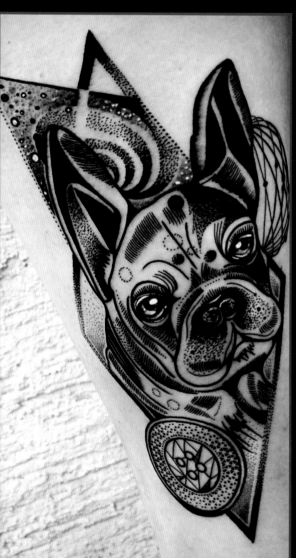

French Bulldog

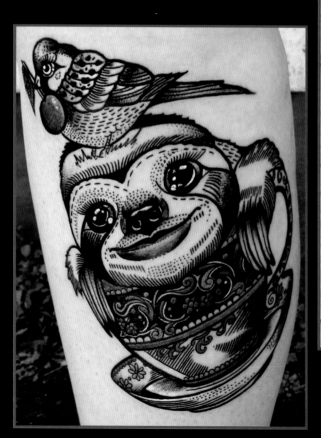

Sloffee Time

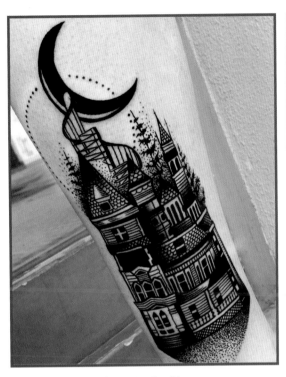

Stairway to the Moon

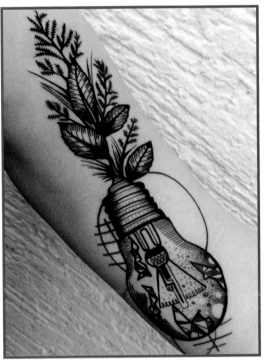

Nature's Electricity

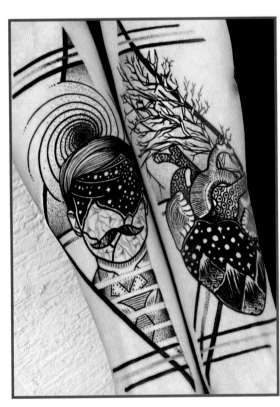

Head vs. Heart

Astronaut

RODRIGO TAS
São Paulo, Brazil

Rodrigo Tas is a tattoo artist born and raised in a low-income neighborhood of São Paulo, Brazil. When he was nine years old, Rodrigo was already drawing cartoon characters and graphic novels. In his early teens, armed with a skateboard and a backpack stocked with spray paint cans, he began to draw his own characters and lettering on the city's walls. Rodrigo studied industrial design and earned a graduate degree in art history and motion graphics.

Rodrigo has worked as an art director and illustrator, and has also taught graphic and fashion design at the undergraduate level in three different universities. Ever on the lookout for new tools, techniques, and surfaces to experiment on, Rodrigo found the world of tattoos. Since 2011, he has spent every day creating and tattooing exclusive designs. Every idea becomes a one-of-a-kind piece of art. Rodrigo has tattooed in New York, Paris, Barcelona, Milan, and elsewhere.

INSTAGRAM: rodrigotas
WEBSITE: www.rodrigotas.com
PORTFOLIO: www.inkstinct.co/artists/featured/
rodrigo-tas

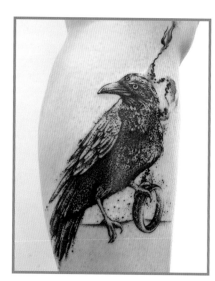

The Three-Eyed Crow with the One Ring, inspired by *Game of Thrones* and *The Lord of the Rings*

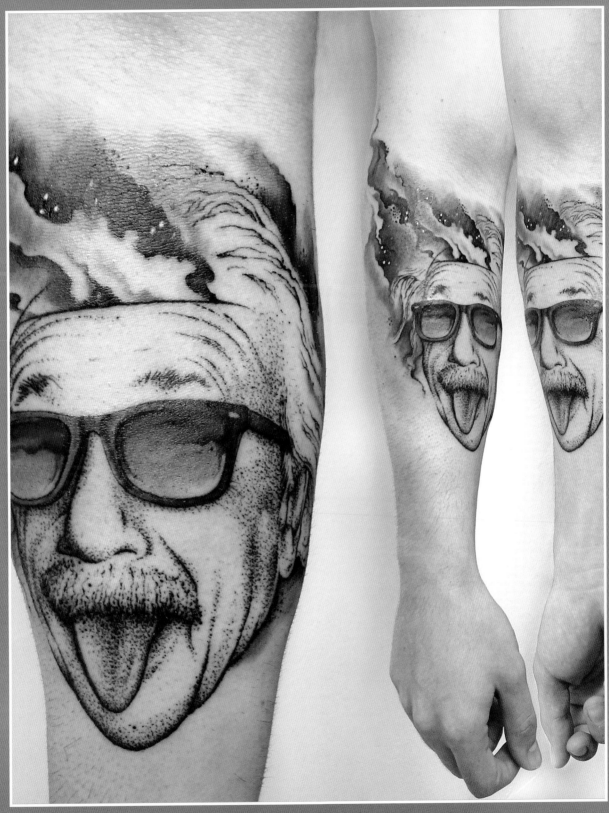

Albert Einstein Nerd Hype

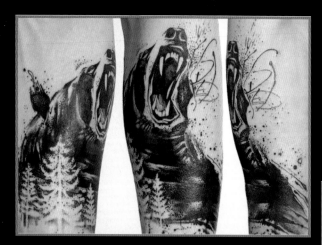

Beorn, inspired by *The Hobbit*

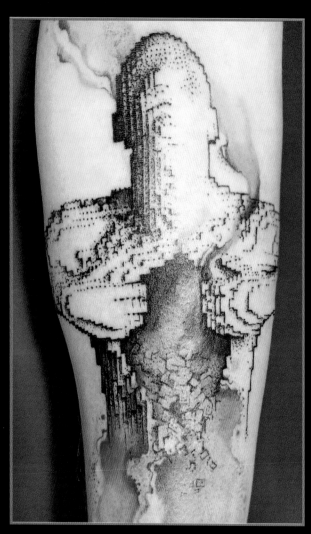

Lego Man

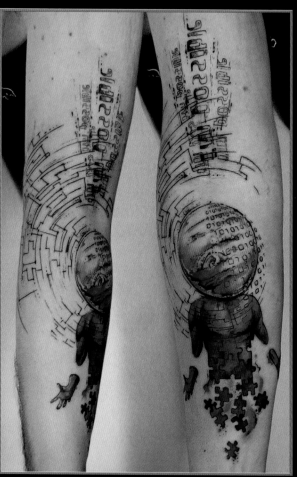

Binary Code

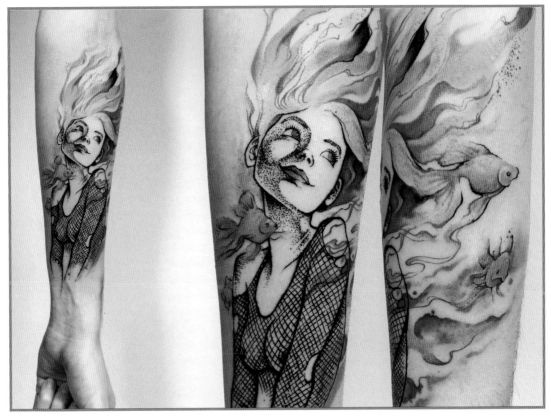

Delirium, inspired by *The Sandman*

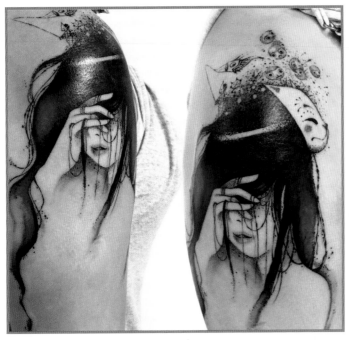

Anime Lover

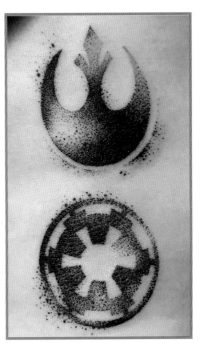

The Rebel Alliance and the Galactic
Empire, inspired by *Star Wars*

HUGO TATTOOER
Seoul, South Korea

Hugo Tattooer is based in Seoul, South Korea. His tattoos are emblematic of a witty style that relies on blackwork. Tattooing is illegal in South Korea, although many artists still do it. Hugo gets his inspiration from many places, but especially from cartoons and children's books. Many of his most popular requests are for cute characters or animals. Hugo is not yet fully covered in tattoos, with a few available spots on his stomach and thighs; he loves every tattoo on his body, except for the small squid on his neck.

INSTAGRAM: Hugotattooer
WEBSITE: www.hugo-tattooer.com
PORTFOLIO: www.inkstinct.co/artists/featured/hugo-tattooer

"I encountered some customers in the past who were willing to take advantage of me using the law, such as running away after the session without paying, or threatening me to give them the whole refund or they'll call the police."

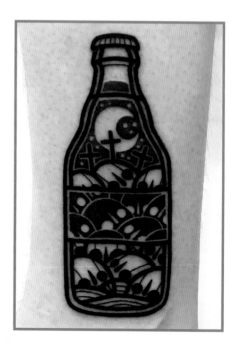

Beer Bottle Full of Skulls

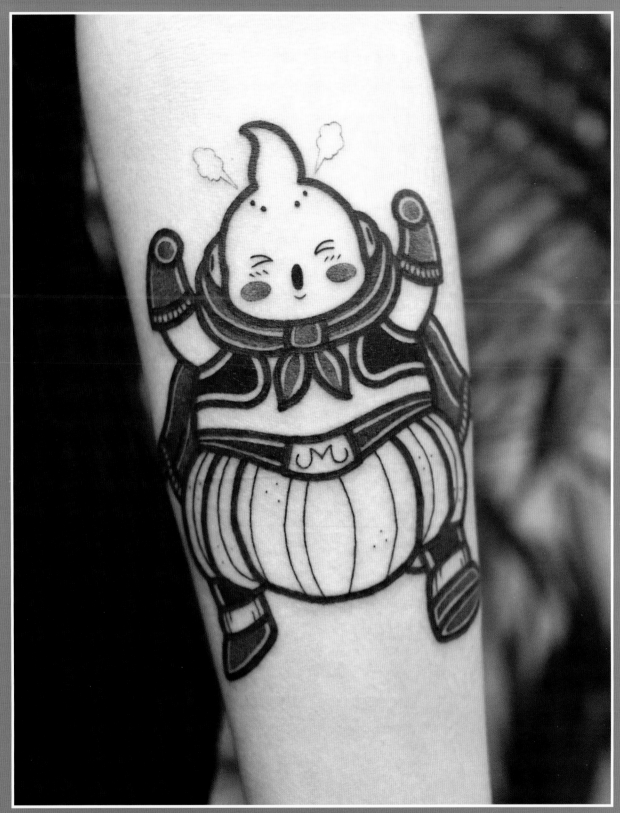

Majin Buu, inspired by *Dragon Ball Z*

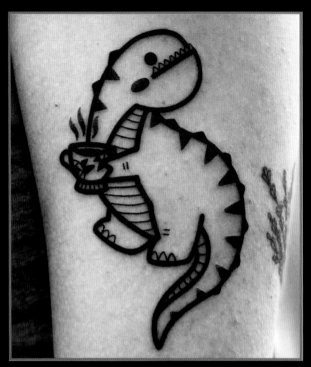

Tea Rex

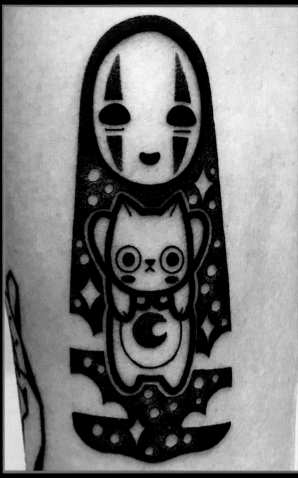

No-Face, inspired by *Spirited Away*

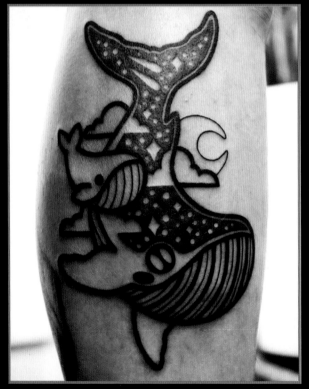

Swimming Through the Night

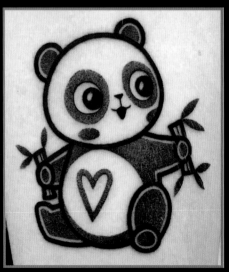

Panda

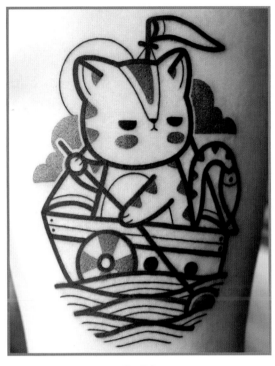

Catfish

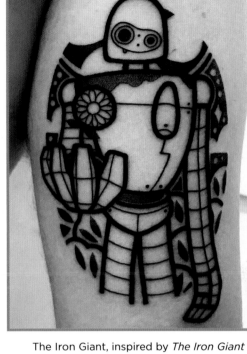

The Iron Giant, inspired by *The Iron Giant*

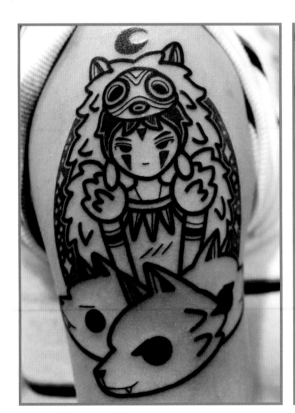

Princess Mononoke, inspired by *Princess Mononoke*

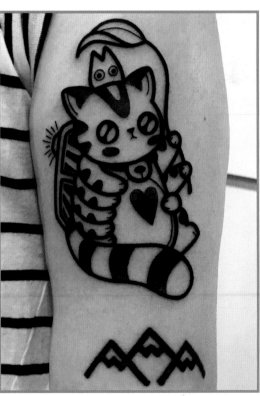

Catbus, inspired by *My Neighbor Totoro*

BRÜCIUS VON XYLANDER
San Francisco, California

Brücius von Xylander is a world-renowned tattoo artist, known for his distinctive custom linework and fine blackwork. He specializes in natural, scientific, and medieval illustrations, as well as tattoos in an etching and engraving style. Since 2009, Brücius has tattooed nonstop! He worked as a fine artist for over thirty years, pursuing drafting, graphic design, oil painting, and architecture. He studied fine art at the Art Center College of Design in Pasadena, California. Among his awards and distinctions, Brücius won first prize at Biennale International Tattoo in 2015, and was named one of FORM.ink's top ten tattoo artists in the San Francisco Bay Area and best tattoo artist in San Francisco for blackwork on Yelp. In 2017, Brücius opened a new tattoo studio, Black Serum, in San Francisco.

INSTAGRAM: _brucius_
WEBSITE: www.bruciustattoo.com
PORTFOLIO: www.inkstinct.co/artists/featured/brucius

"I see a line of continuity between the etcher's tool and the tattoo needle. Ernst Haeckel, Albrecht Dürer, Raymond Pettibon, da Vinci, Francisco de Goya, and Egon Schiele are a few of the many artists that I continue to study."

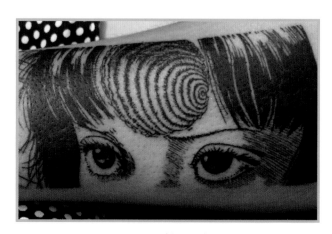

Uzumaki Spiral

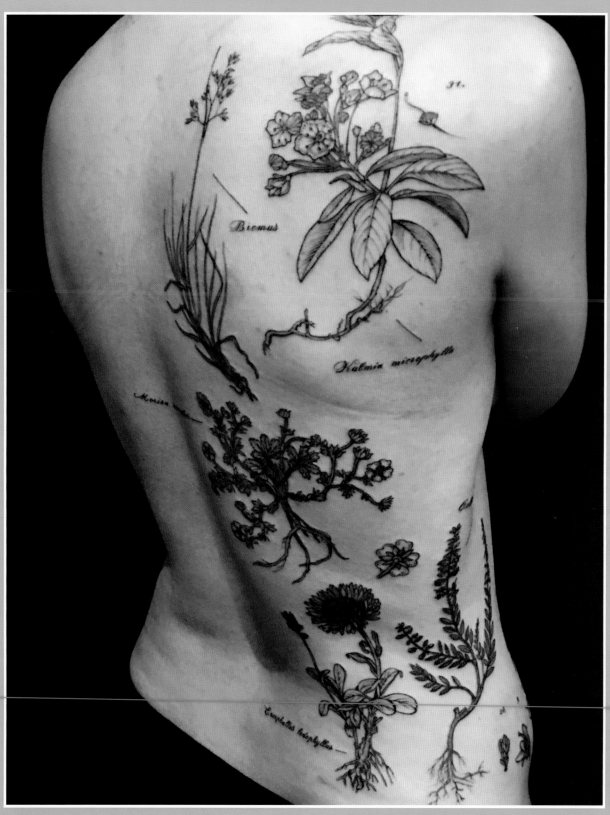

Wildflowers

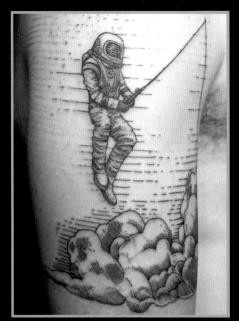

Astronaut Fishing

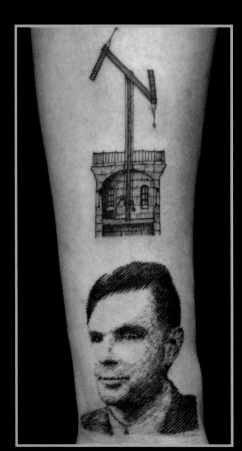

Alan Turing

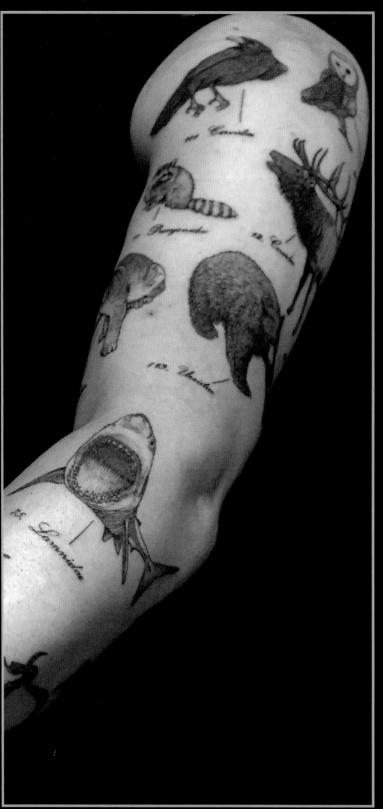

Fauna

"I freak out over old manuscripts, discarded technology, antiquarian arts and knowledge of centuries past. . . . I see art emerging all around me. My time as a tattoo artist is simply a moment where I concentrate this geekiness into a powerful, healing, and life-changing experience for me and my clients."

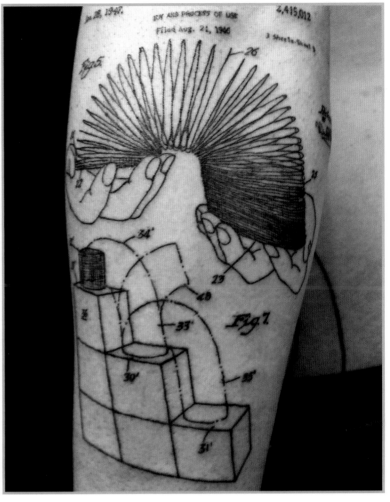

Slinky Patent

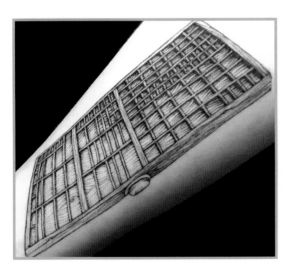

Letterpress Cabinet

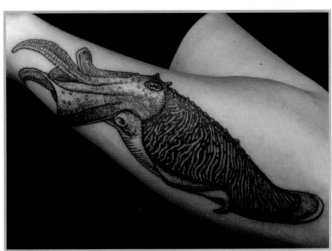

Cuttlefish

BARIŞ YEŞILBAŞ

Brooklyn, New York

Bariş Yeşilbaş is a tattoo artist born in Ankara, Turkey, in 1986. Originally, following his mother's wishes, he went to university, to study economics. During his senior year, he dropped out, moved to Istanbul, and started working as a consultant at a trade firm. Three months later, he was unceremoniously fired. His tattoo artist offered him a job, saying that he could work at the parlor until finding something different. Against the wishes of his family, he said yes and became an apprentice tattooist in 2012. After Bariş completed his first tattoo—a Nintendo Gameboy on himself—he realized that this was what he wanted to do for the rest of his life. All of his tattoos are unique and original designs inspired by his love of geeky sci-fi movies and games from the 1980s and 1990s, including *Fallout*, *G.I. Joe*, *RoboCop*, *Terminator*, *Transformers*, *Jurassic Park*, *Back to the Future*, and more.

Bariş has never regretted his decision to become a tattoo artist. He has met thousands of people, heard their stories, and become a part of their lives and families. He enjoys listening to his clients' experiences and learning from their mistakes. In 2017, he took the opportunity to follow his dreams and move to New York City to work there.

INSTAGRAM: barisyesilbas
WEBSITE: www.barisyesilbas.com
PORTFOLIO: www.inkstinct.co/artists/featured/baris-yesilbas

"As a child I used to watch my father, who is an architect, a lot when he was drawing at home. It kind of amazed me how he can draw anywhere and anytime he wants."

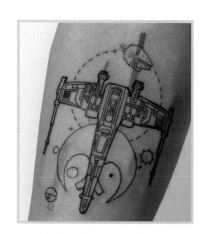

X-Wing Fighter, inspired by
Star Wars

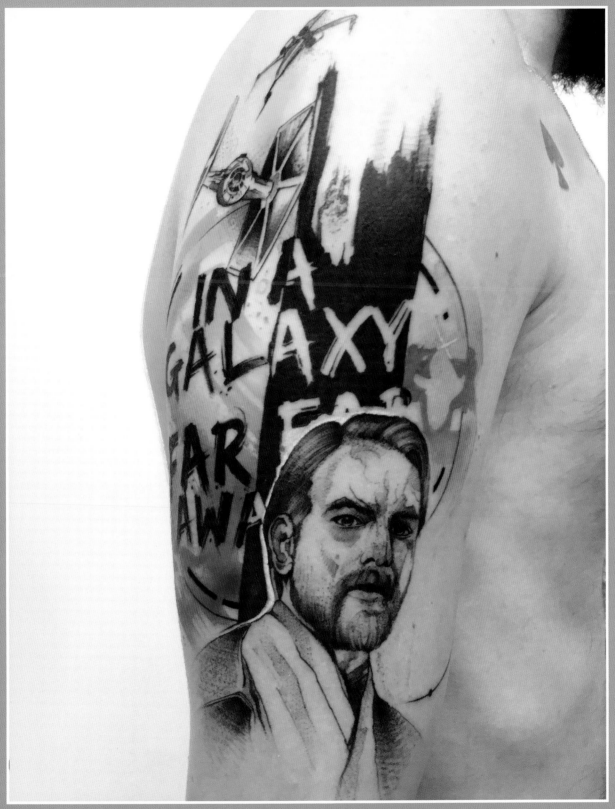

In a Galaxy Far, Far Away, inspired by *Star Wars*

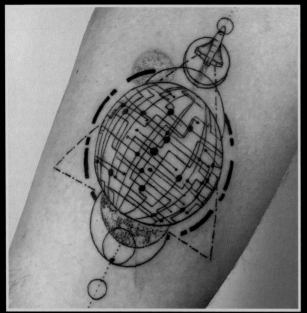

Space

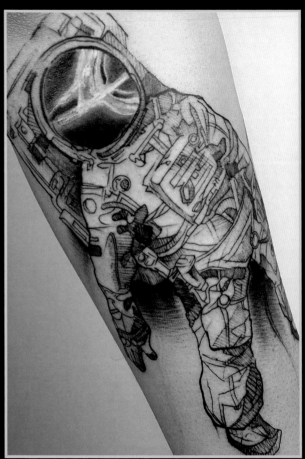

Astronaut

Spiderman, inspired by *Spiderman*

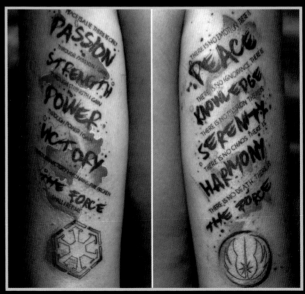

The Sith and Jedi Codes, inspired by *Star Wars*

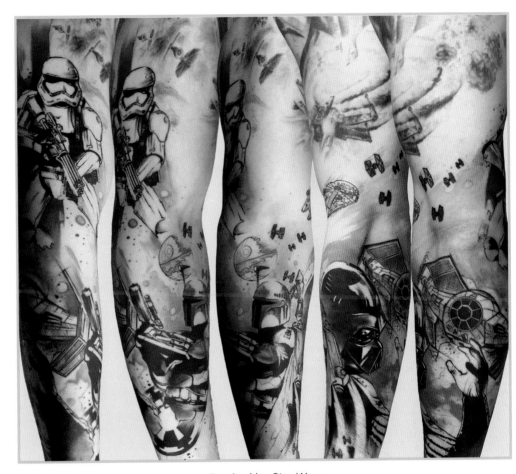

Inspired by *Star Wars*

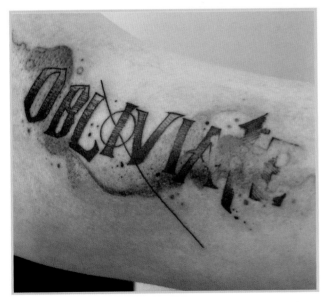

Obliviate, The Memory Charm, inspired by *Harry Potter*

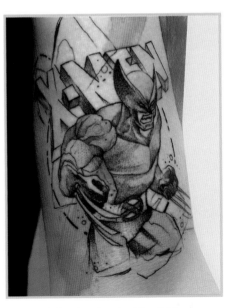

Wolverine, inspired by *X-Men*

MARCELO ZISSU

Rio de Janeiro, Brazil

Marcelo Zissu is a Brazilian tattoo artist based in Rio de Janeiro. Marcelo got his start tattooing because he was searching for meaning as an artist and couldn't find it. He decided to leave everything in Brazil behind and move to a place where he knew nobody; he relocated to New York City. He spent six months exploring the city and painting. He ended up meeting many great people and spending several years in New York, but he didn't find the meaning that he was looking for. He moved back to Rio de Janeiro and, as soon as he returned, ran into a friend who was a tattoo artist. He visited his friend's shop and did a tattoo on his arm without any knowledge of how to do it properly. He realized then that he had found his calling and wanted to learn how to do it properly.

One of Marcelo's most fun and peculiar experiences as a tattoo artist was a circle session involving four artists tattooing each other at the same time (he got a small present tattoo on his leg). He sees tattooing as a transformative ritual whereby people can bring their inner world to the outside. That act of getting a tattoo can be seen as a battle of light and shadow, a call for freedom, letting go, or just acceptance. As a tattoo artist, he is happy to be the vehicle for that.

INSTAGRAM: marcelozissu
PORTFOLIO: www.inkstinct.co/artists/featured/marcelo-zissu

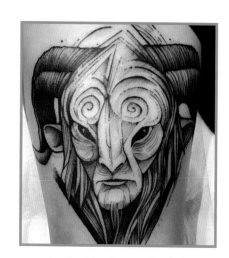

Inspired by *Pan's Labyrinth*

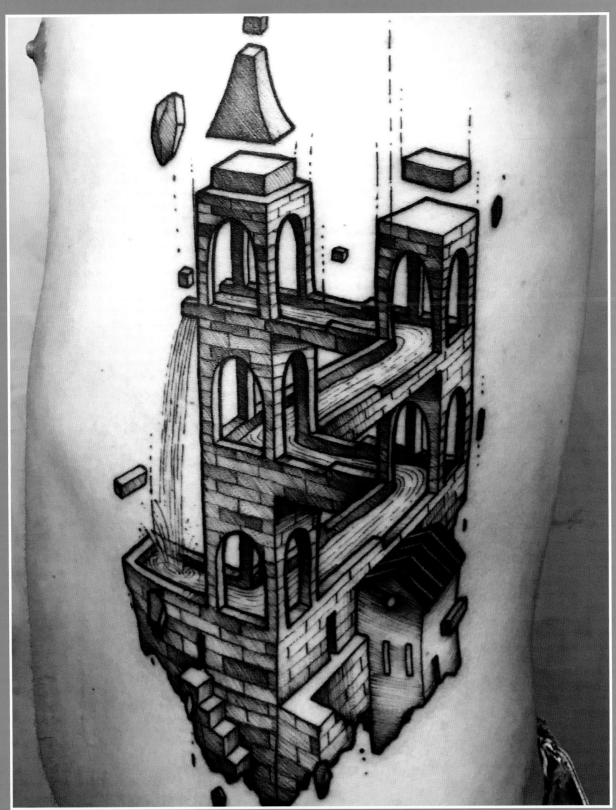

An Escher-inspired optical illusion tattoo

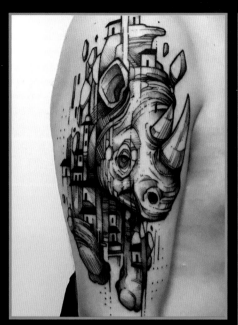

People Living on Rhinos

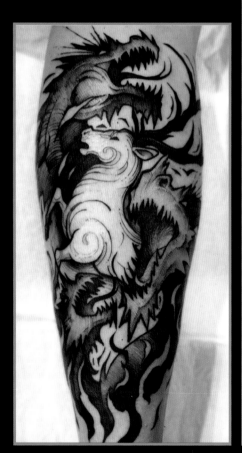

Baratheon vs. Targaryen, inspired by
Game of Thrones

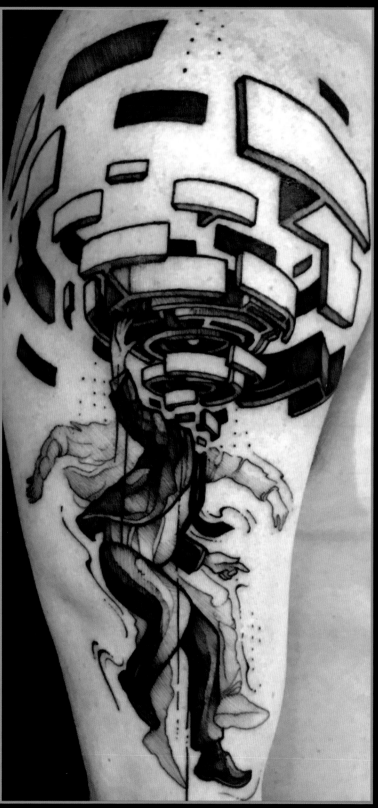

Expansion

Knowledge Is Light

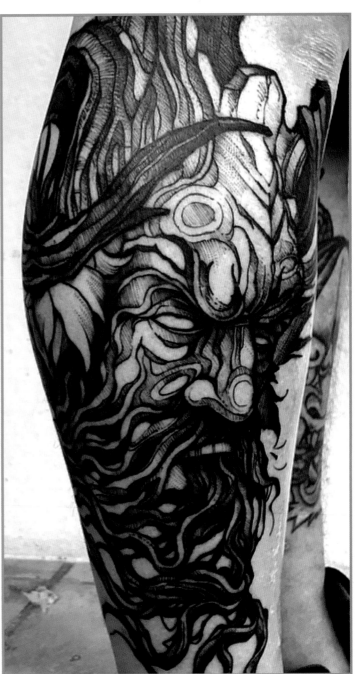

Ent: Force of Nature

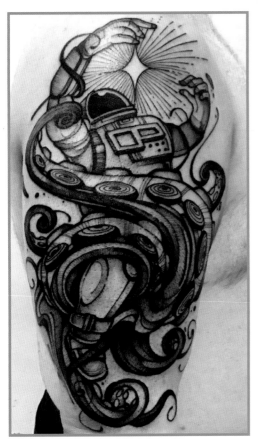

An Astronaut Emerges from the Tortuous
Tentacles of Shadow

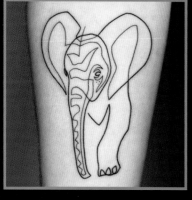

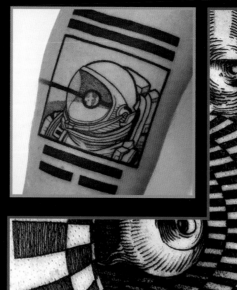

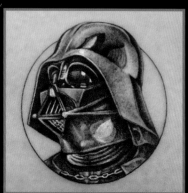

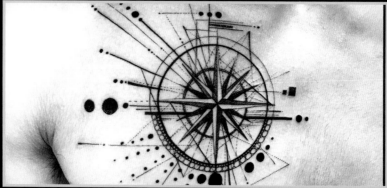

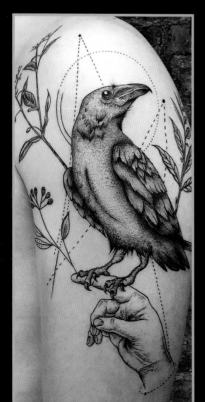

This page (clockwise from top right): Optic Illusion by Lustandconsume; Compass by Yeekii Lo; Raven by Bicem Sinik; Darth Vader by Mr.K, inspired by *Star Wars*; Elephant by Mo Ganji; Astronaut by Daniel Matsumoto

Opposite (clockwise from top right): Mr.K, Sasha Kiseleva, Daniel Matsumoto, Marin Tereshchenko, Sergey Berlin, Dino Nemec (center).

GALLERY

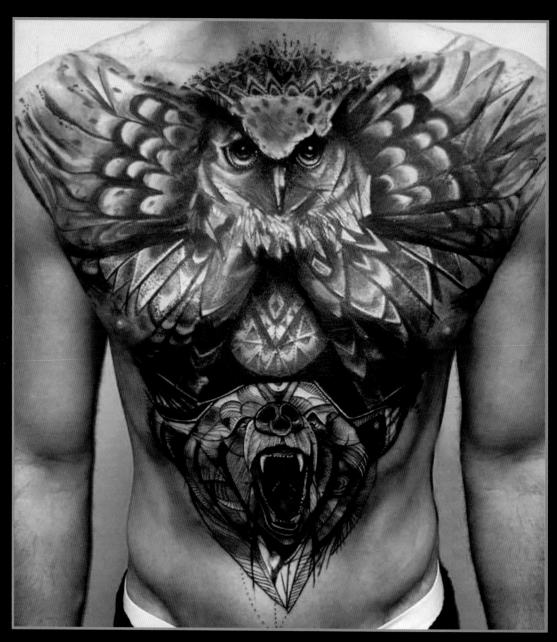

Owl and Bear by Mo Mori

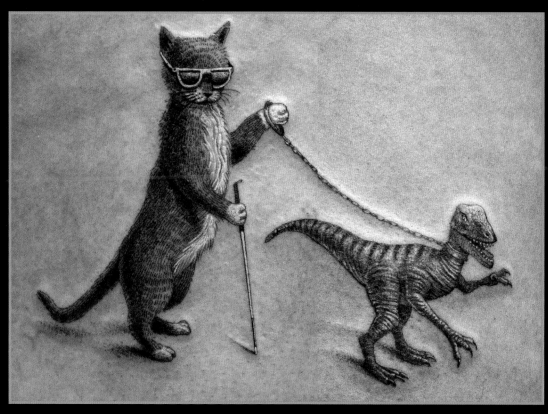

Blind Cat and His Guide Velociraptor by Sven Rayen

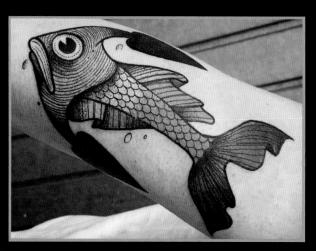

Anchor Fish by Andrea Bianchi

Class: Aves

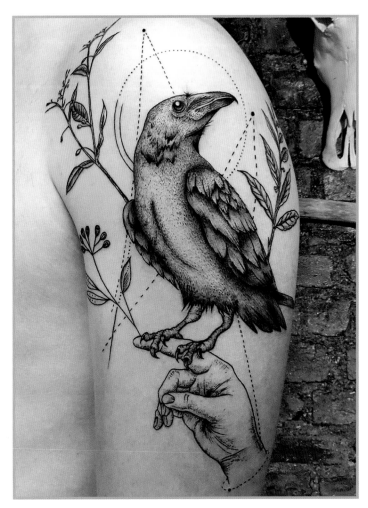

Raven by Bicem Sinik

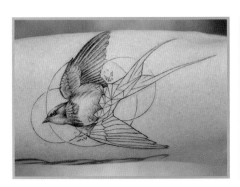

Geometric Bird by Mr.K

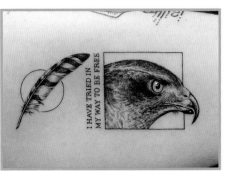

Tattoo by Mr.K, inspired by "Bird on a Wire"
by Leonard Cohen

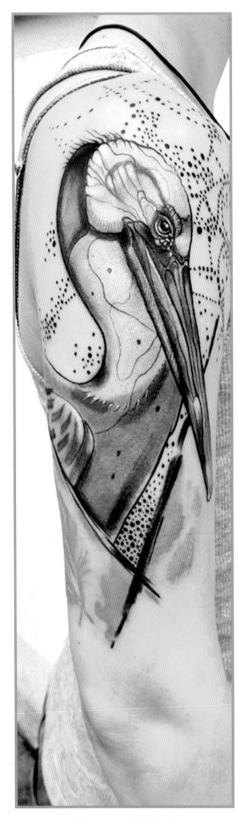

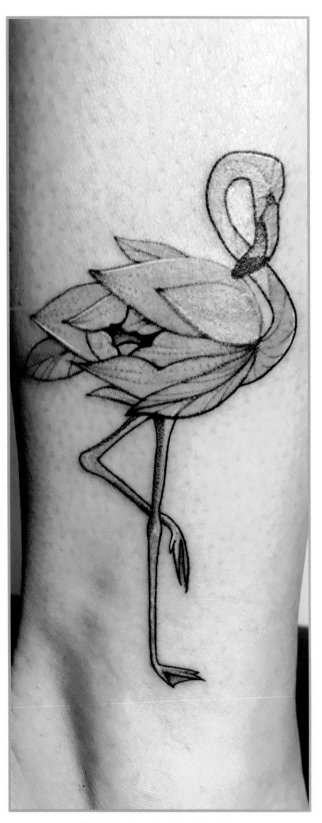

Pelican by Mo Mori

Pink Flamingo by Nora Lyashko

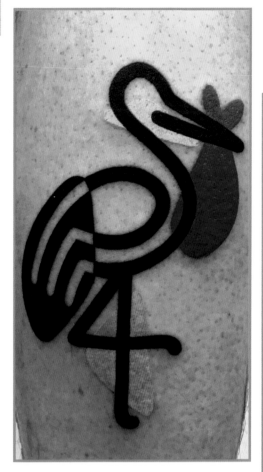

Animal-inspired tattoos by Mattia Mambo, including
(clockwise from above) a penguin, a duck, and a stork

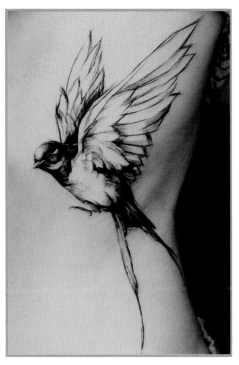

Swallow in Flight by Diana Severinenko

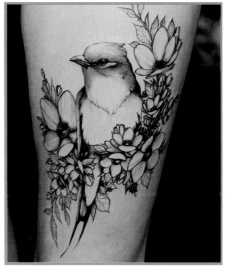

Blue Jay by Diana Severinenko

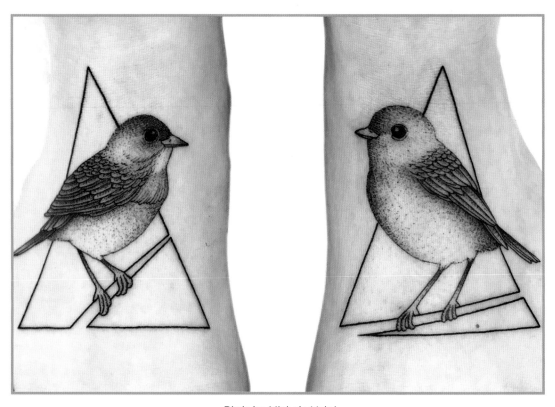

Birds by Michele Volpi

Class: Mammalia

Panda by Mattia Mambo

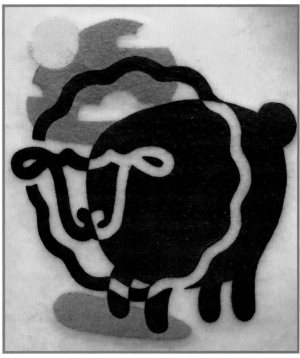

Sheep by Mattia Mambo

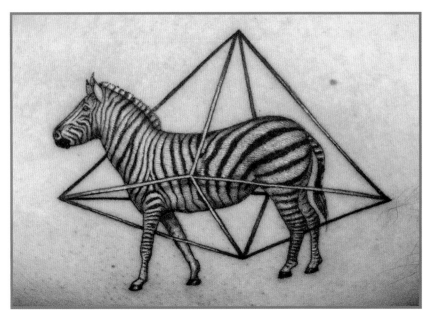

Zebra in a Prism by Sven Rayen

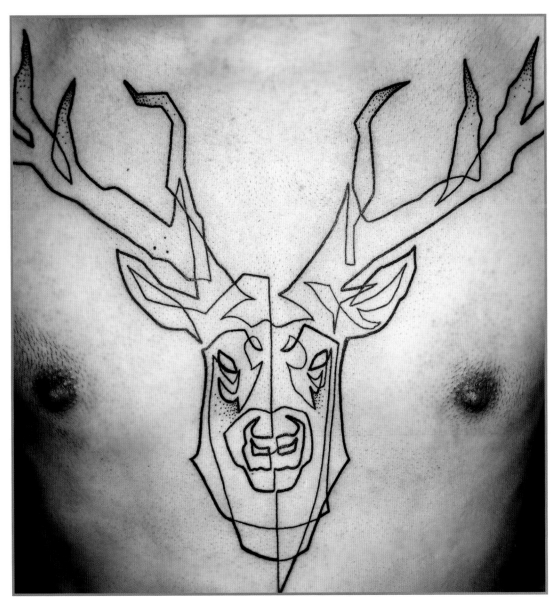

Single-line deer with antlers by Mo Ganji

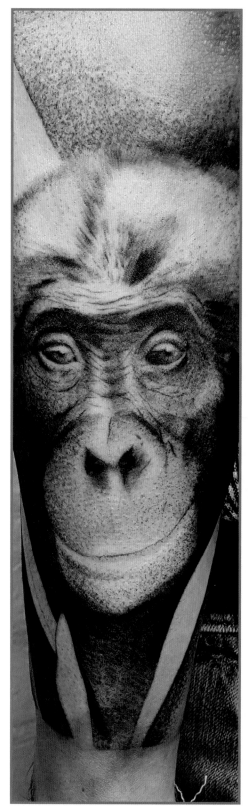

Ape by Arthur Perfetto

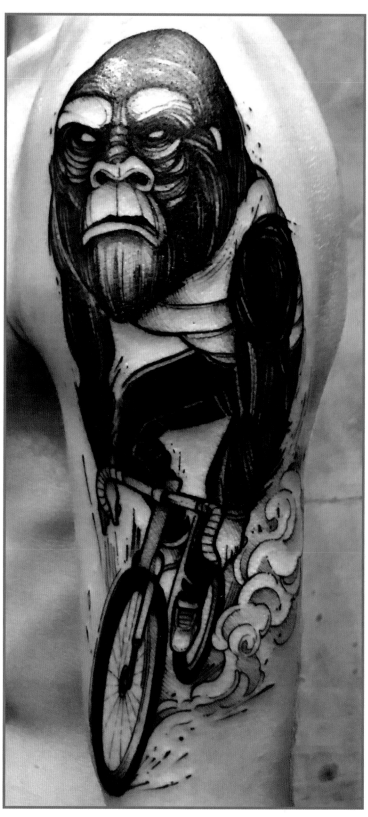

Ape Riding a Bicycle by Marcelo Zissu

Order: Carnivora

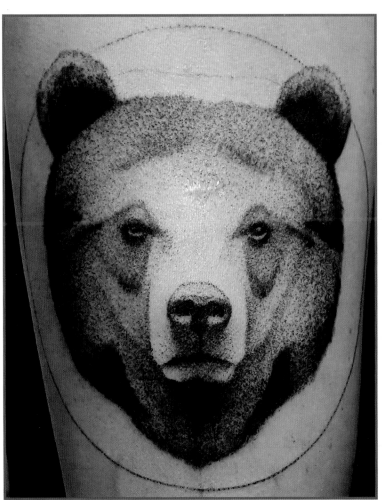

Bear by Arthur Perfetto

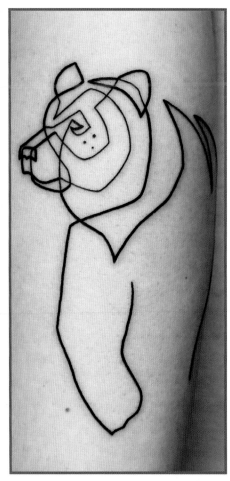

Single-line bear by Mo Ganji

Family: Canidae

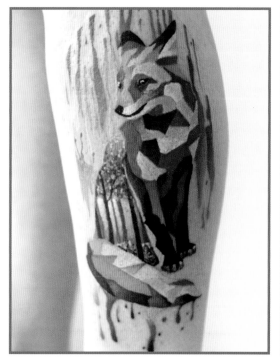

Fox by Martynas Šnioka

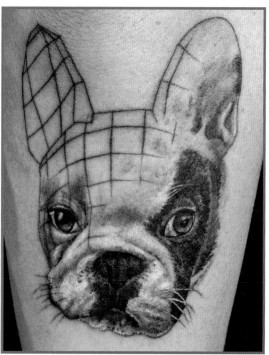

French Bulldog by Sven Rayen

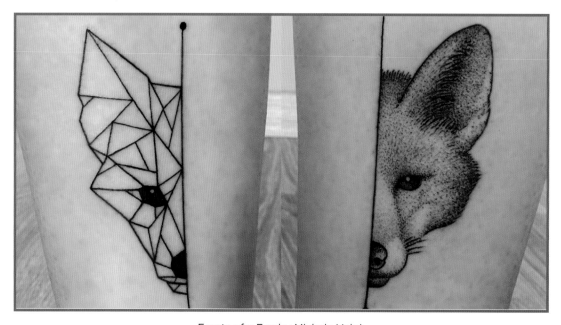

Facets of a Fox by Michele Volpi

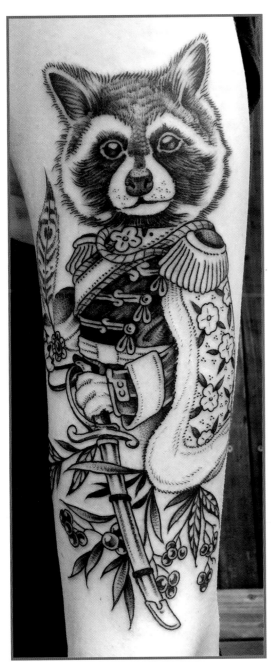

Gentleman Soldier Raccoon by Lustandconsume

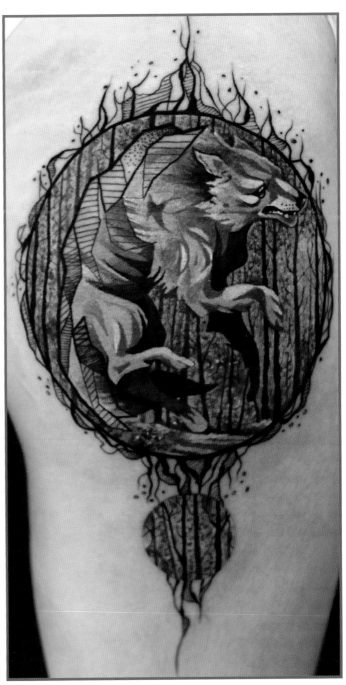

Wolf by Martynas Šnioka

Family: Felidae

Cat Eyes and Nose by Tattooist DOY

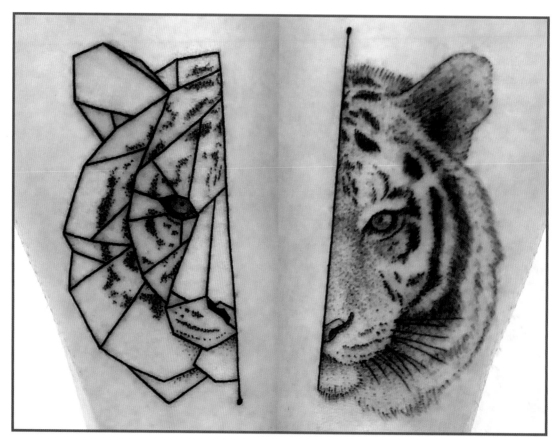

Facets of a Tiger by Michele Volpi

124

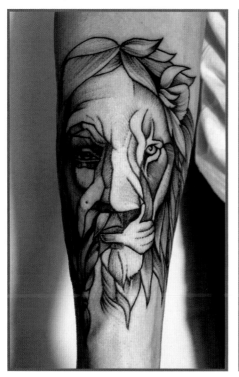

Half Man, Half Lion by Alina Tiurina

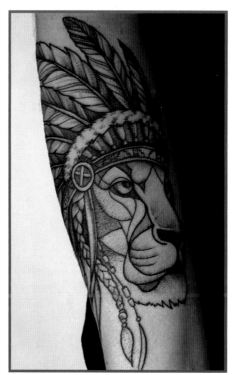

Tiger with Native American Headress
by Alina Tiurina

Lions by Mo Ganji

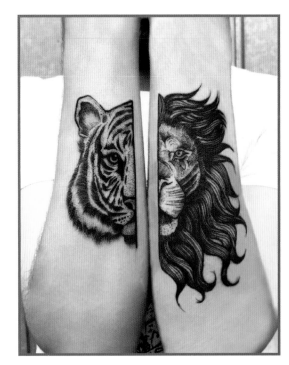

Tiger and Lion by Andrea Bianchi

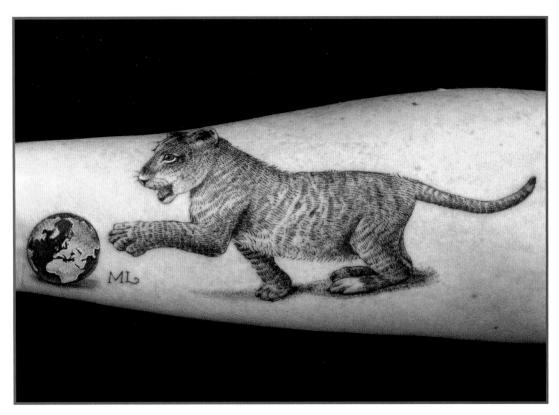

A Cub Playing with the World by Sven Rayen

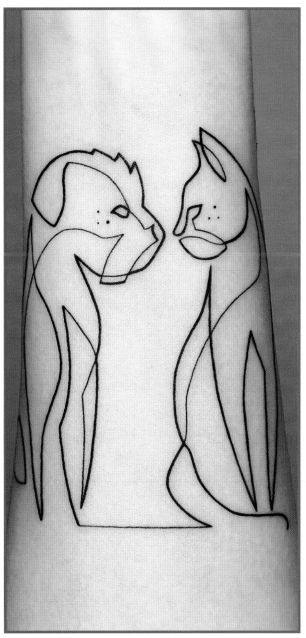

Dog and Cat by Mo Ganji

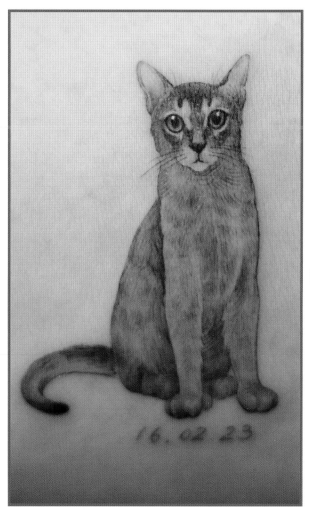

Cat by Tattooist DOY

Class: Cetacea

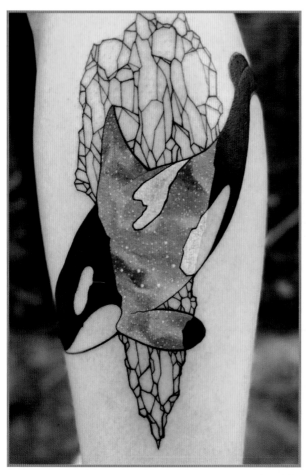

Orca by Dino Nemec

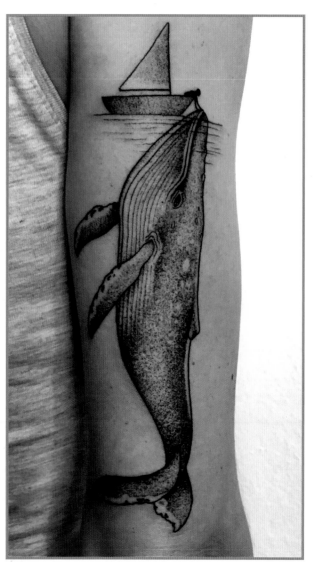

Blue Whale by Anna Neudecker

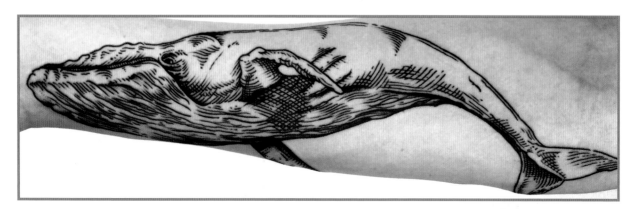

Whale by Loïc LeBeuf

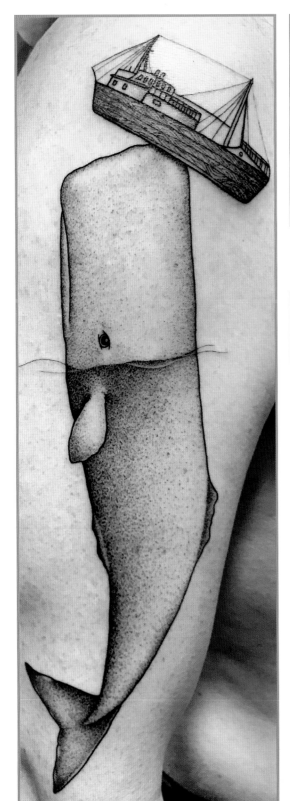

Sperm Whale by Michele Volpi

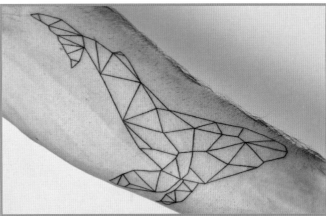

Geometric Whale by Pablo Torre Rodriguez

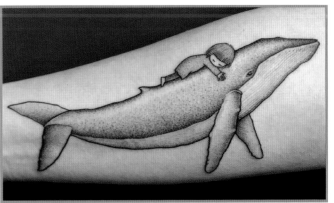

Girl Hugging Whale by Michele Volpi

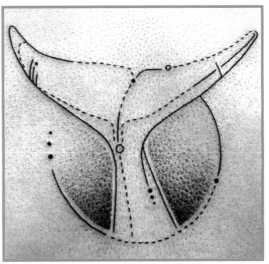

Whale Tail by Bicem Sinik

Class: Proboscidea

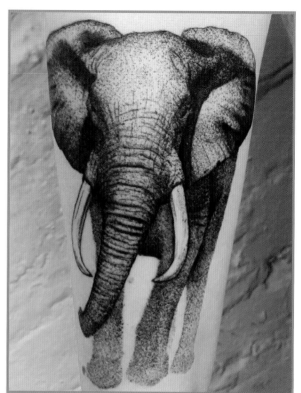

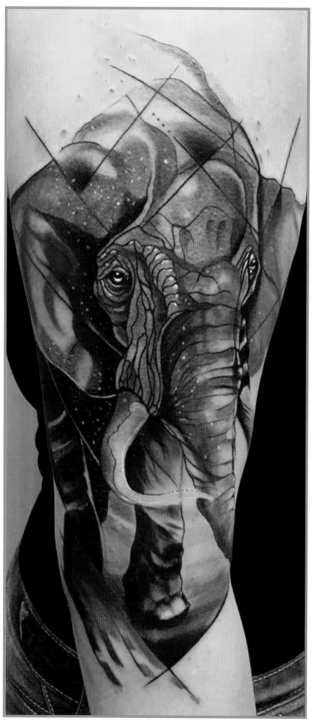

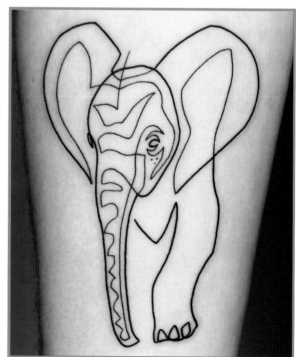

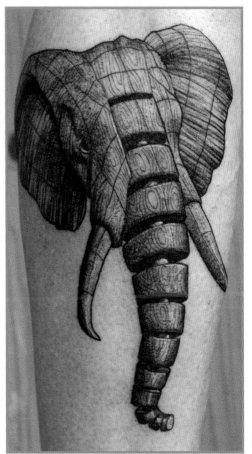

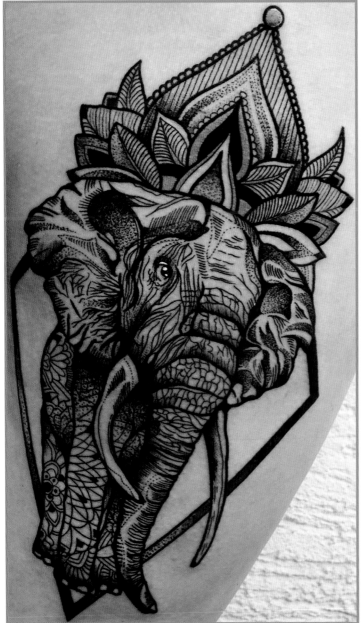

This spread: Elephant tattoos by Mo Mori (far left); Arthur Perfetto (opposite top); Mo Ganji (opposite bottom); Jessica Svartvit (left), and Sven Rayen (above)

Class: Reptilia

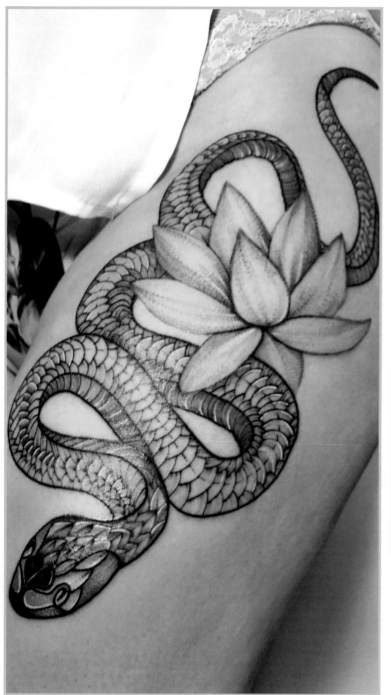

Snake and Lotus by Nora Lyashko

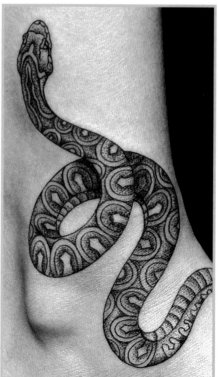

Snake by Bicem Sinik

INVERTEBRATES

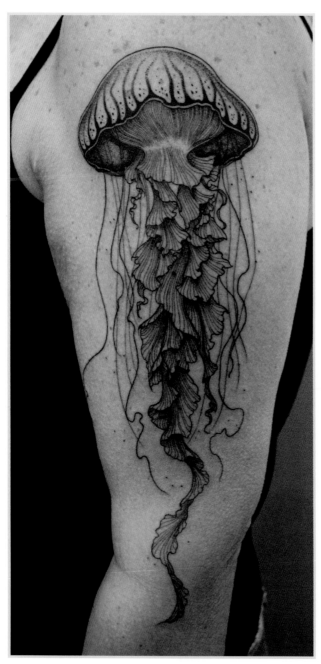

Jellyfish by Sandra Cunha

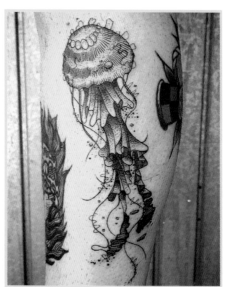

Jellyfish by Andrea Bianchi

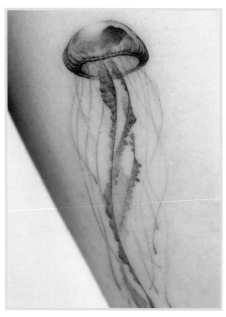

Watercolor Jellyfish by Tattooist DOY

Class: Insecta

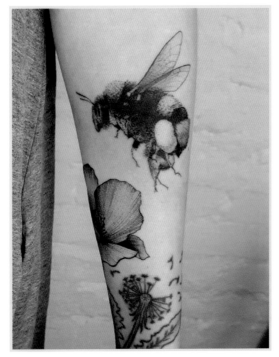

Bee by Arthur Perfetto

Beetle by Alina Tiurina

Bee by Hugo Tattooer

Evolution of a Butterfly by Michele Volpi

Young Goku with older Goku within, inspired by *Dragon Ball* and *Dragon Ball GT*, by Matteo Nangeroni

Super Saiyan Goku, inspired by *Dragon Ball Z*, by Inez Janiak

Cat Onigiri Kitty by Hugo Tattooer

Tattoos by Luca Testadiferro (clockwise from top left): Domo-kun, the mascot of Japanese broadcaster NHK; the Crescent Moon Wand, inspired by *Sailor Moon*; and Monkey D. Luffy, inspired by *One Piece*.

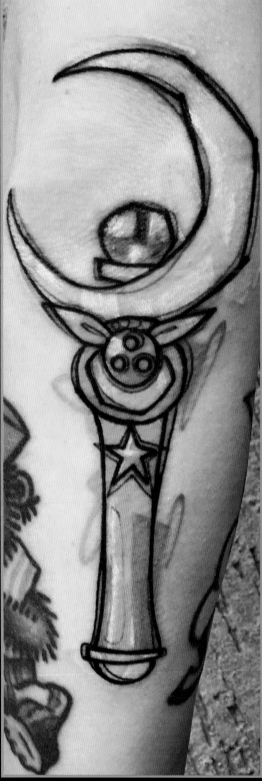

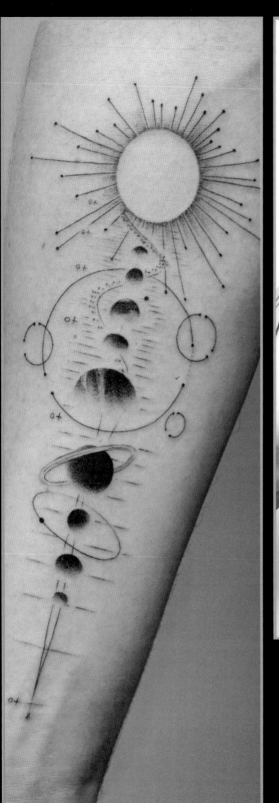

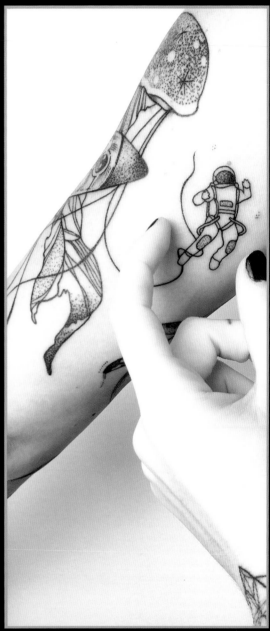

Astronaut by María Fernández

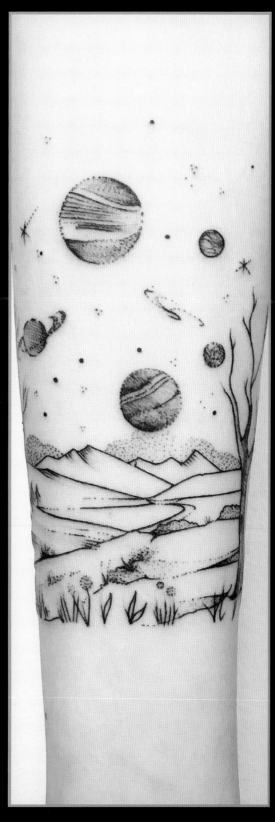

ASTRONOMY

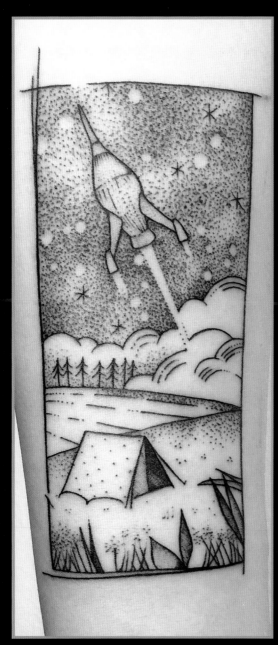

A Rocket Launch (above) and Distant Planets
(right) by María Fernández

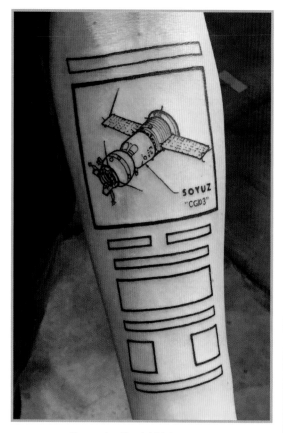

Soyuz by Daniel Matsumoto

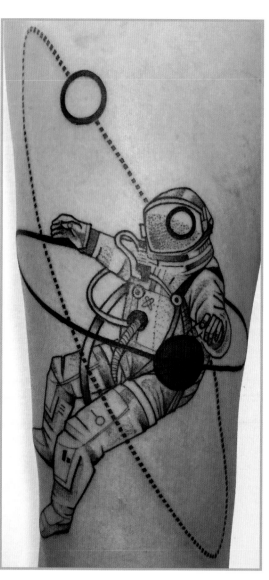

Astronaut by Daniel Matsumoto

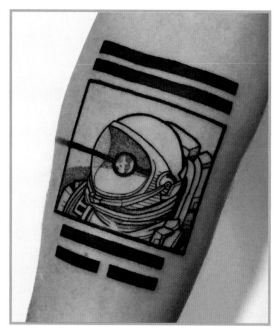

Astronaut by Daniel Matsumoto

Earth by Mattia Mambo

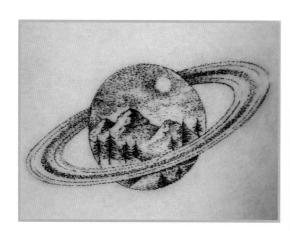

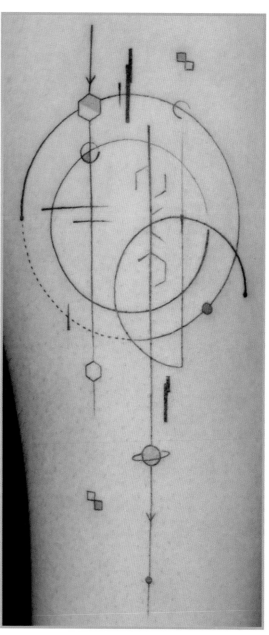

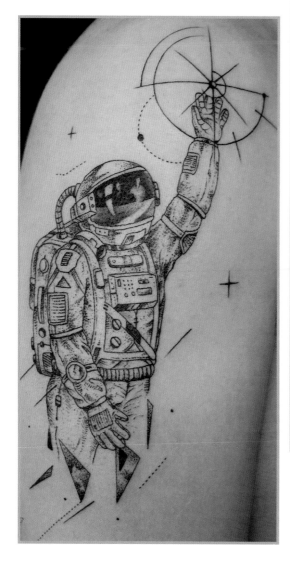

Tattoos by Emrah Ozhan (clockwise from top left): Saturn and its rings; the solar system; and an astronaut touching the stars.

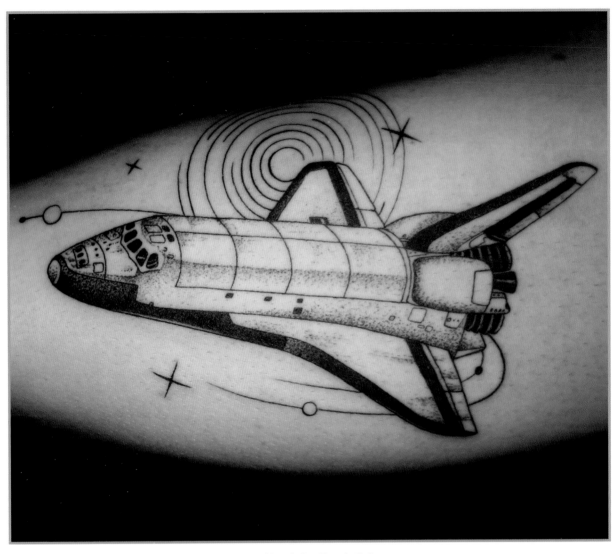

Space Shuttle by Emrah Ozhan

 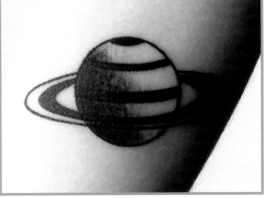

Solar System (left) and Saturn (right) by Jake Haynes

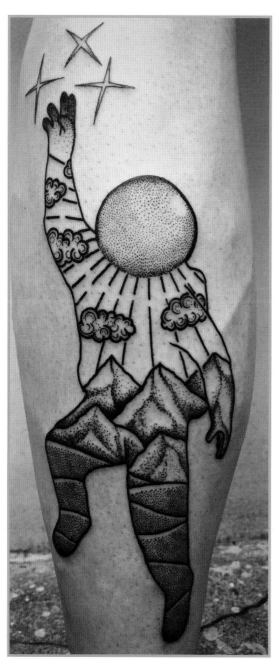

Humanity Reaching for the Stars
by Roma Severov

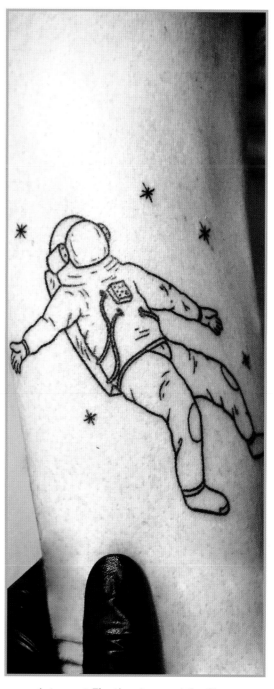

Astronaut Floating Amongst the Stars
by Jake Haynes

143

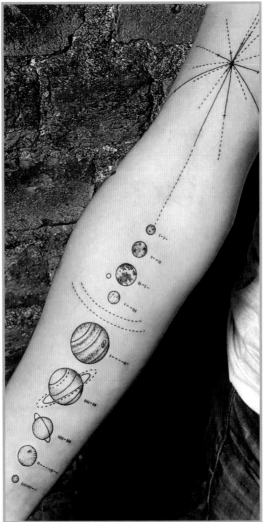

Solar System by Bicem Sinik

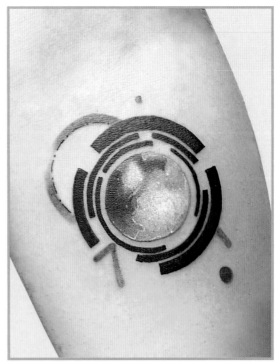

Stargate by Bariş Yeşilbaş

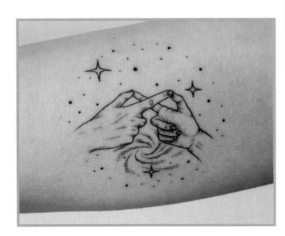

Hands Across Space by Pablo Torre Rodriguez

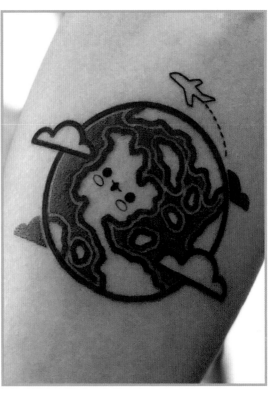

Earth by Hugo Tattooer

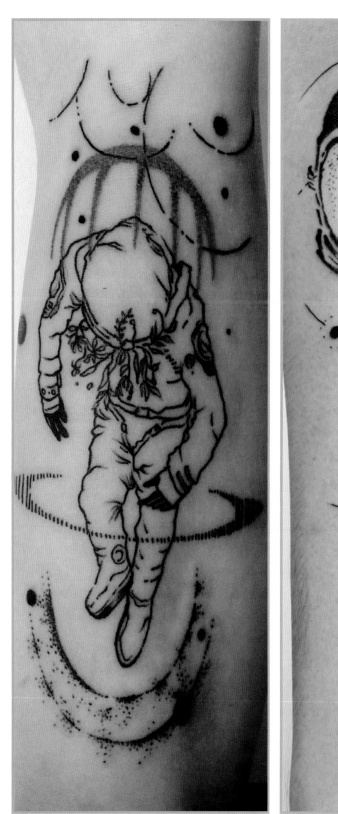
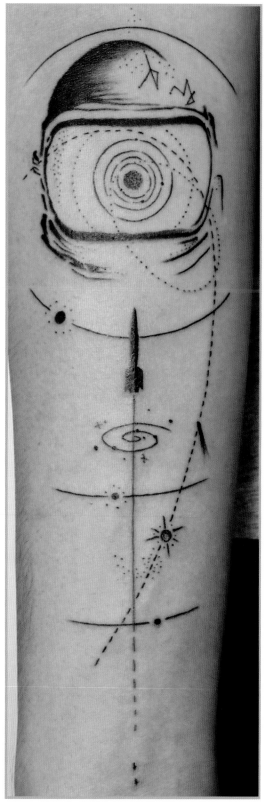

Abstract space-inspired tattoos by Aline Wata

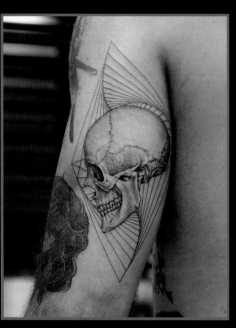

Skull by Mr.K

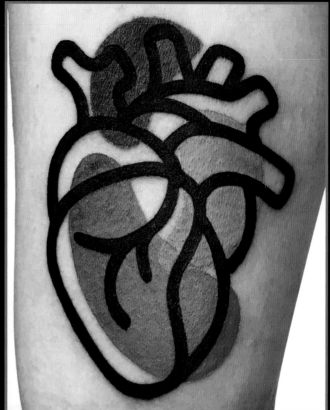

Heart by Mattia Mambo

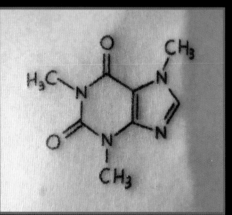

Caffeine by Jake Haynes

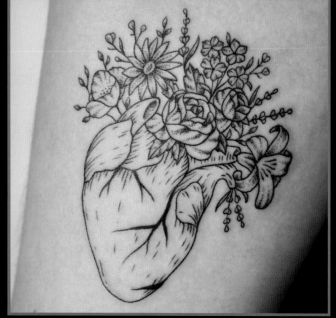

Flowering Heart by Pablo Torre Rodriguez

146

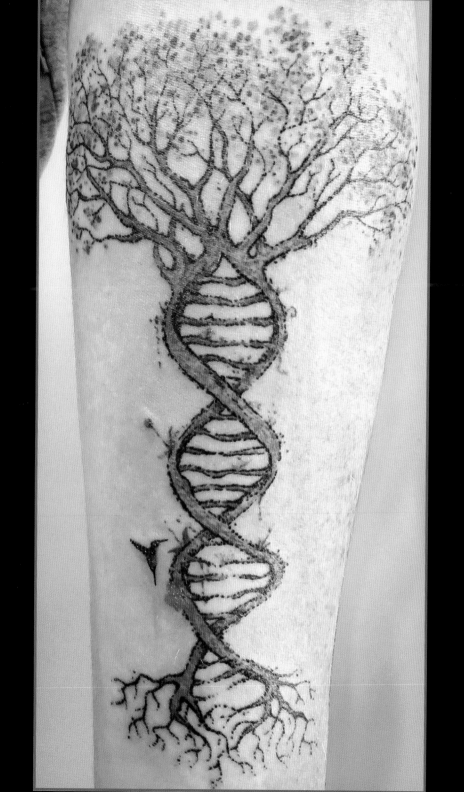

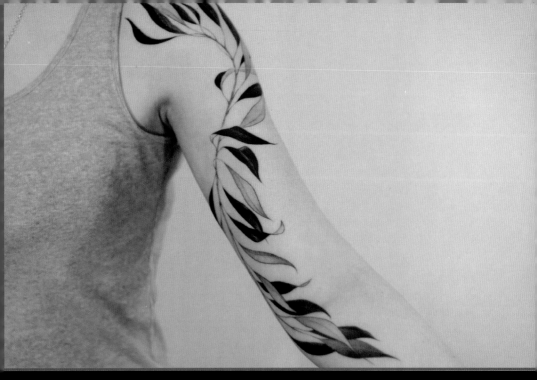

Vine by Tattooist DOY

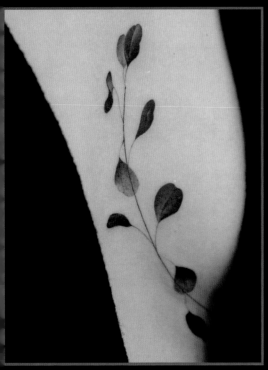

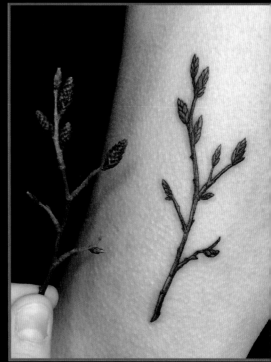

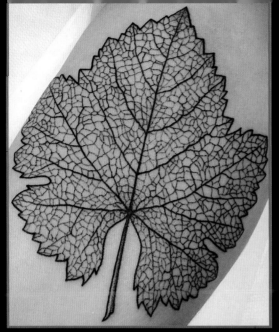

Leaf by Michele Volpi

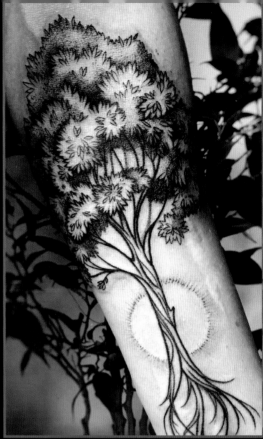

Tree with Roots by Sasha Kiseleva

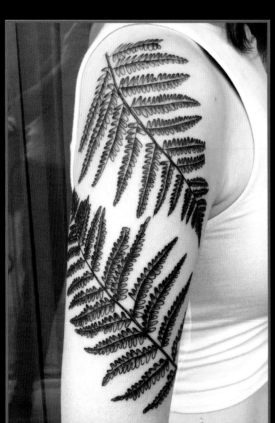

Ultrarealistic Fern Leaves by Marin Toreshchenko

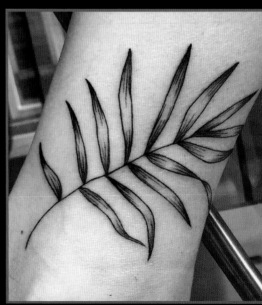

Leaf Stalk by Marin Toreshchenko

ANGIOSPERMS

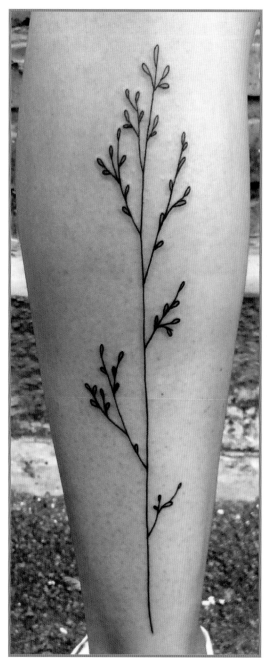
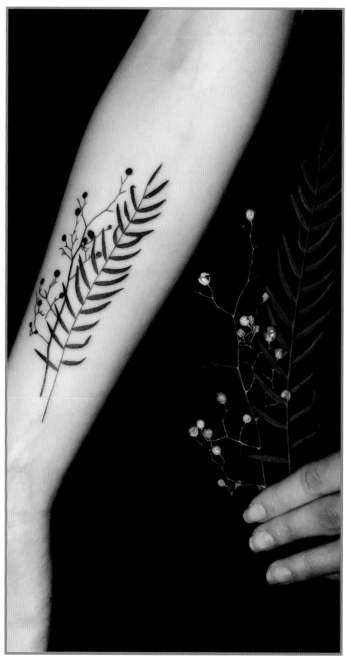

Ultrarealistic botanical tattoos by Marin Tereshchenko

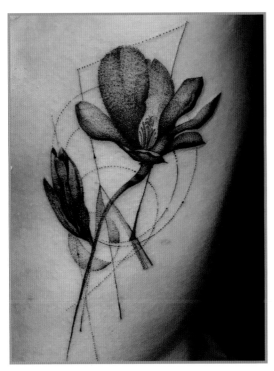

Geometric Magnolia by Yeekii Lo

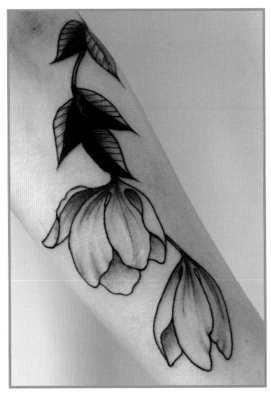

Flower by Pony Wave

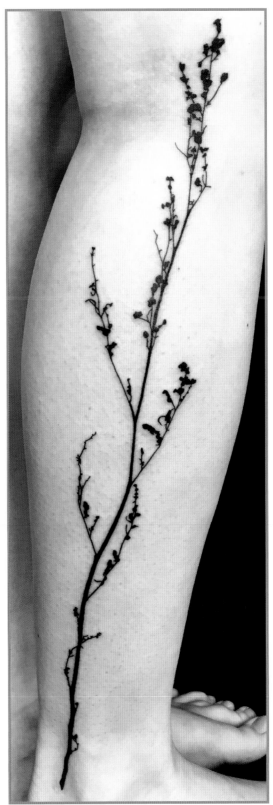

Ultrarealistic Plant Stalk by Marin Tereshchenko

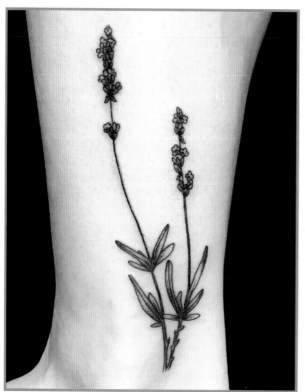
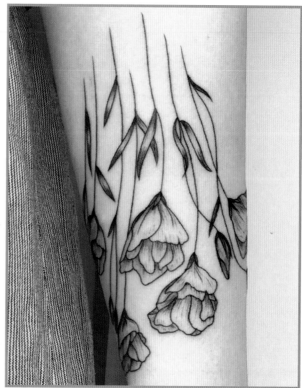

Ultrarealistic flowers by Marin Tereshchenko

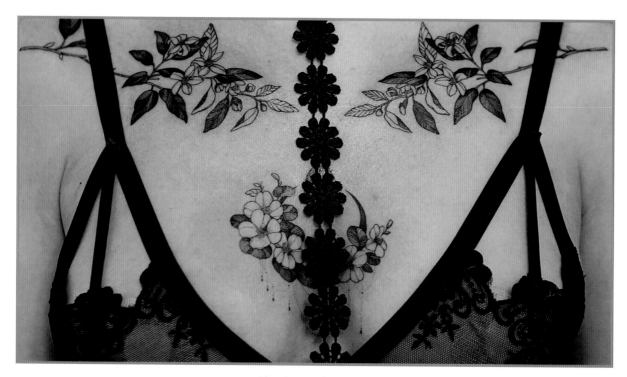

Floral tattoo by Zihwa

Eudicots

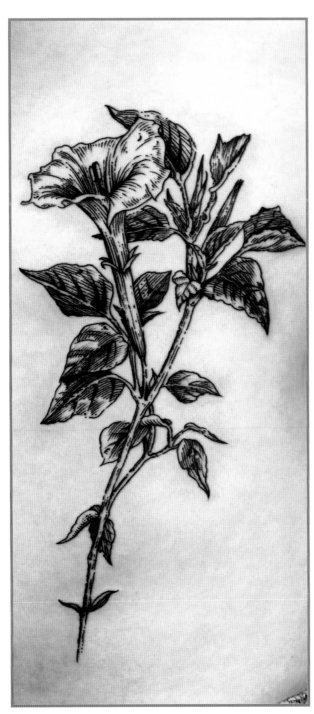

Morning Glory by Loïc LeBeuf

Lavender by Mo Ganji

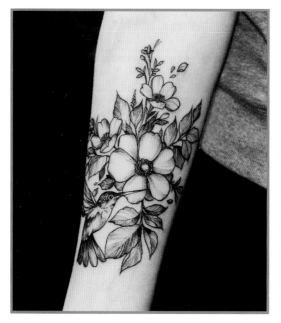
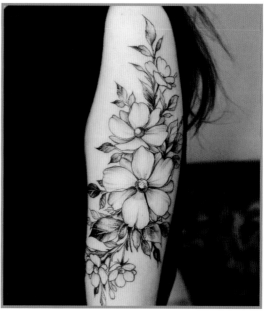
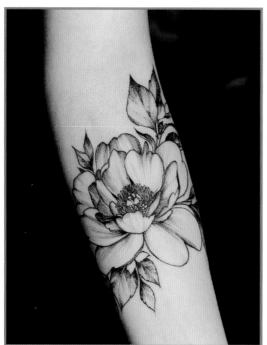
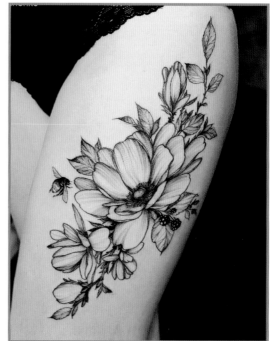

Hyperrealistic wildflowers by Diana Severinenko

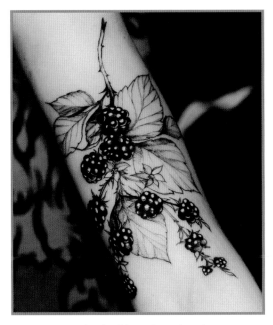

Berries by Diana Severinenko

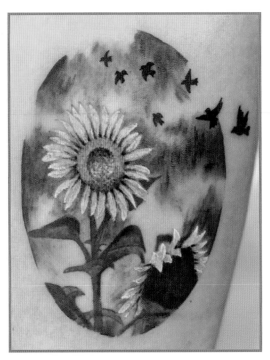

Sunflowers by Andrea Morales

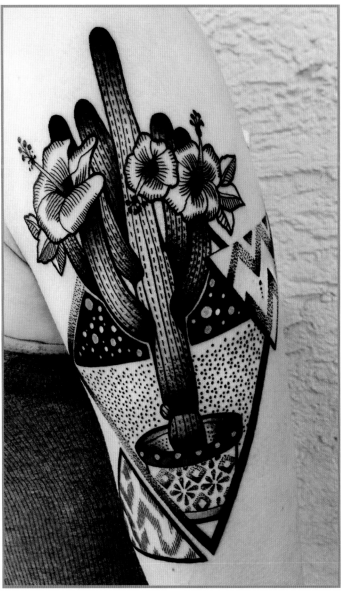

Flowering Cactus by Jessica Svartvit

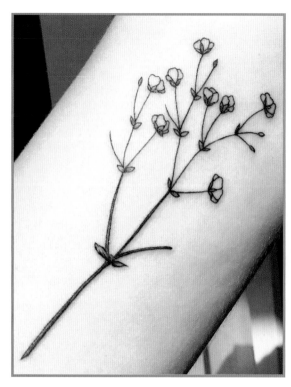

Ultrarealistic Flowers by Marin Tereshchenko

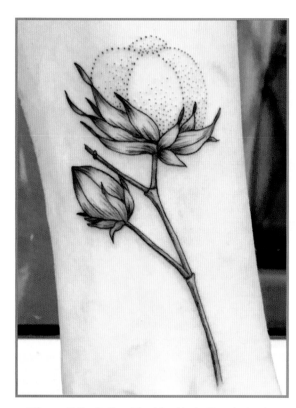

Ultrarealistic Cotton Plant by Marin Tereshchenko

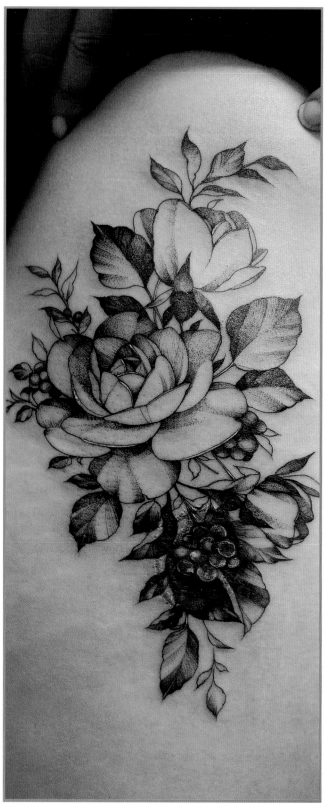

Roses by Zihwa

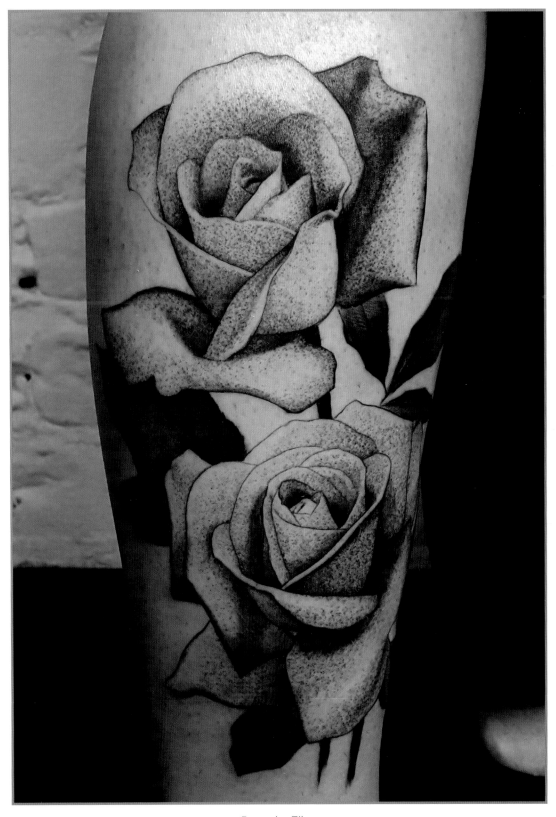

Roses by Zihwa

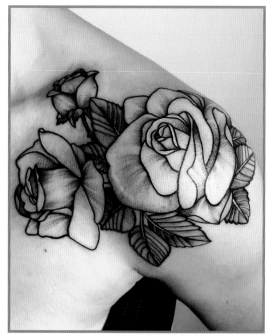
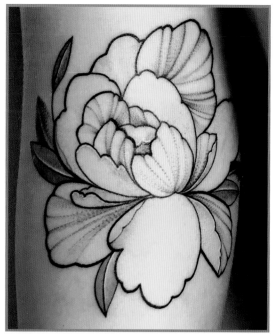
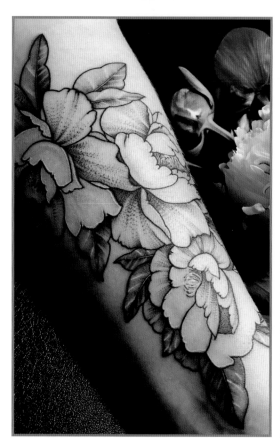
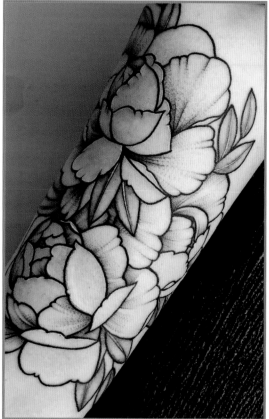

Rose and Peony tattoos by Nora Lyashko

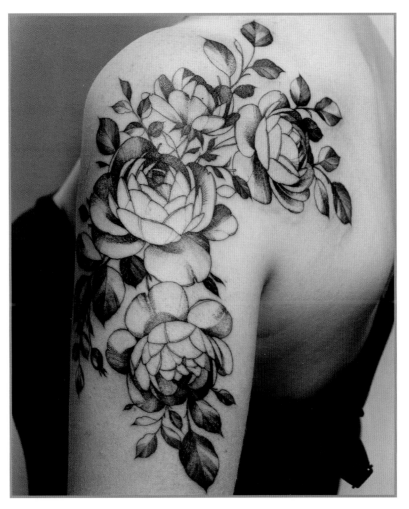

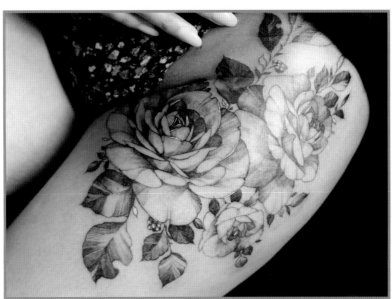

Rose tattoos by Zihwa

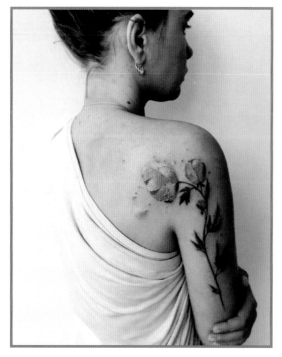

Peonies by PisSaro

Boho Wedding Bouquet by PisSaro

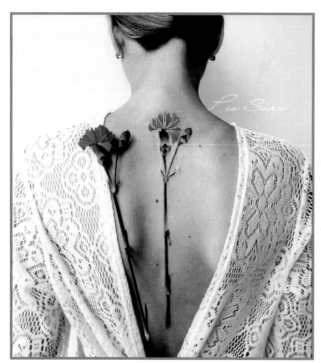

Portrait of a Carnation by PisSaro

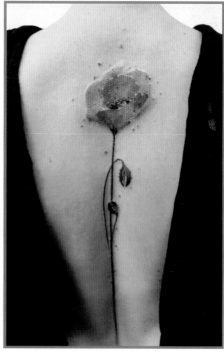

Poppy by PisSaro

Monocots

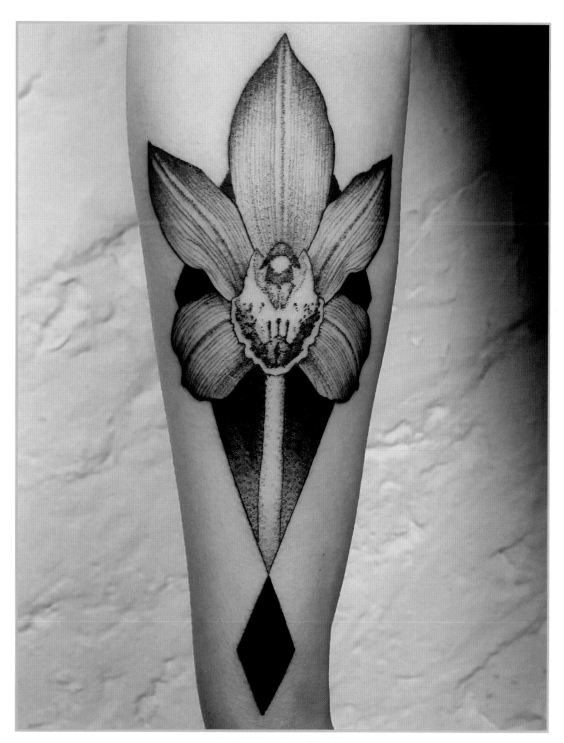

Orchid by Arthur Perfetto

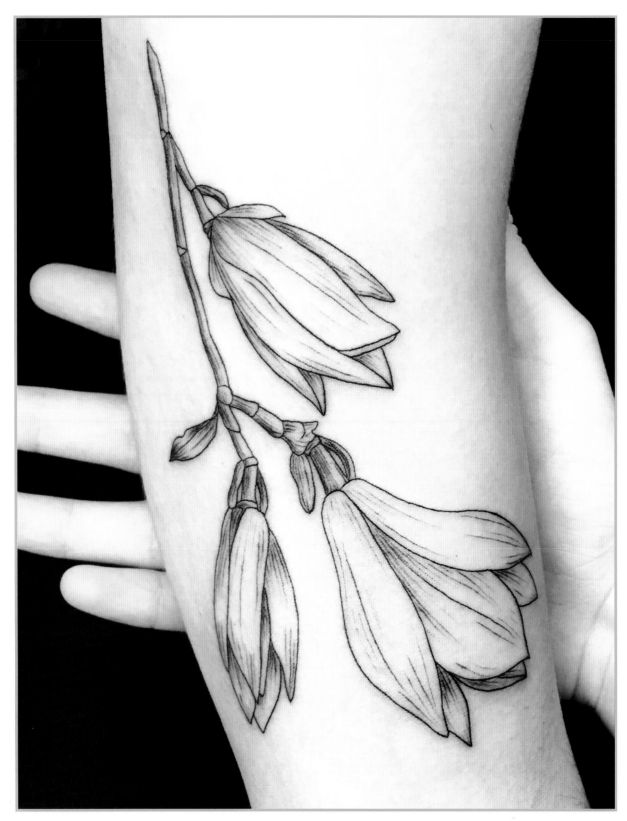

Ultrarealistic Magnolias by Marin Tereshchenko

Ultrarealistic Wheat by Marin Tereshchenko

Tulips by Aline Wata

163

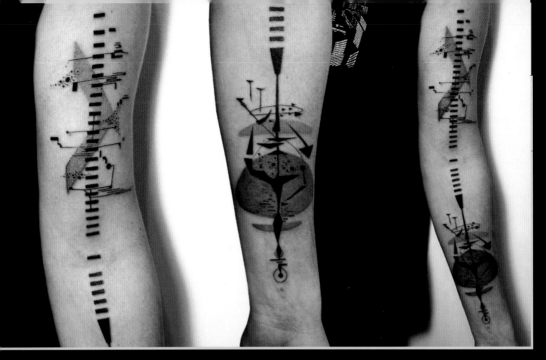

This page: Abstract tattoos by Aline Wata

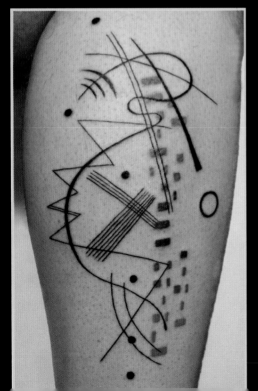

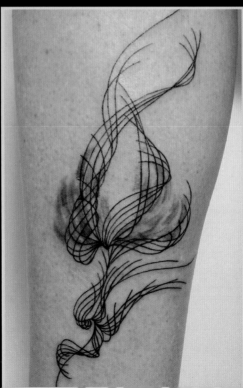

CONCEPTUAL

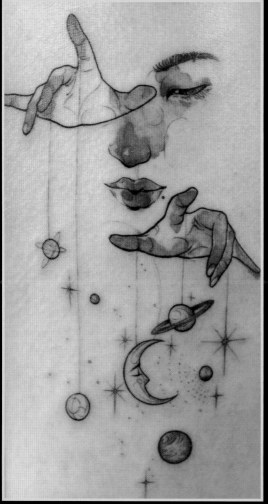

Master of the Universe by Tattooist DOY

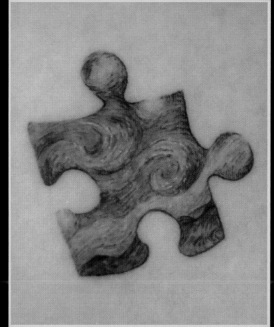

Puzzle Piece by Tattooist DOY, inspired by Vincent van Gogh's *Starry Night*

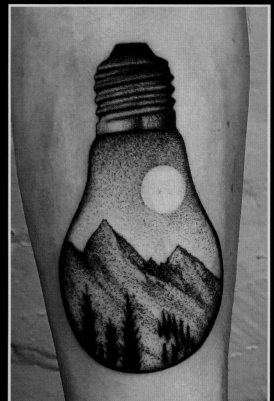

Reaching Out by Curt Montgomery

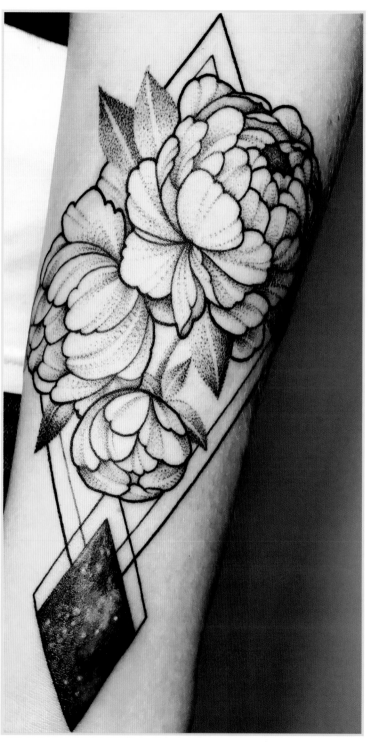

Flowering Galaxy by Nora Lyashko

Man's Best Friend by Indomito

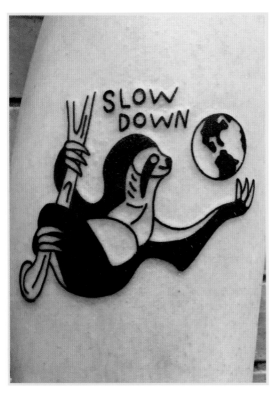

Slow Down, World by Indomito

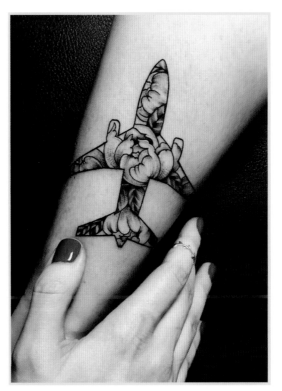

Flowering Airplane by Nora Lyashko

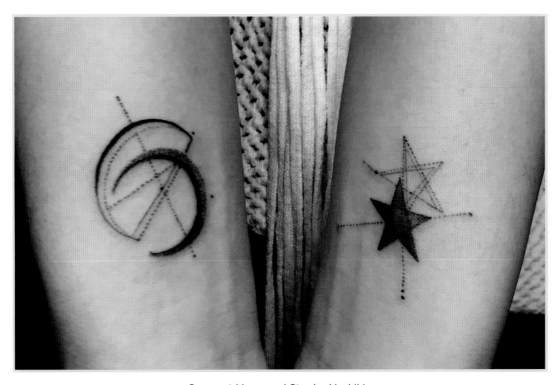

Crescent Moon and Star by Yeekii Lo

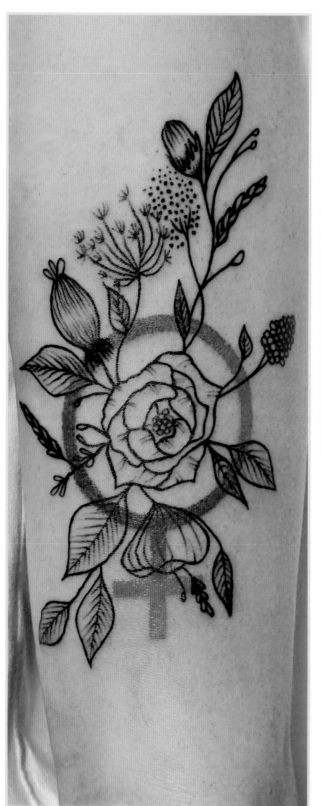

Female Power by Aline Wata

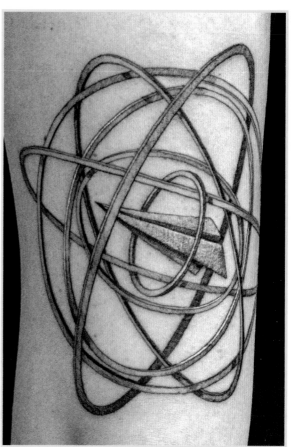

Flight Physics by Sven Rayen

Flight by Pablo Torre Rodriguez

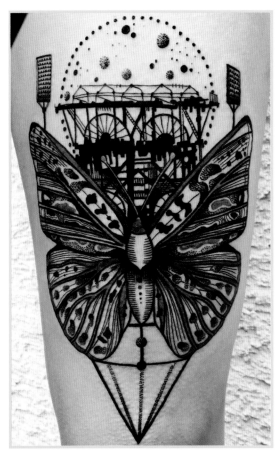

Carnival Butterfly by Jessica Svartvit

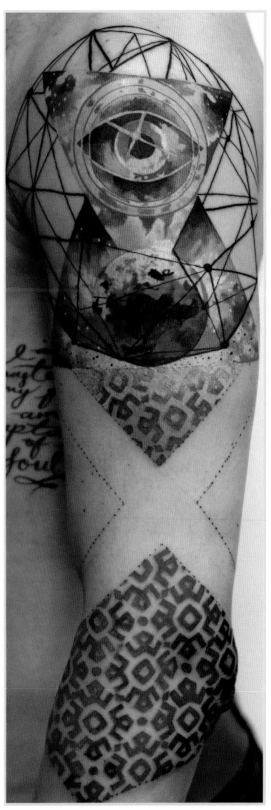

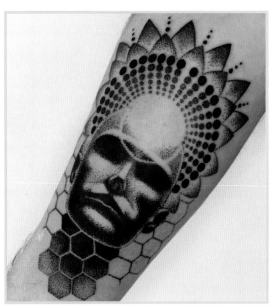

Third Eye by Pony Wave

Galactic Eye by Martynas Šnioka

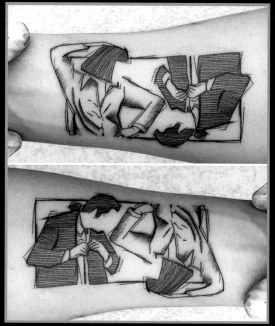

Vincent Vega and Mia Wallace tattoo by
Andrea Bianchi, inspired by *Pulp Fiction*

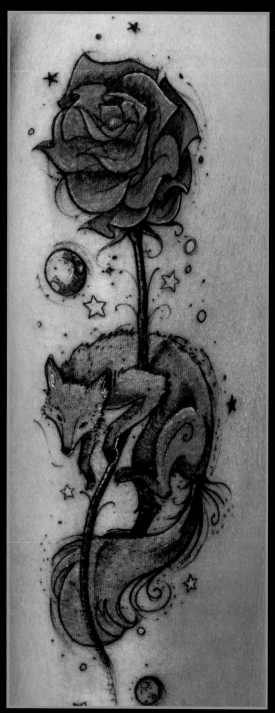

Fox and Rose by Rob Carvalho, inspired
by *The Little Prince*

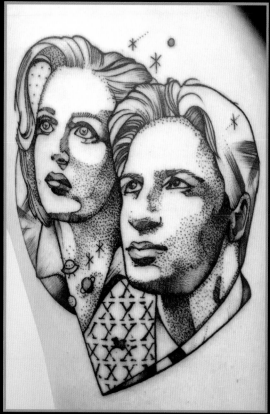

Scully and Mulder tattoo by María Fernández,
inspired by *The X-Files*

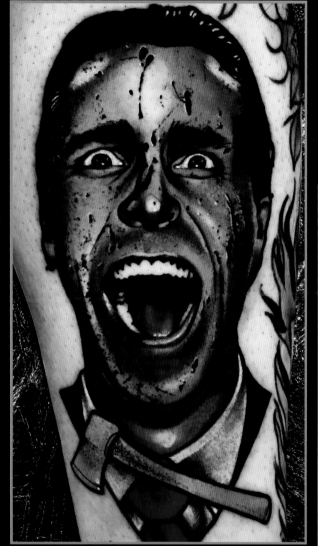

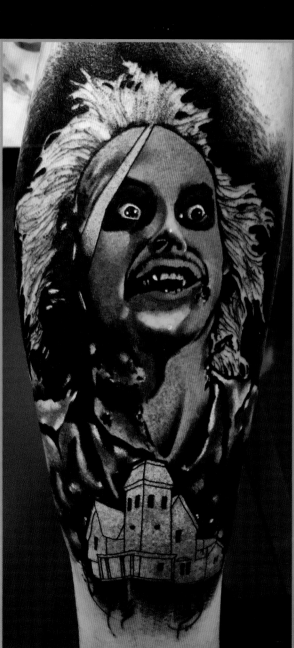

Tattoos by Little Andy, inspired by *American Psycho* (above) and *Beetlejuice* (right).

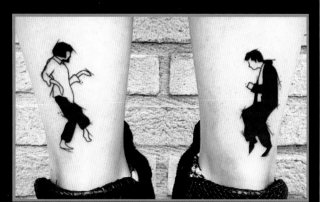

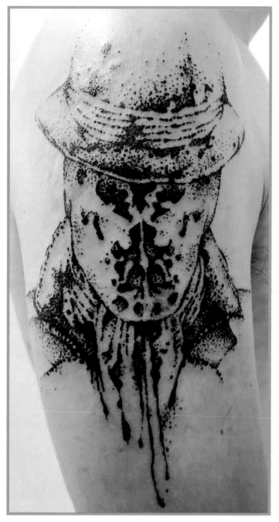

Rorschach by Rodrigo Tas, inspired by *Watchmen*

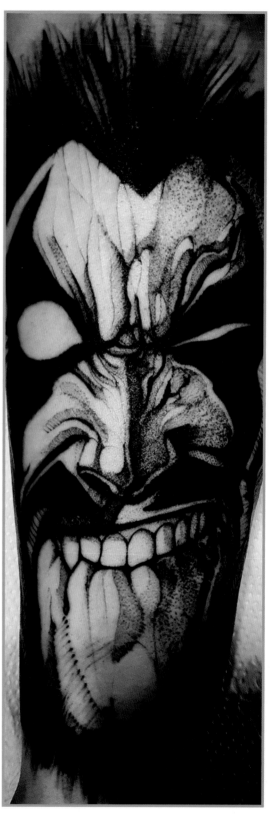

Lobo by Felipe Kross, inspired by DC Comics

FANTASY

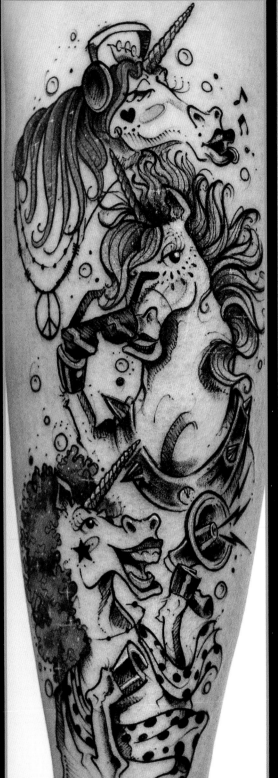

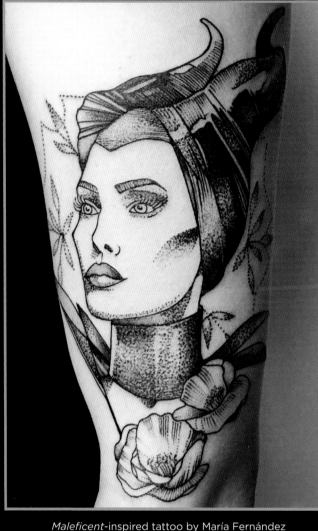

Maleficent-inspired tattoo by María Fernández

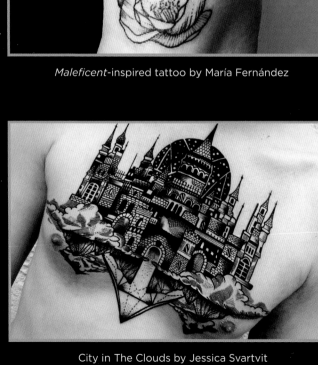

Unicorn tattoo by Rob Carvalho, inspired by
My Little Pony: Friendship Is Magic

City in The Clouds by Jessica Svartvit

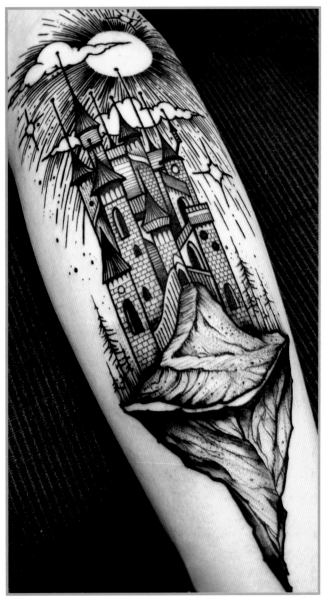

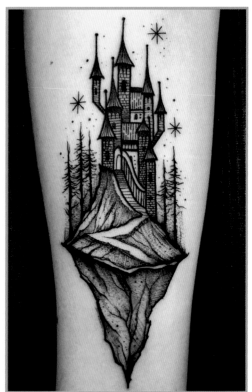

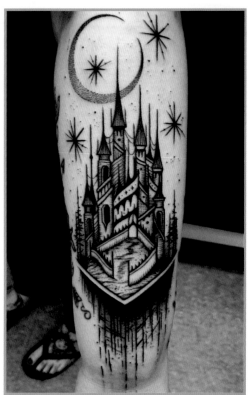

This page: Castles by Thomas Eckeard

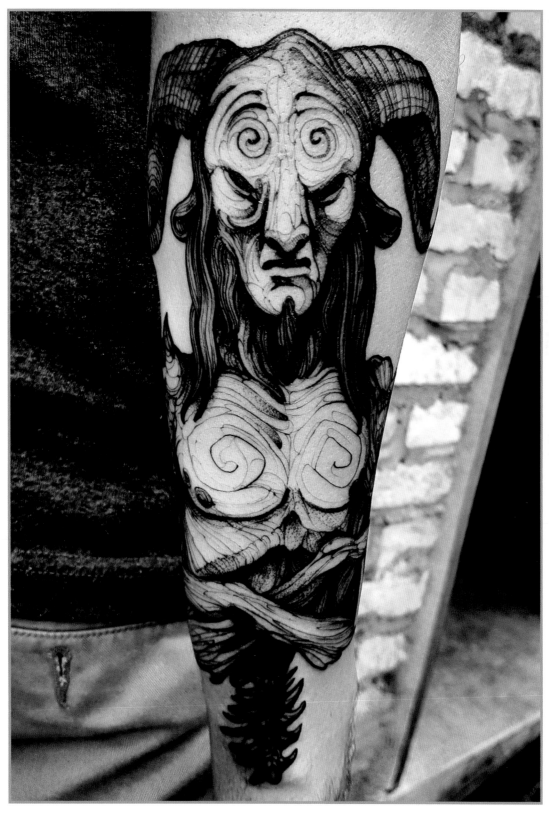

Tattoo by Felipe Kross, inspired by *Pan's Labyrinth*

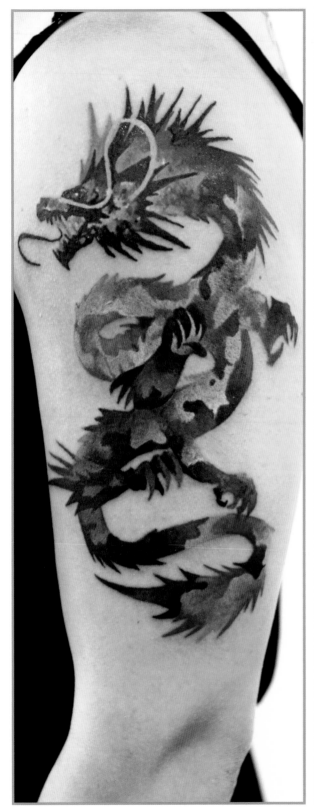
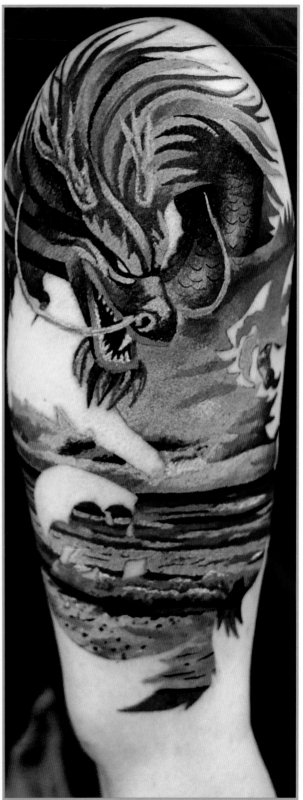

Dragon tattoos by Martynas Šnioka

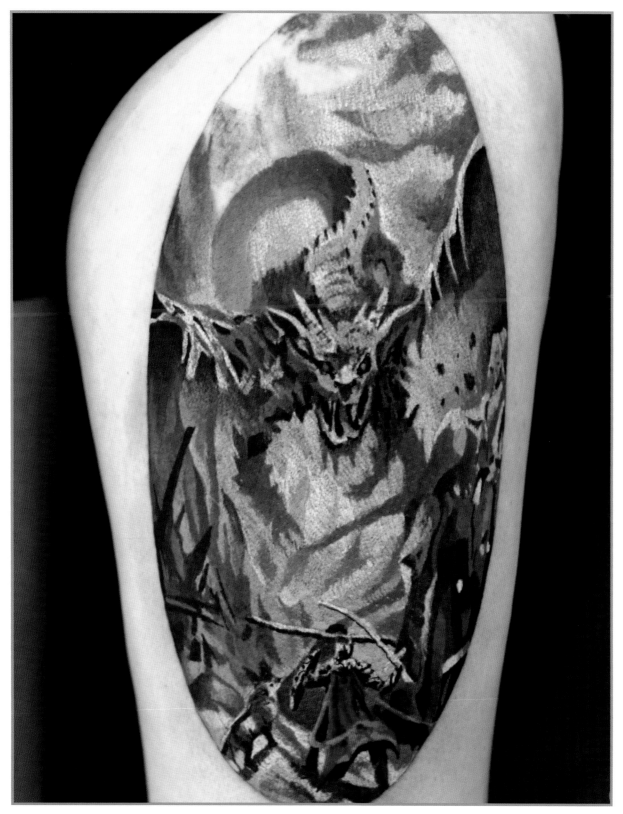

Warrior Facing a Dragon by Martynas Šnioka

179

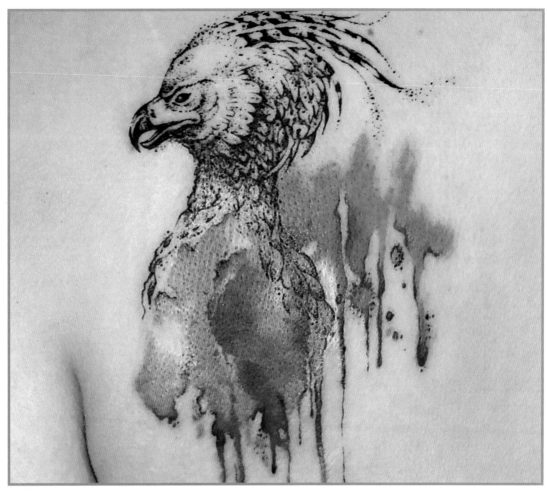

Fawkes the Phoenix by Rodrigo Tas, inspired by *Harry Potter*

Tree by Rodrigo Tas, inspired by *The Lord of the Rings*

Wands by Pablo Torre Rodriguez, inspired by *Harry Potter*

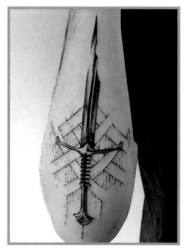

Shard of Narsil by Rodrigo Tas, inspired by *The Lord of the Rings*

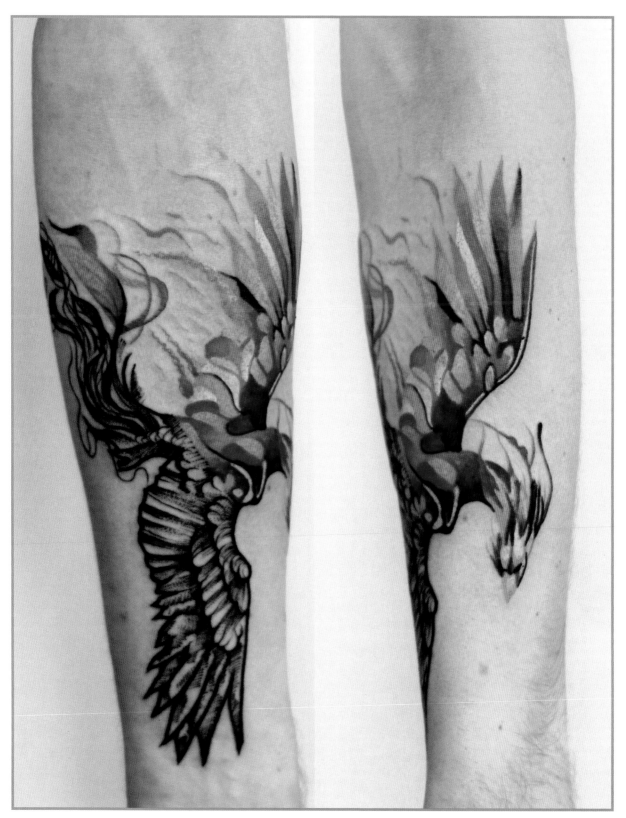

Phoenix tattoo by Martynas Šnioka

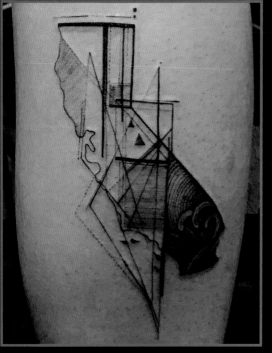

Geometric California by Yeekii Lo

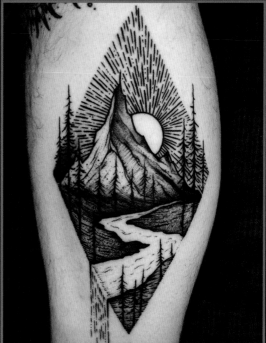

Mountain Stream by Thomas Eckeard

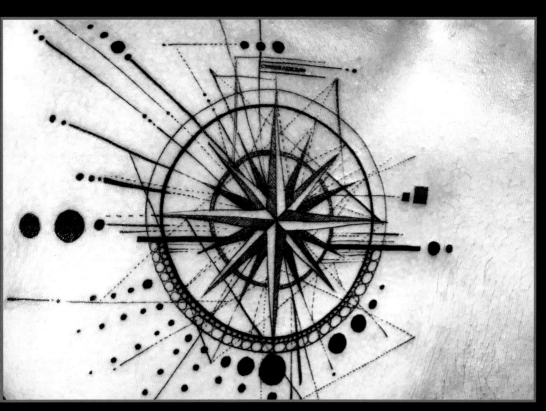

Compass by Yeekii Lo

182

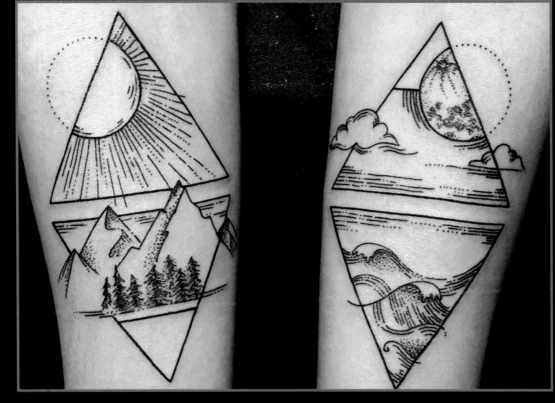

This page: Mountain and Sea Landscapes by Bicem Sinik

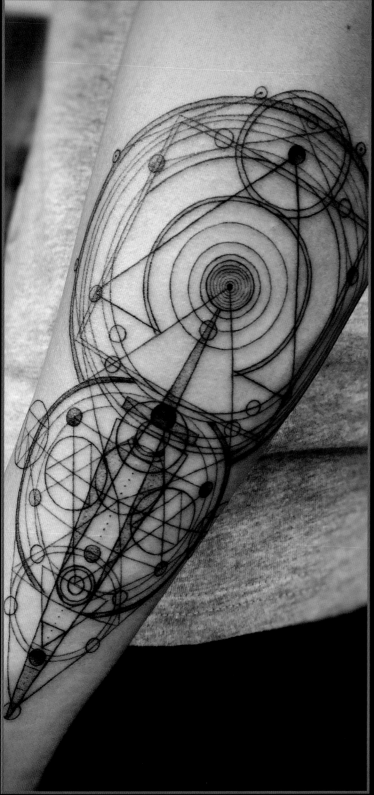

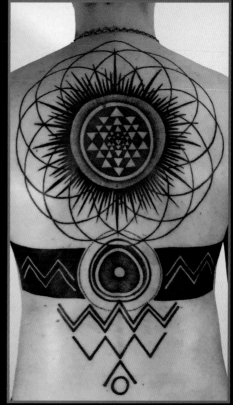

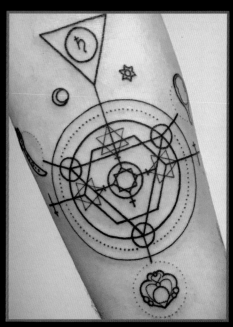

Cosmic Geometry by Balazs Bercsenyi

Top and above: Sacred Geometry
Mandalas by Daniel Matsumoto

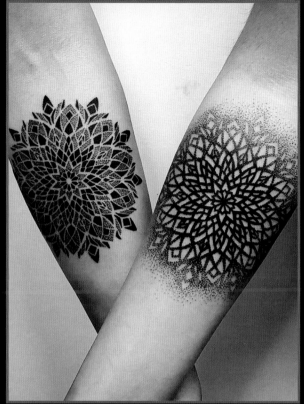

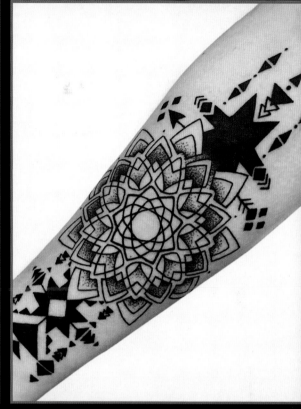

Inverted Mandalas by Matteo Nangeroni

Tribal Mandala by Pony Wave

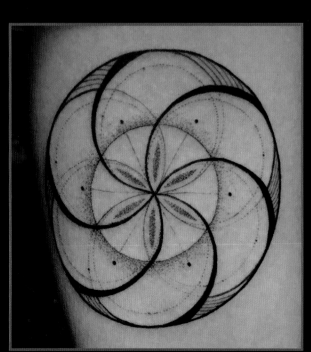

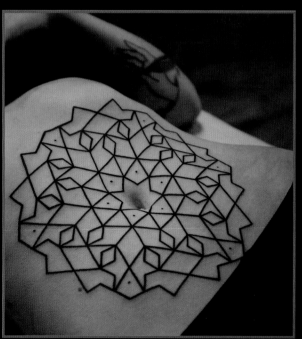

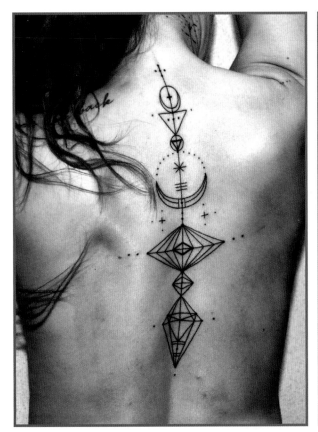
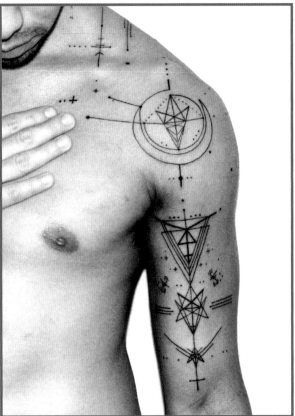
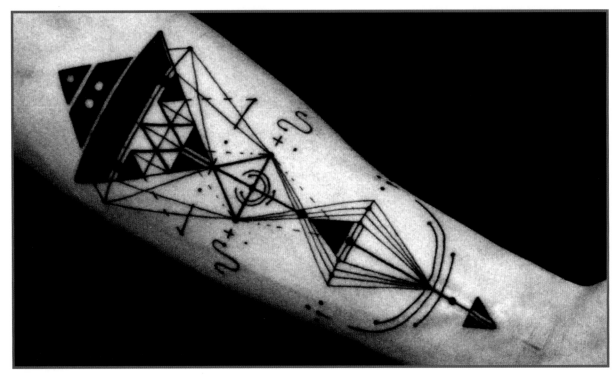

This spread: Mental geometry tattoos by Sergey Berlin

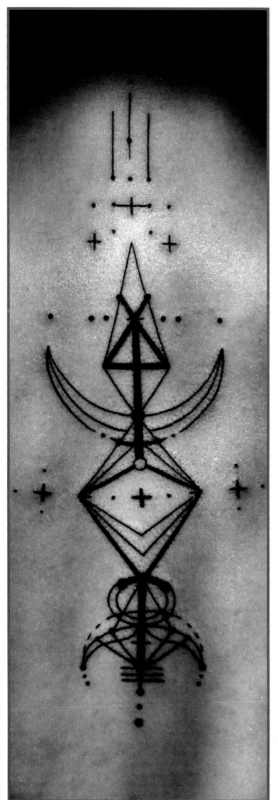

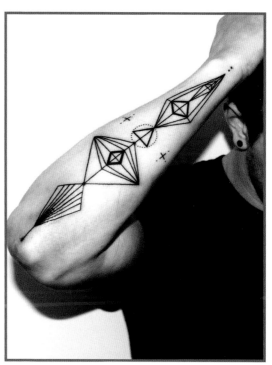

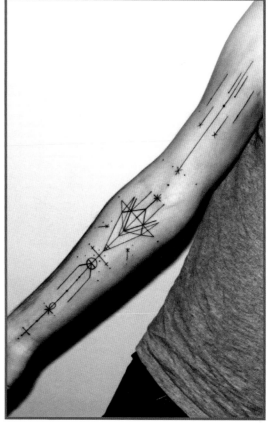

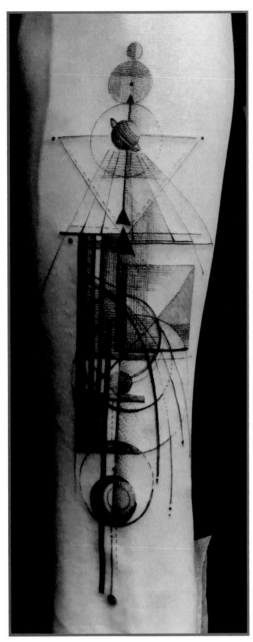

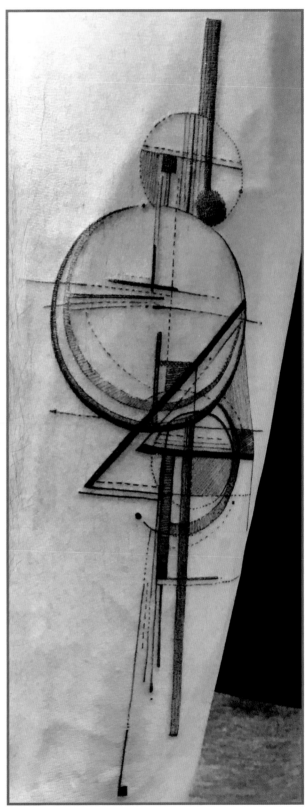

This spread: Abstract geometric tattoos by Yeekii Lo

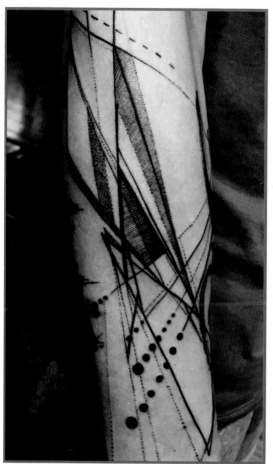

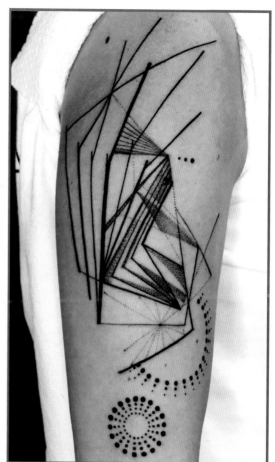

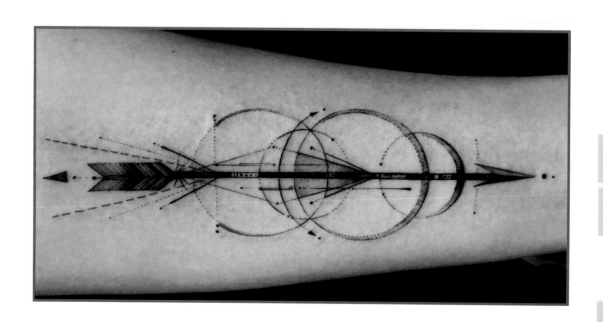

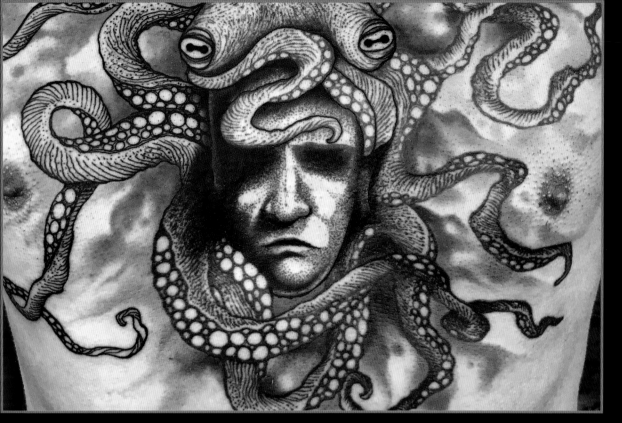

Tattoo by Dino Nemec, inspired by Cthulhu from the "The Call of Cthulhu" by H.P. Lovecraft

The White Rabbit by Nora Lyashko, inspired
by *Alice's Adventures in Wonderland*

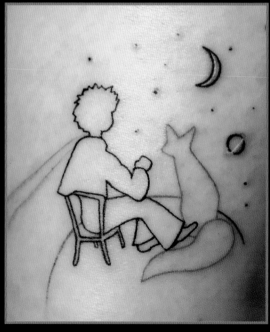

The Fox and the Prince by Nora Lyashko,
inspired by *The Little Prince*

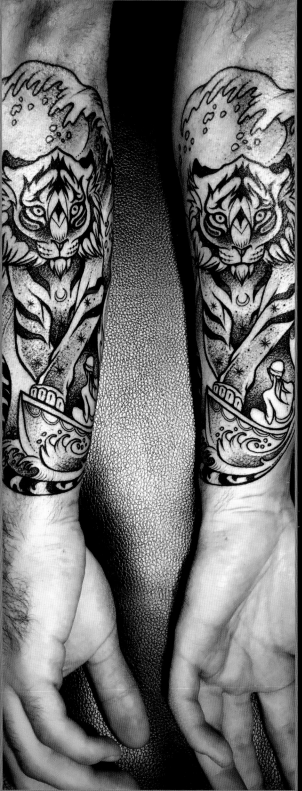

LITERATURE

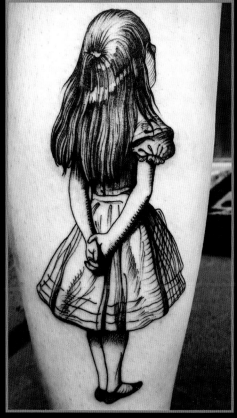

Alice by Felipe Kross, inspired by
Alice's Adventures in Wonderland

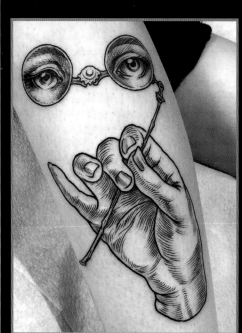

Tiger on a Boat by Sasha Kiseleva, inspired by *Life of Pi*

Vintage Reading Spectacles by

Left Brain Logic versus Right Brain Creativity
by Martynas Šnioka

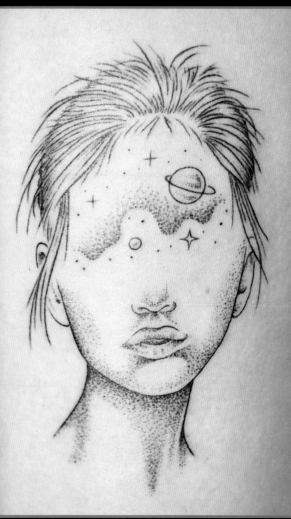

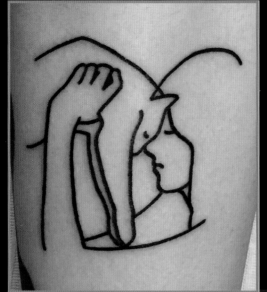

Kitty Cuddles by Curt Montgomery

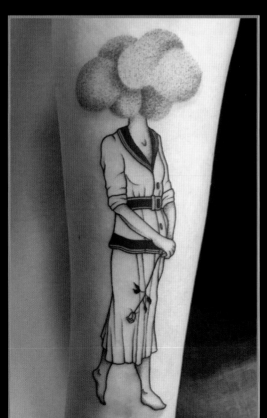

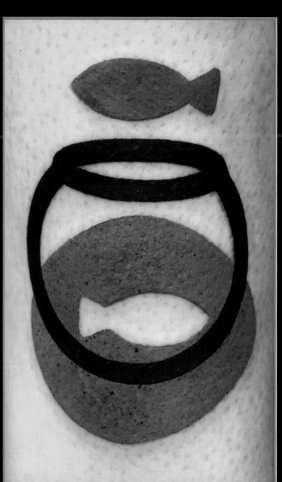

Out of Water by Mattia Mambo

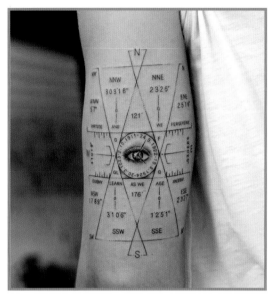

And We Learn as We Age by Mr.K

Choose Your Way by Matteo Nangeroni

Courage by Anna Neudecker

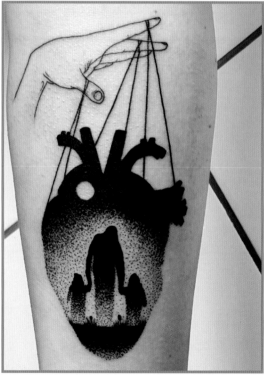

Heartstrings by Matteo Nangeroni

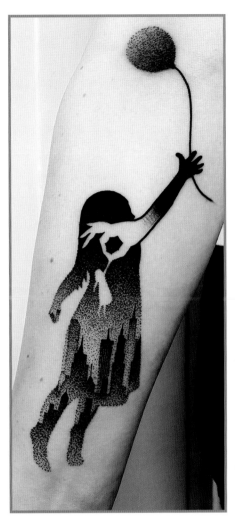

Inside You by Matteo Nangeroni

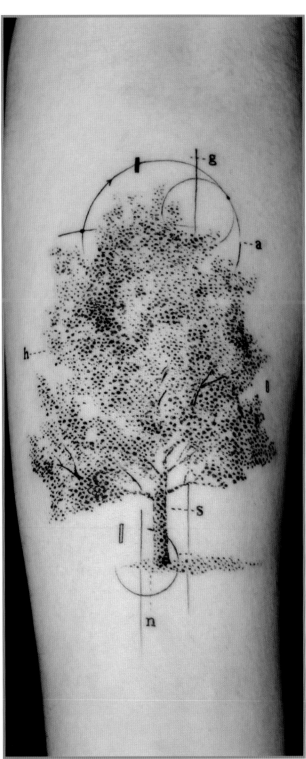

Memory Tree by Emrah Ozhan

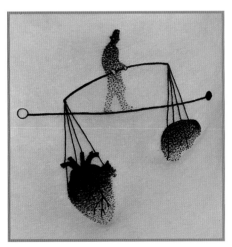

Between Mind and Hearts by
Matteo Nangeroni

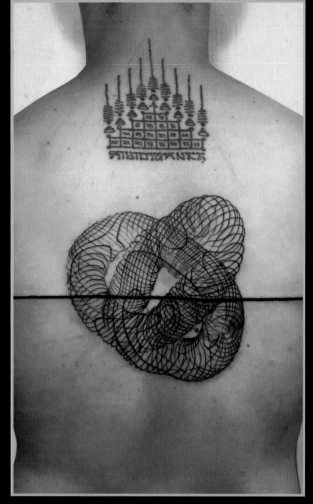

Energy Beam tattoo by Daniel Matsumoto, inspired
by *Donnie Darko*

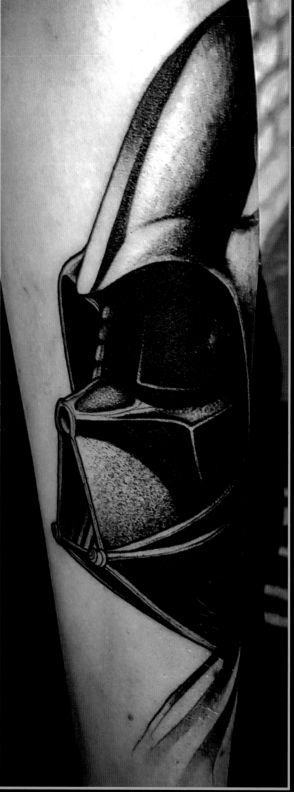

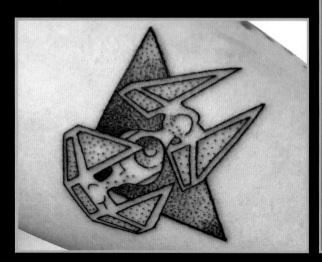

TIE Interceptor by María Fernández, inspired by *Star Wars*

Darth Vader by Felipe Kross, inspired by *Star Wars*

SCIENCE FICTION

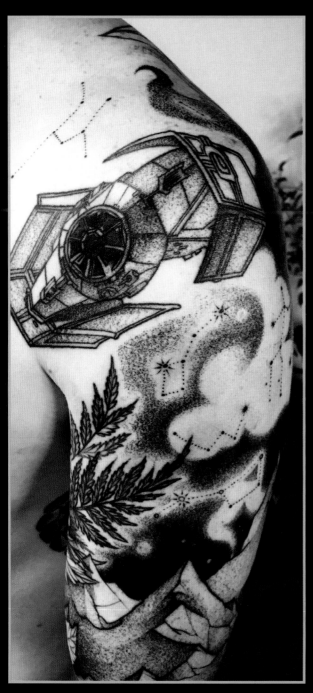

Darth Vader's TIE Advanced by Sasha Kiseleva,
inspired by *Star Wars*

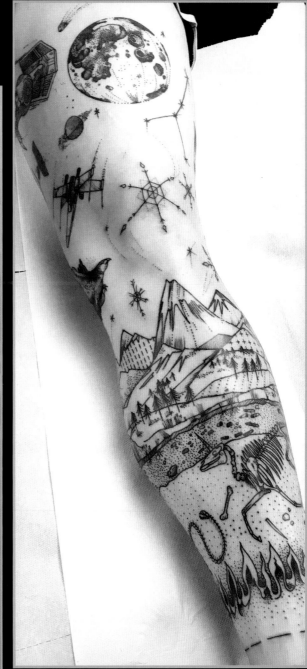

Star Wars–inspired landscape by María Fernández

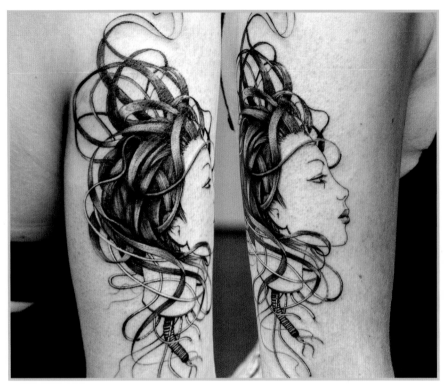

Biomechanical by Sven Rayen

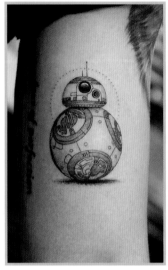

BB-8 by Mr.K, inspired
by *Star Wars*

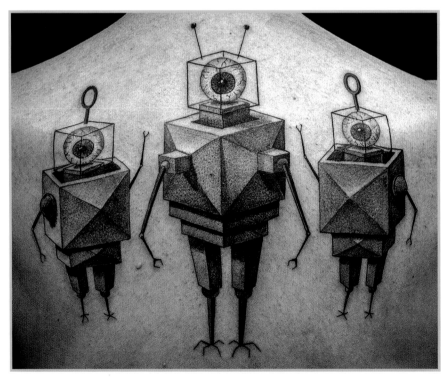

We Are the Robots by Sven Rayen

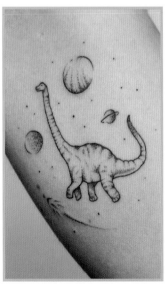

Space Brontosaurus by
Pablo Torre Rodriguez

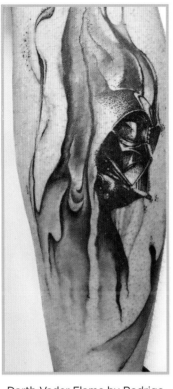

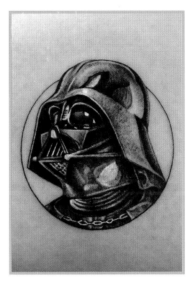

Darth Vader Flame by Rodrigo
Tas, inspired by *Star Wars*

Darth Vader by Mr.K, inspired
by *Star Wars*

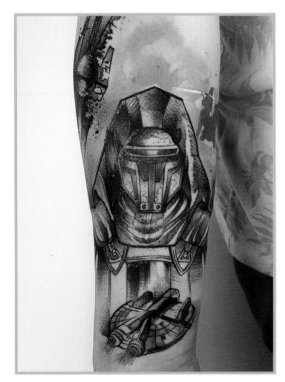

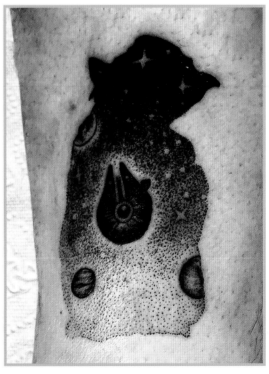

Darth Revan by Bariş Yeşilbaş, inspired by *Star
Wars: Knights of the Old Republic*

The *Millennium Falcon* within Yoda by Roma
Severov, inspired by *Star Wars*

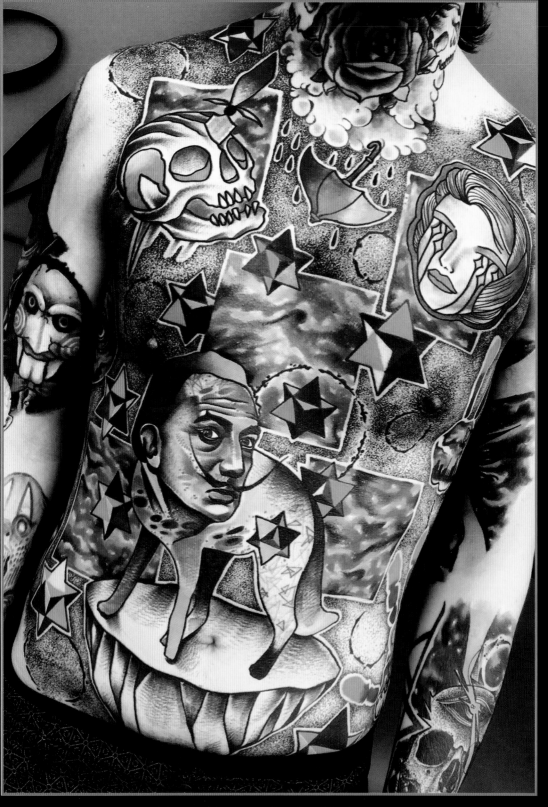

A surrealist tattoo collage by Little Andy

SURREALISM

Two-Room Fish by Andrea Bianchi

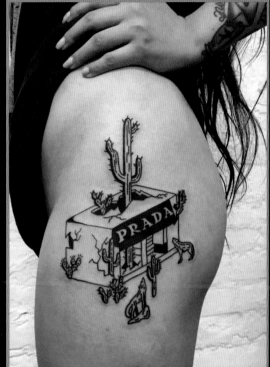

Tattoo by Indomito, inspired by *Prada Marfa*, an art installation in Texas by Elmgreen and Dragset

Above the Love but Under the Influence by Balazs Bercsenyi, inspired by a sculpture by Johnson Tsang

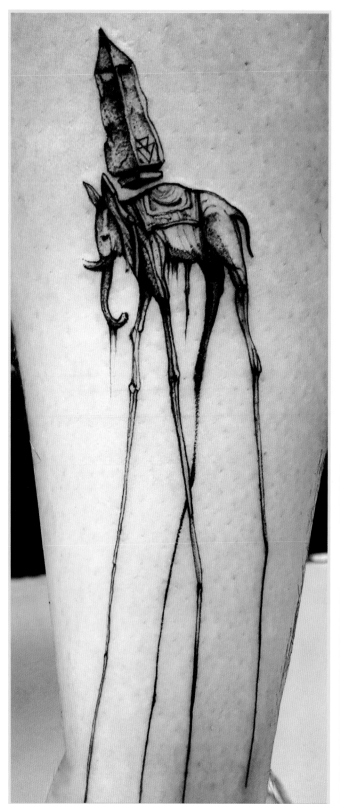

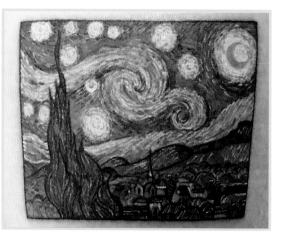

Tattoo by Eva Krbdk, inspired by
Vincent van Gogh's *Starry Night*

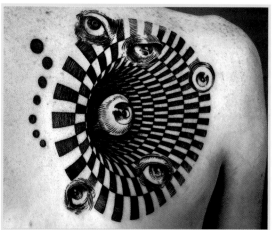

Optic Illusion by Lustandconsume

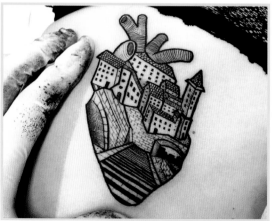

Tattoo by Felipe Kross, inspired by
Salvador Dalí's *The Elephants*

Perugia in the Heart by Andrea Bianchi

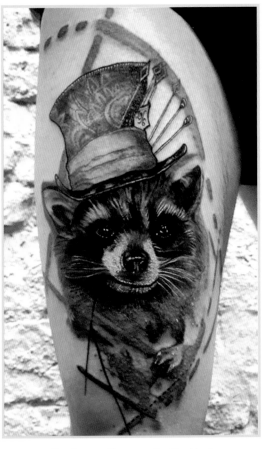

Gentleman Raccoon by Mo Mori

The Jump by Anna Neudecker

Flora by Curt Montgomery

Oblivion by Matteo Nangeroni

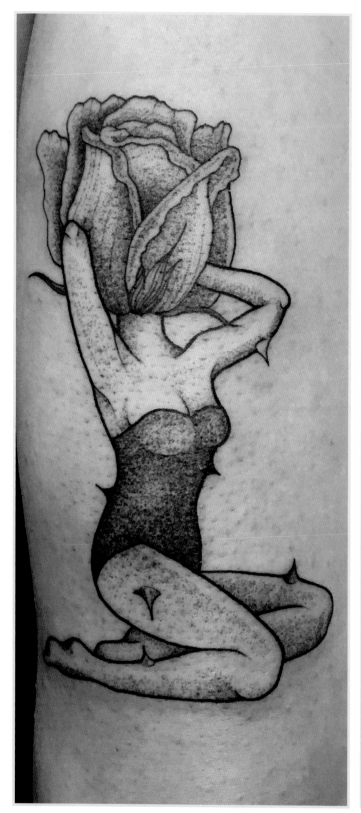

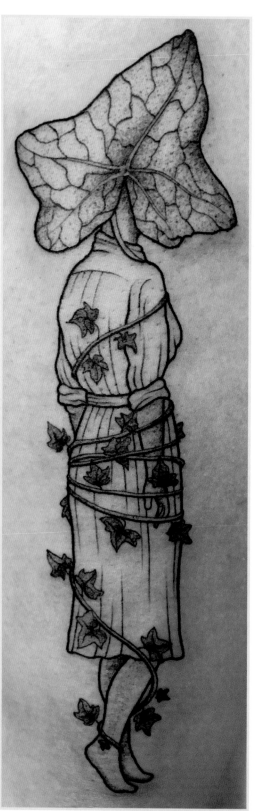

Prickly Rose by Anna Neudecker

Poison Ivy by Anna Neudecker

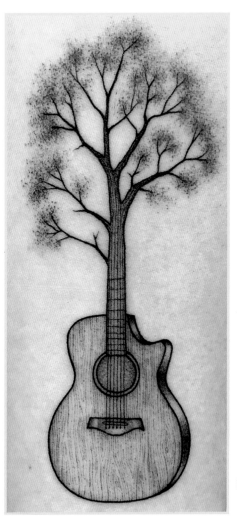

Guitar Tree by Michele Volpi

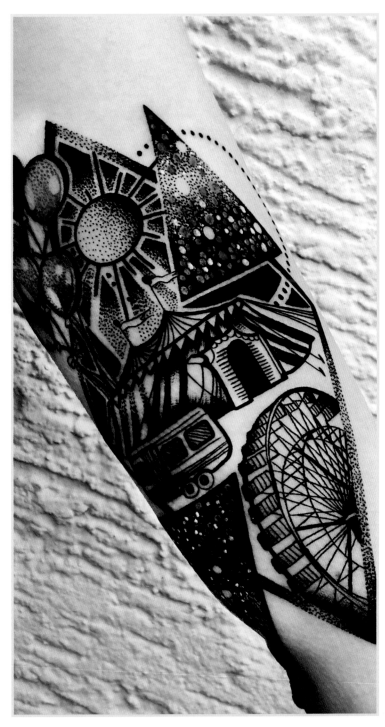

Amusement Park by Jessica Svartvit

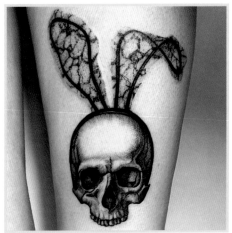

Playboy Skull by Alina Tiurina

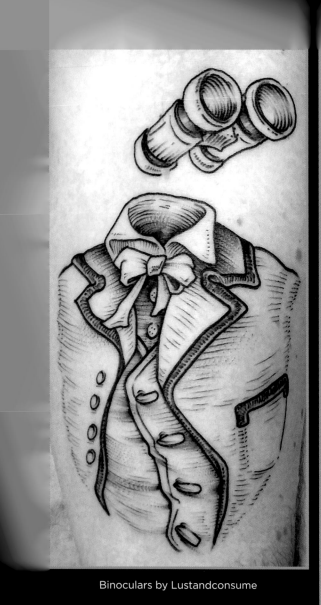

Binoculars by Lustandconsume

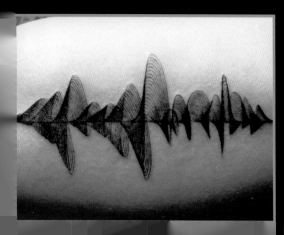

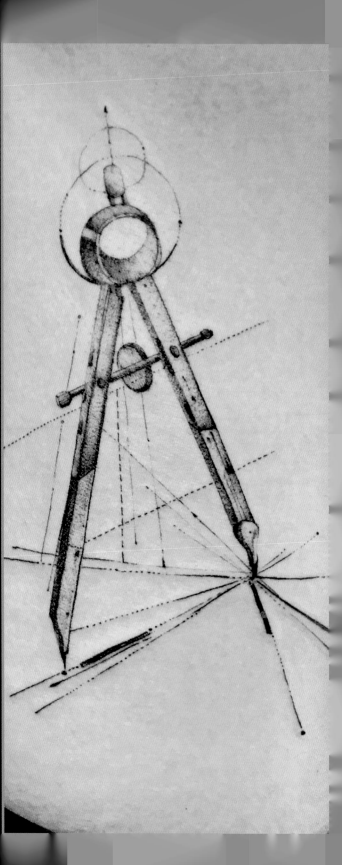

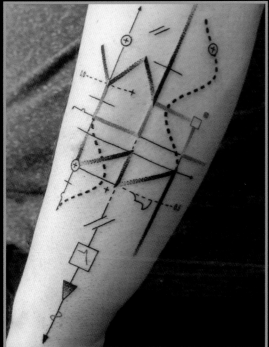

Sound Wave Diagrams by Emrah Ozhan

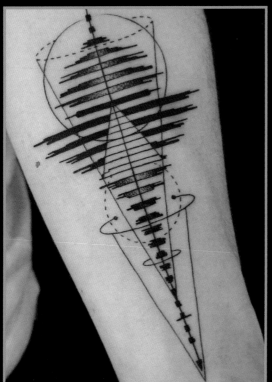

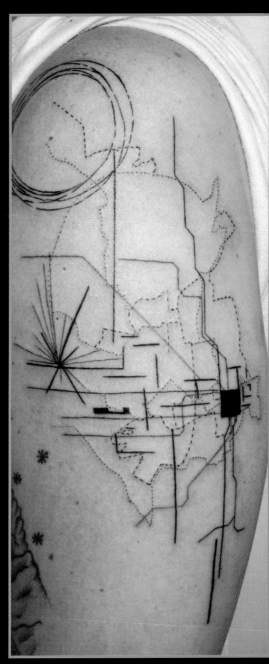

GPS-inspired tattoo by Aline Wata

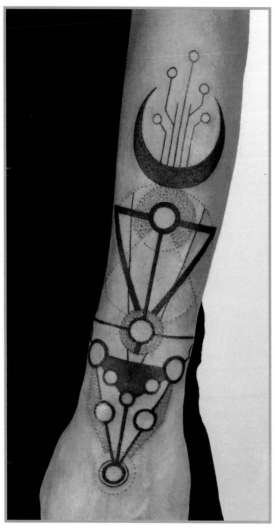

This spread: Neo-tribal, mechanical-inspired tattoos
by Daniel Matsumoto

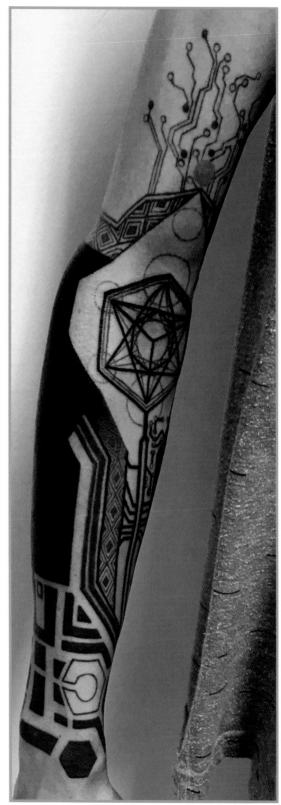

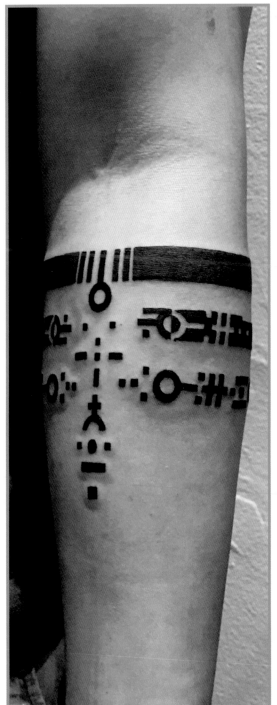

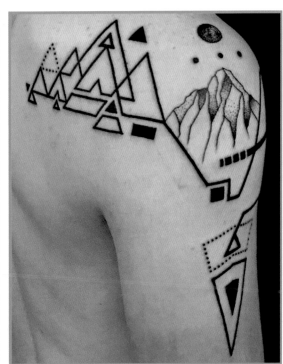

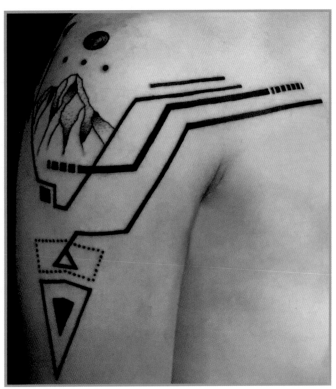

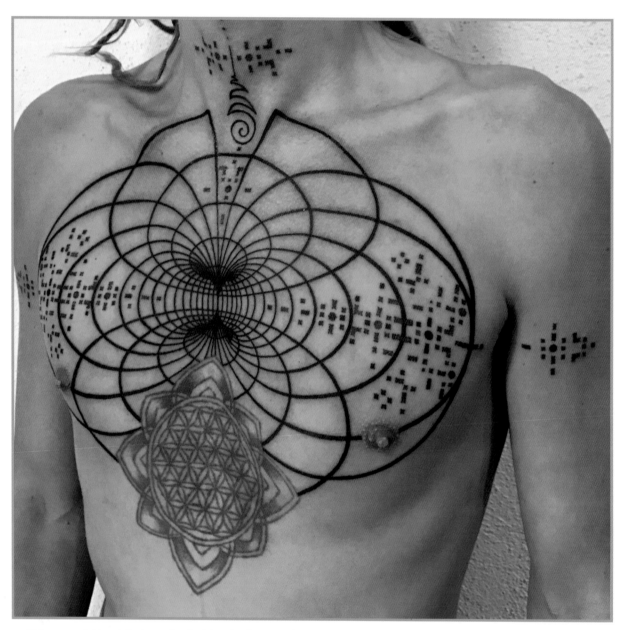

This spread: Neo-tribal, mechanical-inspired tattoos by Daniel Matsumoto; Geometric Fox by Mo Mori (far right).

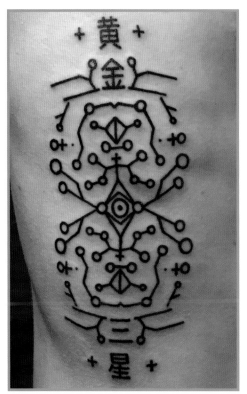

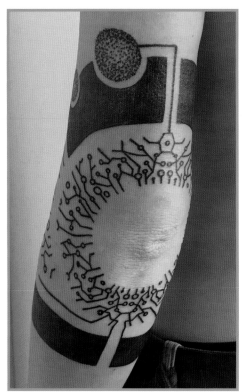

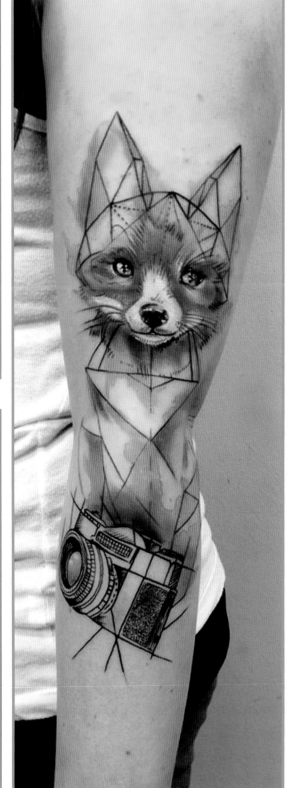

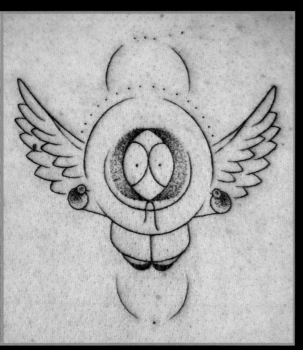

Kenny McCormick by Pablo Torre Rodriguez,
inspired by *South Park*

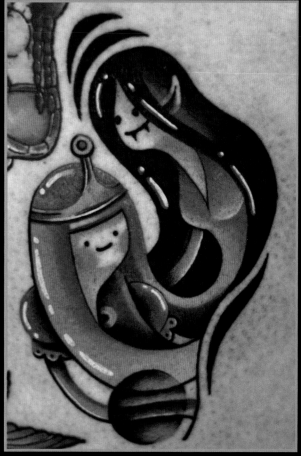

Bubblegum Princess and Marceline the Vampire Queen
by David Cote, inspired by *Adventure Time*

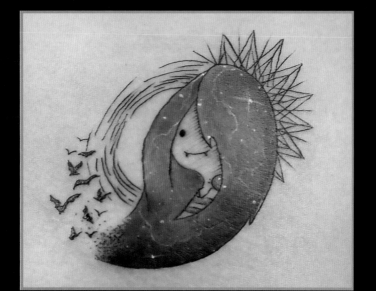

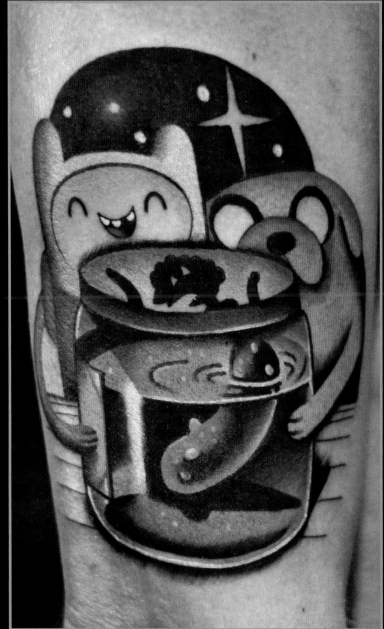

Finn, Jake, and Prismo by David Cote, inspired by *Adventure Time*

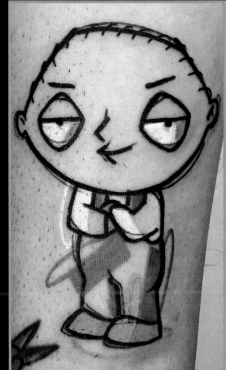

Stewie by Luca Testadiferro, inspired by
Family Guy

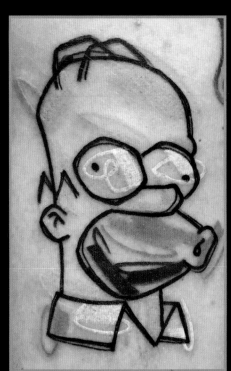

Homer by Luca Testadiferro, inspired by

ABOUT THE ARTISTS

SERGEY BERLIN is a Russian tattoo artist who invented a new style of tattooing, dubbed "mental geometry." The style is based on his practical knowledge about how the human consciousness is constructed and how we realize our desires. Before he became a tattooist, Sergey worked in advertising agencies as a copywriter, shot commercial movies as a director, and published *Sexual & Brutal*, a magazine covering modern art, fashion, and photography. He began tattooing in 2014 and has traveled internationally to work as a guest artist in studios around the world. Sergey is on Instagram as @berlinsergey.

BOMBAY FOOR, is an Italian tattoo artist whose real name is **Andrea Bianchi**. He was born in Seveso, a small town close to Milan, in 1985. He came to tattoos from the graffiti, marker, and fanzine world. He began by tattooing several friends in his apartment and then decided to leave his job to focus exclusively on tattoos. Andrea just wanted to draw for a living and seeing his work on people's skin became more and more fascinating. The inspiration for his works comes from classical artists like Escher, Mœbius, Fornasetti, and Sergio Toppi. He likes to partner with tattoo artists in different countries so he can travel around the world, but he is normally based at Lodo Tattoo in Milan. His work is on Instagram as @Bombayfoor.

SANDRA CUNHA is a Brazilian tattoo artist who has only been working as a professional since 2015. However, this career path has been her dream since she was a little girl. When she was seventeen, she started studying visual arts with a specialty in painting at the Federal University of Minas Gerais, in the city of Belo Horizonte, where she lives. She works at Inkonik Tattoo Studio in Belo Horizonte, mixing pointillism and etching. She only tattoos her own blackwork drawings, which are full of detail while remaining clean and easy to understand. Sandra is on Instagram as @sandracunhaa.

INDOMITO is a nomadic Spanish tattoo artist. His work can be seen on his website (www.indomito.co). Indomito is on Instagram as @indomito8.

SASHA KISELEVA is a Russian tattoo artist. She was stolen from a nest of dodo birds in infancy and grown with love by a gnomon clan in Siberia. She became a twilight shaman by rite of initiation and covered herself in ritual tattoos in the Mongolian prairie. She works in Moscow, the cold capital of Russia, determined to give humans a piece of tiny soulful inky eternity straight from her wild heart. Her work can be seen at her website, www.kiseleva.me, and on Instagram, @Sashakiseleva.

SANGHYUK KO, also known as **Mr.K**, moved to New York City from South Korea in the late 2000s. A Parsons-trained graphic designer working in fashion, his credits include the founding of K47, a streetwear brand. Perpetually fascinated with intricately detailed design and fine-line art, Mr.K eventually became obsessed with the unique applications of single needle tattoos, a technique that uses just one needle that is beautiful and dangerously delicate. In the hands of a well-trained technician, the tattoos heal beautifully and last forever. Mr.K works at Bang Bang tattoo studio in New York and enjoys meeting clients from around world. He is on Instagram as @mr.k_tats.

LOÏC LEBEUF is a Swiss tattoo artist from Geneva, Switzerland. He was always fascinated by the world of graphic art and so was naturally attracted to become a multimedia designer. This, in turn, led him to tattoos. He studied at the School of Applied Arts in Geneva and founded his tattoo studio when he graduated. His studio allows him to make the most of his knowledge and his creative impulses to create original works for his clients. A perfectionist and an eccentric, he is a serious artist and loves his work. Loïc's work can be seen on his website, www.lebeuf.ch, and on Instagram, @_lebeuf_.

YEEKII LO has been tattooing since 2013. She is based in Hong Kong. Her style focuses on delicate line and dot work without color. She likes to create lines over shapes and does original work on each person. Yeekii is on Instagram as @yeekiitattoos.

NORA LYASHKO is a Ukrainian tattoo artist currently based in Saint Petersburg, Russia. As a child, she developed a love for art and decided to devote her life to it. She began studying tattoo artistry and has successfully graduated with a degree. At first, she thought tattooing would be a hobby, but as time progressed, it became her passion. Nora is happy that her profession has also allowed her to express her creativity, as well as travel around the world to share her talents with others. She aspires to ensure that everyone leaves her chair with a clean, precise, and vivid illustration that will remain for a lifetime. Her ultimate goal is not

only to combine unique graphics, but also to blend pastel colors into a work of art. Nora is on Instagram as Nora_ink.

MATTIA MAMBO is an Italian tattoo artist whose real name is Mattia. He was born near Milan, where he lives and works. In high school, he studied art and met many people who have since become colleagues and customers and have been very important for his current job. After graduating from school, he worked in a restaurant for several years. Cooking is his passion and he has been working to merge it with tattoos, bring the theme of food onto skin. Mambo's style, which he dubs "*destrutturato*," incorporates the bright and flat colors of Japanese tattoos with the simplicity of old-school techniques. He attempts, with just a few lines and colors, to create a strong visual image with sharp impact, like a sticker. Mambo also likes to draw and design things that aren't tattoos, including skateboards and clothing. Mambo's guiding philosophy, no matter whether he's designing a tattoo or something else, is that less is more. He is on Instagram as @Mambotattooer.

DANIEL MATSUMOTO is a tattoo artist currently based in São Paulo, Brazil. He was born in 1991 and raised in Japan. He studied philosophy in university and is engaged in the study of spirituality, occultism, Buddhism, and ancestralism. Daniel believes that artificial consciousness and human consciousness and spirituality will converge into one in the remote future. His work as a tattoo artist reflects some of those beliefs. He is on Instagram as @omze__.

CURT MONTGOMERY is a Toronto-based tattoo artist working out of Holy Noir Tattoos. Tattooing since 2014, he has developed his own recognizable adaptation of black minimalism tattoos, dedicating his work to strange, hilarious and often erotic content. He is on Instagram as @curtmontgomerytattoos.

MO MORI had her first contact with tattooing in 2011. She was an artist before that, but the experience with the tattoo arts made her realize that she wanted to become a tattoo artist. She spent two years in a studio in Berlin, Germany, learning how to create tattoos and all of the tricks her mentors could teach her. After her apprenticeship, time seemed to speed up: she traveled a lot, either to conventions or as a guest artist. She visited several spots in Germany, Iceland, Norway, and Switzerland. Through a work period in a big tattoo shop, she had the chance for a technical exchange with experienced tattoo colleagues that further improved her technique. Her work is characterized by her love of animals and diving into a surreal world. Mo is curious and always open to adding a special touch to her work. In 2017, she opened her own studio on the outskirts of Berlin, Atelier Mori Capelli, with her colleague Cory Capelli. Ever since finding her profession, Mo feels like she is the luckiest person in the world. She is on Instagram as @momori_ink.

MATTEO NANGERONI is an Italian tattoo artist who started tattooing in February 2014. He began with a tattoo on his leg, inked with a Chinese kit and instructions from a YouTube tutorial. Matteo enjoyed the experience so much that, after a while, he decided to leave his job as an accountant to become a tattoo artist. His friends and family opposed this decision because he didn't even draw before he did his first tattoo. But he had passion for the art of tattooing and so he spent a few months practicing drawing, sometimes doing so for more than eighteen hours a day. Matteo created a small sketchbook of his artwork to show to studios so he could get an internship. One of these studios accepted him and he began learning how to professionally tattoo there. After a year of work, he began to tattoo by himself in his home. After just four months, customers started to write to him for commissions. From then, he started working as a guest in many studios, sometimes with more than ten different studio appearance in a month. Matteo is very grateful to all of his clients. He is on Instagram as @matteonangeroni.

DINO NEMEC was born in 1984 and raised in Entre Ríos, Argentina. In 2005, he moved to the United States, to his mother's home state of Ohio. Dino's first language is Spanish. In 2006, this self-taught tattoo artist did his very first tattoo (on his own leg), learning the hard way. He specializes in linear, abstract, and vintage illustration-style fine tattoos. He also really enjoys doing freehand tattoos and is very lucky to have amazing clients that trust him enough to let him draw on them. He works at Lone Wolf tattoo studio in Columbus, Ohio. Dino is married to an amazing woman and the father of two beautiful little human beings, Luciana and Vigo. His work can be seen on his website, www.dino-nemec.com, and on Instagram, @dinonemec.

ANNA NEUDECKER, also known as **La Bigotta**, was born in 1982 in Munich, Germany. When she was two years old, she moved to Italy and settled between Rome and Milan. From a young age, she showed great passion for drawing in all its forms. The versatility of her artistic ability can also be found in her attendance at the Academy of Fine Arts of Rome. Eventually, her studies led her to the art of tattooing. Anna began her career as a tattoo artist in 2014. After much experimentation and gaining some experience, she passed from old-school styles to realism, finally finding inspiration for her unique style in etchings of the Victorian age and in Surrealism. She is on Instagram as @labigotta.

ARTHUR PERFETTO was born and raised in São Paulo, Brazil, but relocated to Berlin, Germany. From an early age, he was influenced by the Impressionists because of his mother, a fan of that era. He started learning how to draw when he was eleven years old. His best friends Brian Gomes and Brice Gomes introduced him to tattooing when was twenty-five. Since that moment, tattooing has been his passion. Arthur's work is on Instagram as @arthurperfetto.

SVEN RAYEN was born in 1980 in the Belgian city of Leuven. In 2002 he obtained a master's degree in fine arts, with an expertise in graphical techniques and drawing. After graduating from school, he worked as an illustrator, as a tattoo artist at SinSin Tattoo in Antwerp, and as a guest tattoo artist at Sang Bleu London and Shamrock Tattoo Dublin. He moved back to Antwerp and cofounded a private tattoo and design studio, Studio Palermo, with his high school friend, Ti. Sven is on Instagram as @svenrayen.

PABLO TORRE RODRIGUEZ's interest in tattoo art began at a very young age, while studying illustration in La Coruña, Spain, his hometown. Since the beginning, he's chased the idea of etching his art onto people's skin, freeing it from the rigidity of a piece of paper. That's why, as soon as he finished his studies, he started his training at Zink—a tattoo studio in La Coruña—where he learned the basics and improved his techniques. In 2014, he decided to move to Madrid to begin working on his own and developing a personal style. He began to focus on black tattoo art, illustrative works, geometric and fine lines, and precise dot work. Pablo's style is defined by accuracy and attention to little details. His works are usually very delicate and clean, mainly based on an illustrative style, representing natural elements, art, objects, symmetries, and geometries with some surreal touches. He is a resident artist at Alchemist's Valley, a tattoo studio in the heart on Madrid that specializes in black tattoo art. Pablo's work can be seen at his website, www.alchemistsvalley.com, and he is on Instagram as @pt78tattoo.

DIANA SEVERINENKO is a tattoo artist from Kiev, Ukraine. She developed a love for drawing from early childhood, and spent a lot of time trying to improve her style and techniques. In school, she studied art. When she was sixteen, she began to engage with tattoos because she wanted to find a career that would employ her drawings and she always liked the look of tattoos. For each of Diana's customers, she draws a unique design, normally with plant and animal motifs. She considers tattoos to be adornments, and therefore thinks proper placement on the body is very important. She seeks inspiration in the observation of nature. Diana is on Instagram as @dianaseverinenko.

ROMA SEVEROV is a full-time tattoo artist from Ukraine, currently living and working in Warsaw, Poland. He spent seven years in a pharmaceutical university and has a bachelor's degree in physics, and a master's degree in biophysics. He is a specialist in clinical pharmacy. In spite of his academic training, he always knew that he was meant to be an artist. He started tattooing around 2012 because he developed a passion for drawing. He enjoys the simplicity of tattooing, which draws him to the linework style. When not tattooing, Roma enjoys his hobbies of traveling with his family and street photography. His work is on Instagram as @Severovroma.

Lithuanian tattoo artist **MARTYNAS ŠNIOKA** currently tattoos at Angis Tattoo in Vilnius, though his work is appreciated around the world. The talented illustrator and street artist has a bold graphic style that uses bright colors to give his tattoos life; his blackwork designs are also stunning. Combining elements of watercolor, abstract, and graphic tattoos, Martynas's work is a fine example of contemporary tattooing. He is on Instagram as @shnioka.

TATTOOIST DOY is a South Korean tattoo artist based at INKEDWALL in Seoul. In university, he studied visual design and has been tattooing for more than ten years. However, tattooing is illegal in South Korea and Tattooist DOY has been trying to change cultural awareness and South Korean law with his tattoos. His philosophy as an artist is to create positive and beautiful works of art that help to improve the legal situation of Korean tattoo artists. He is on Instagram as @tattooist_doy.

MARIN TERESHCHENKO is a Ukrainian tattoo artist who began tattooing in 2012. Her floral tattoos have a unique style and she likes to work with different plants. She only uses black ink. Her work can be seen on her website, www.mary-ink.com, and on Instagram, @mary_tereshchenko.

LUCA TESTADIFERRO is an Italian tattoo artist who started in 2013. He came from the world of graffiti. He started at the Tattoo Artist Studio in Fabriano, Italy, where Matteo Cascetti taught him everything about tattooing—not only the techniques, but also how to work with customers and be a good artist. After leaving the Tattoo Artist Studio, he started a collaboration with the Kosta Dorika Tattoo Studio in Ancona, Italy. Luca loves being a tattoo artist because he can share and learn new things. He enjoys talking with his colleagues about how they work, what they think, what they use. The key to his artwork is the simplicity. His drawings are simple: a few well-placed lines and just the right amount of color combine for a powerful graphic punch. Luca is on Instagram as @lucatestadiferro.

ALINA TIURINA is a Ukrainian tattoo artist. She studied to be an artist and spent five years working as a painter. One day, a friend invited her to visit a tattoo studio in Saint Petersburg, Russia. Her friend suggested that she try tattooing herself. Alina fell in love with this new experience. Now she works in Russia, Ukraine, the United Arab Emirates, Europe, and the United States. Tattooing gives her artistic freedom and the ability to travel around the world. She is on Instagram as @alinatu.

MICHELE VOLPI is an Italian tattoo artist. He was born in Sant'Elpidio a Mare, a town in central Italy, in 1991. He loves every form of art: drawing, technical drawing, photography, painting, and so on. He worked hard to improve his drawing skills and to define his fine blackwork tattoo style. He's fascinated by nature and loves to represent it in a minimal, surreal, and poetic way. Michele began tattooing in October 2013, when he was twenty-two years old. He taught himself to tattoo and then moved to Bologna where he began practicing in a studio. In May 2017 he had the opportunity to tattoo at Vaders.Dye in Hamburg, Germany, and also guest tattooed at LTW Tattoo Studio in Barcelona, Spain in September 2017. Art is the best way he knows to express himself and his feelings, so tattooing is his lifestyle. Michele is on Instagram as @_mfox.

ALINE WATANABE is a tattoo artist from São Paulo, Brazil. She started tattooing in October 2014, when she became an apprentice in a studio. After five months, she started at a private studio. She has a degree in fashion and worked with surface design in the textile industry, but she decided to stop working with fashion when she discovered the universe of tattoos. She loves her chosen profession and gives much importance to the act of tattooing a person, finding great value in the experience. Aline's style can be defined as abstract figurative, because she likes cleaner compositions with geometry, solid colors, and minimalism. However, her style is constantly undergoing changes and evolving because tattooing is always a continuous learning experience. Aline is on Instagram as @alinewata.

PONY WAVE was born and raised in Russia, where she started her path as a tattoo artist. Now a resident of Los Angeles, California, she tries to travel as much as she can. When she began tattooing, her style was close to colorful realism and used new techniques; she used a lot of colors. Now, she has fallen in love with blackwork tattoos, minimalist elements, and geometry. However, she is still searching for her own style, which is why she enjoys experimenting. In her opinion, minimalism and geometry are levels of art development between worlds. She goes through her sketches very thoughtfully and thoroughly and every tattoo she inks is unique. She is on Instagram as @ponywave.

ZIHWA is a South Korean tattoo artist. She crafts delicate floral tattoos at Reindeer Ink (www.reindeerink.com) in Seoul. Zihwa is on Instagram as @zihwa_tattooer.

INDEX

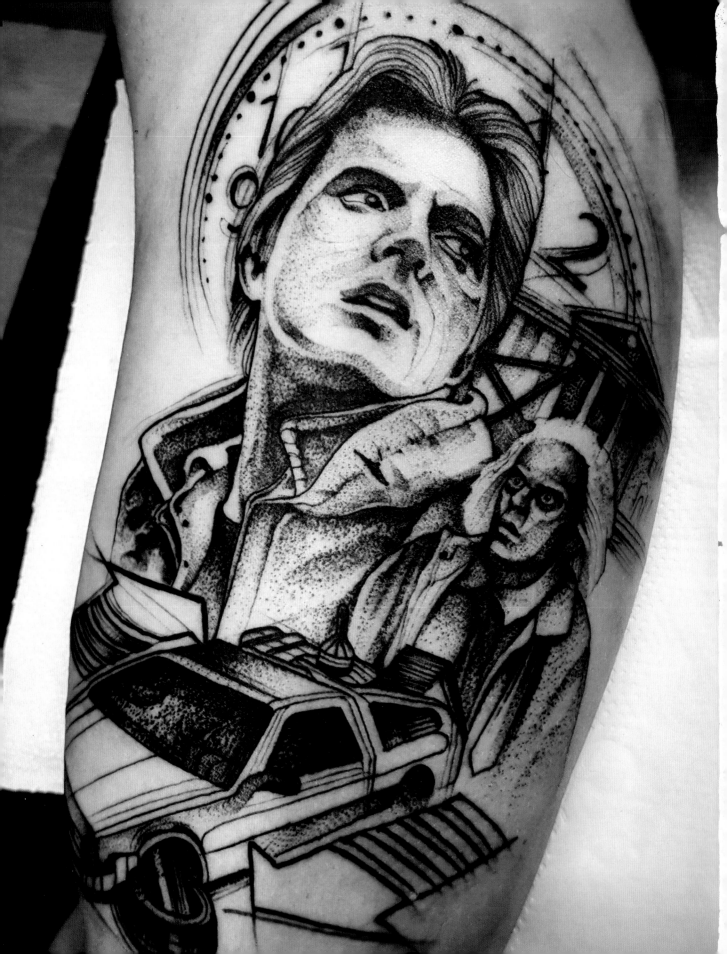